New York City on Instagram

Edited by Dan Kurtzman

RIZZOLI
NEW YORK

New York Paris London Milan

First published in the United States of America in 2017
by Rizzoli International Publications, Inc.
300 Park Avenue South
New York, NY 10010
www.rizzoliusa.com

Text © 2017 Dan Kurtzman

Instagram is used with permission by Instagram, LLC.
The publisher, author, and contributing photographers are independent
and not affiliated with, endorsed, or sponsored by Instagram LLC.

Photographs herein were curated from Instagram and used by
permission of the photographers. All photographs copyright
© 2017 by the individual photographers; credits listed on pages 205–207.

2017 2018 2019 2020 / 10 9 8 7 6 5 4 3 2 1

ISBN-13: 978-1-59962-139-5
Library of Congress Control Number: 2017933351

Project Editor: Elizabeth Smith
Design: Lynne Yeamans

Printed in China

Distributed in the U.S. trade by Random House, New York

PAGE 2: **@thewilliamanderson** Walking down Fifth Avenue
as a blizzard brings the city to a standstill.

OPPOSITE: **@papakila** Overlooking the FDR Drive and the Financial
District from the Manhattan Bridge on an autumn evening.

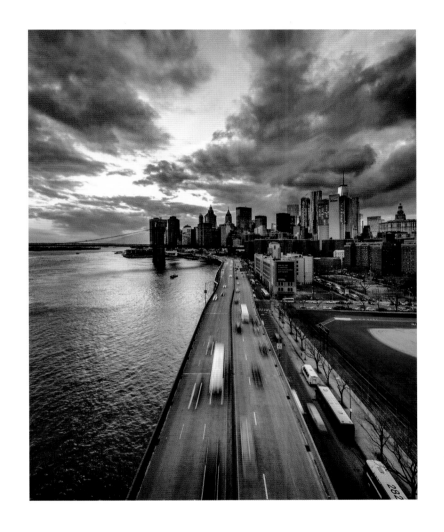

To the New York Instagram community,
whose passion, talent, and creativity inspire us all.

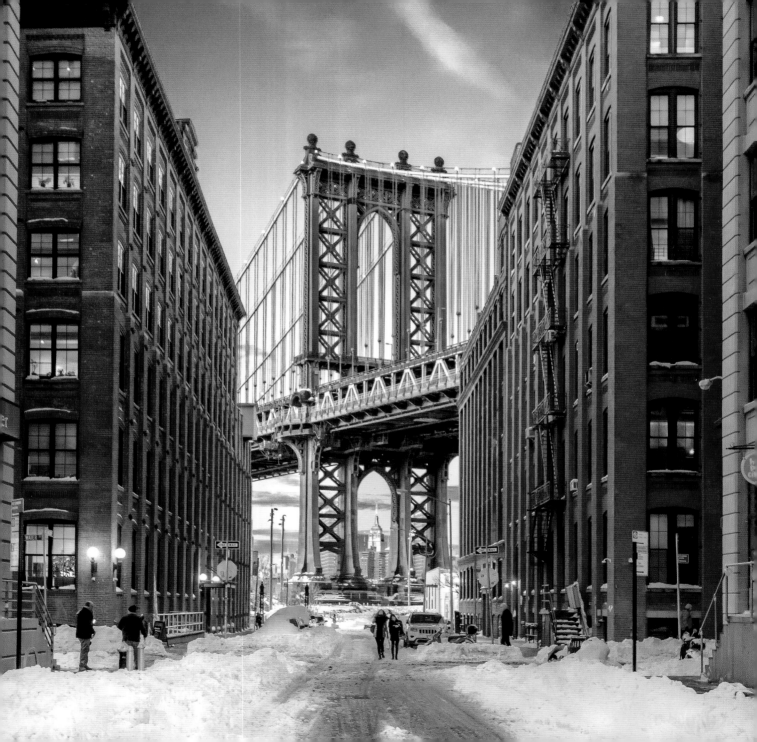

INTRODUCTION

New York City has long been considered one of the most photogenic cities in the world, but at no time has its magic been more passionately and extensively captured than right now, through the lens of Instagram.

On any given day, you will find Instagram photographers in the city that never sleeps venturing out before dawn to catch a dramatic sunrise over the city, or seeking out rooftop views at night to capture the sparkling lights of Manhattan's ever-changing skyline. Walking amid the bustling throngs to snap colorful vignettes of city life, or escaping to Central Park in search of vibrant autumn colors or magical winter scenes. Pointing their cameras upward to capture unique perspectives of some of the world's most impressive architectural sights, or soaring through the sky in helicopters to share jaw-dropping aerials looking down at the concrete jungle.

By showcasing some of the most memorable images from more than forty wonderfully talented and acclaimed Instagram photographers, this book paints a unique portrait of New York City's iconic sights and hidden treasures, while also providing a snapshot of the innovation and artistry happening on Instagram. Spurred on by the vibrant and creative Instagram community, a new generation of artists has emerged, contributing to a global photography revolution that has produced remarkable work and reached a larger audience than ever before, with more than 600 million active Instagram users and counting. At the heart of that revolution is New York City, the most photographed city in the world on Instagram.

To encapsulate the New York Instagram experience, I have pored over tens of thousands of photographs to select images that represent a range of artistic

OPPOSITE: **@nyclovesnyc** An iconic view of the Manhattan Bridge from Washington Street in DUMBO, Brooklyn.

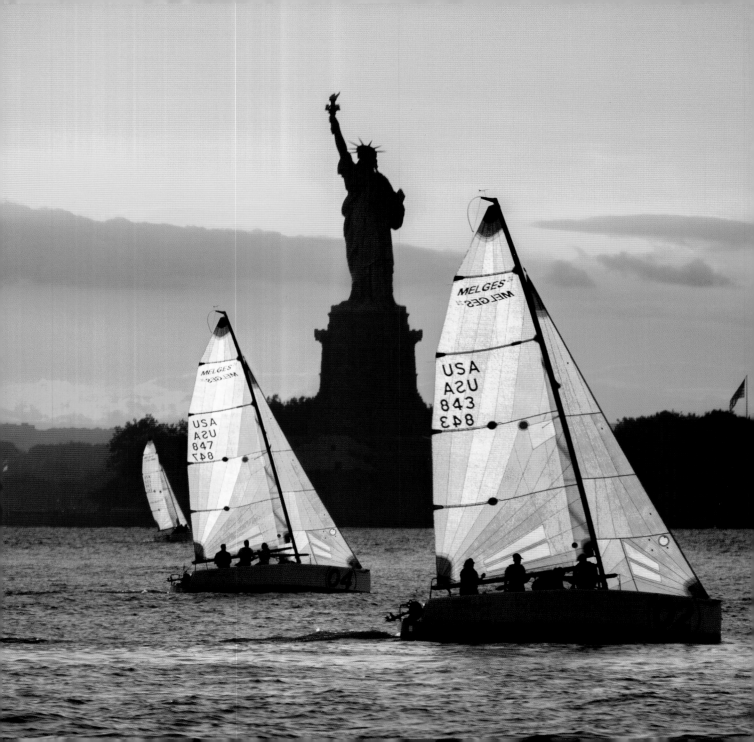

styles and subjects throughout the city. While there is a wide array of photography flourishing on Instagram, this book focuses primarily on urban landscapes, architectural and street photography that shows how Instagram photographers have rediscovered the greatest city in the world.

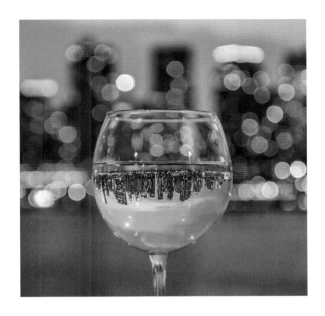

Some of the photographers featured in this book are professionals, while others are semipros and hobbyists. Some are among the city's most popular Instagram photographers, with tens of thousands of followers, while others are talented up-and-comers. In many ways it is an impossible task to select a representative sampling of photographers when the city is teeming with talent, or to narrow down so many amazing photographs to a single volume. But I hope that this book provides a taste of the Instagram experience that can serve as a springboard for exploring the work of these accomplished photographers, as well as the many others like them who are part of the thriving Instagram community.

Whether you're an aspiring photographer, enthusiastic visitor, or a local simply looking for great New York locations to explore, let the images in this book inspire you to seek out and experience these places for yourself. Perhaps that means walking across the Brooklyn Bridge during the early morning golden hour, chasing the perfect alignment of the setting sun during "Manhattanhenge," or watching the skyscrapers shine at twilight from the Top of the Rock or Brooklyn Bridge Park. This book aims to provide a taste of the Instagram experience that can serve as a springboard for exploring the work of these accomplished photographers.

—DAN KURTZMAN

OPPOSITE: **@dubsonata** Sailing past the Statue of Liberty at sundown.
ABOVE: **@nyclovesnyc** Raising a glass to Manhattan's skyline.

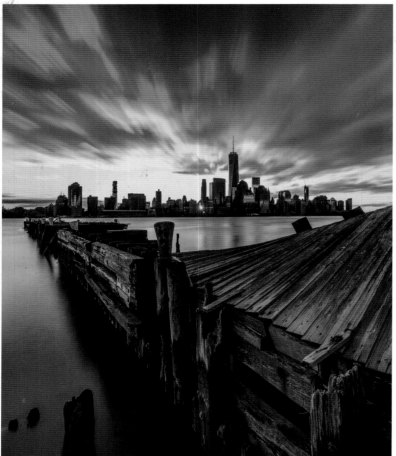

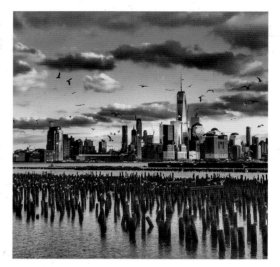

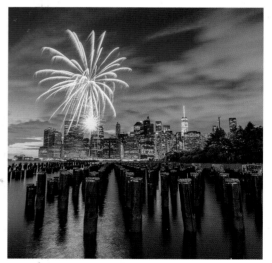

ABOVE: **@gettyphotography**
Twisted sunrise from
the New Jersey waterfront.

TOP RIGHT: **@milan2ny**
Lower Manhattan, from
Hoboken, NJ.

BOTTOM RIGHT:
@matthewchimeraphotography
Watching fireworks over
Manhattan from Brooklyn
Bridge Park.

OPPOSITE: **@papakila**
"Blue hour" view of
Lower Manhattan over
the pier pilings at
Brooklyn Bridge Park.

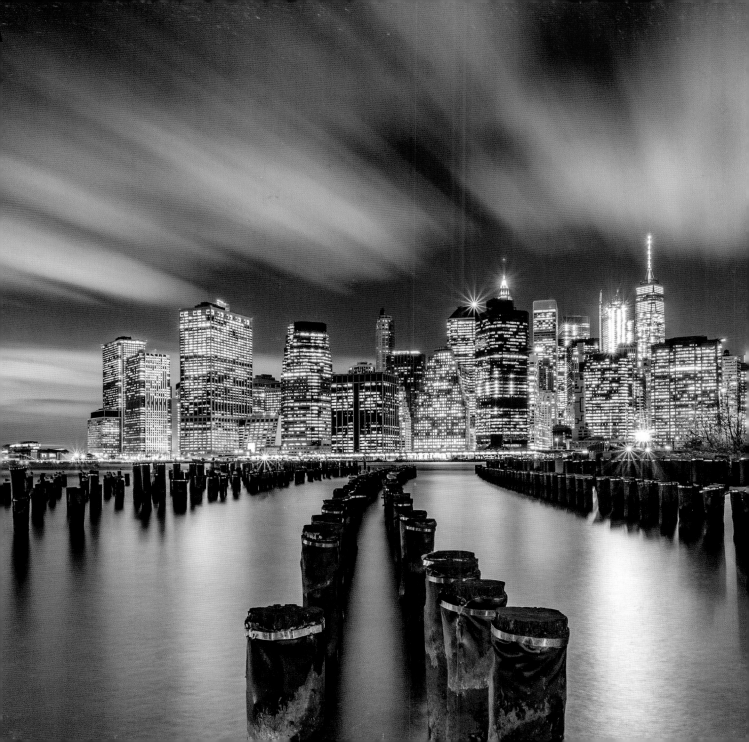

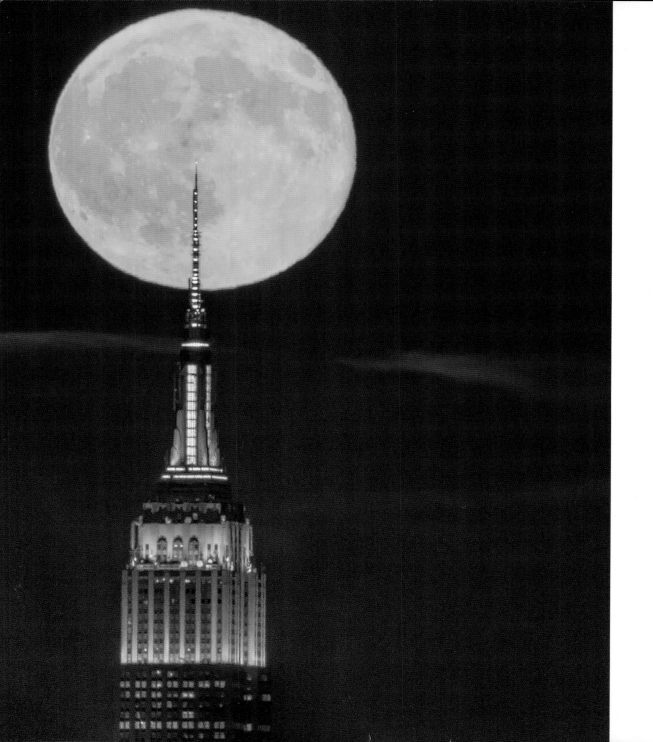

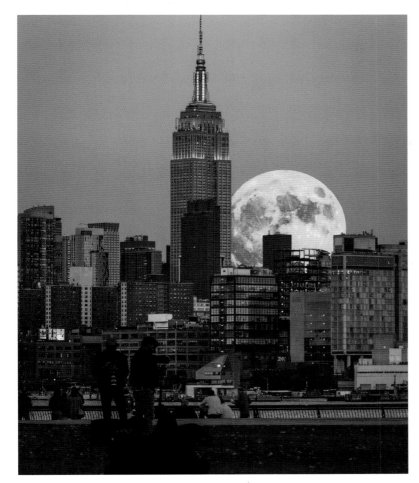

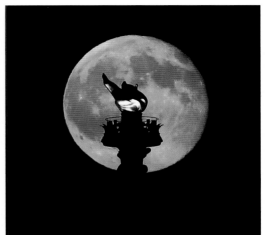

TOP RIGHT: **@garyhershorn** Lady Liberty's torch with a rising full moon.

BOTTOM RIGHT: **@johnnyyonkers** Beaver Moon from Liberty State Park, Jersey City, NJ.

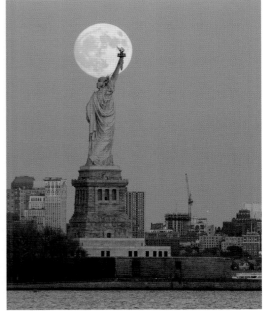

OPPOSITE: **@jkhordi** Sturgeon Moon crossing behind the spire of the Empire State Building.

ABOVE: **@beholdingeye** Supermoon rising.

RIGHT: **@garyhershorn** Crescent moon setting alongside One World Trade Center.

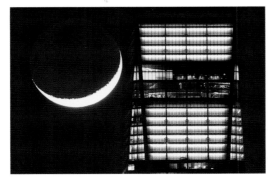

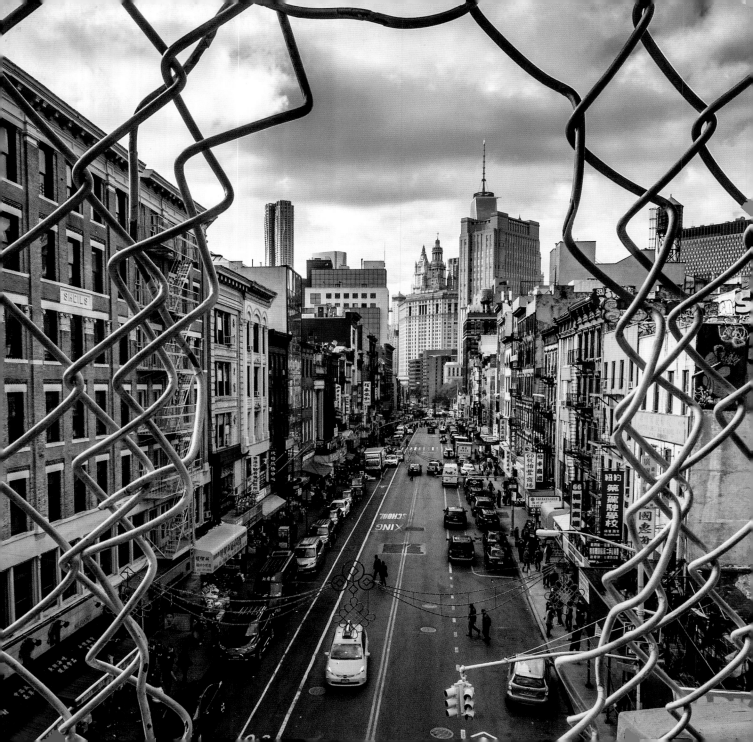

OPPOSITE: **@dankurtzman-photography** East Broadway in Chinatown, seen from the Manhattan Bridge walkway.

RIGHT: **@dankurtzman-photography** The setting sun, bathing 42nd Street in light, seen from the Tudor City Overpass.

FOLLOWING SPREAD: *(left)* **@javan** Enjoying a spring day at Gantry Plaza State Park, Long Island City, Queens. *(right)* **@dankurtzman-photography** Facing off at the Chess & Checkers House in Central Park.

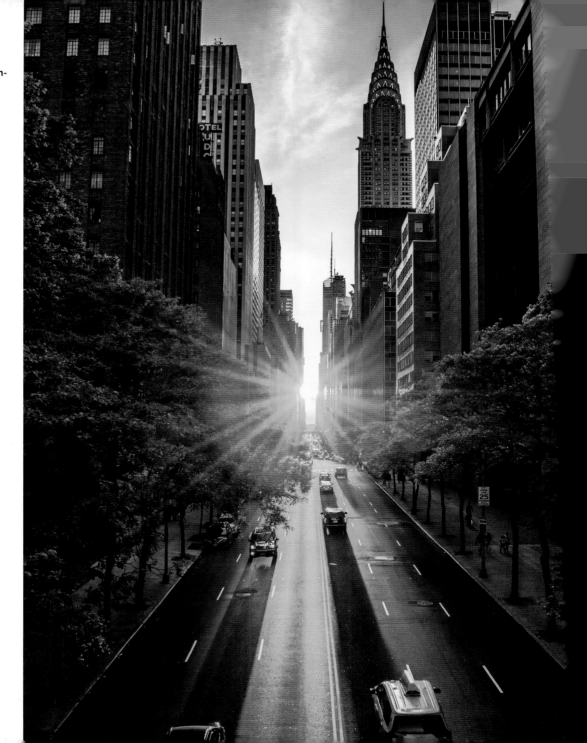

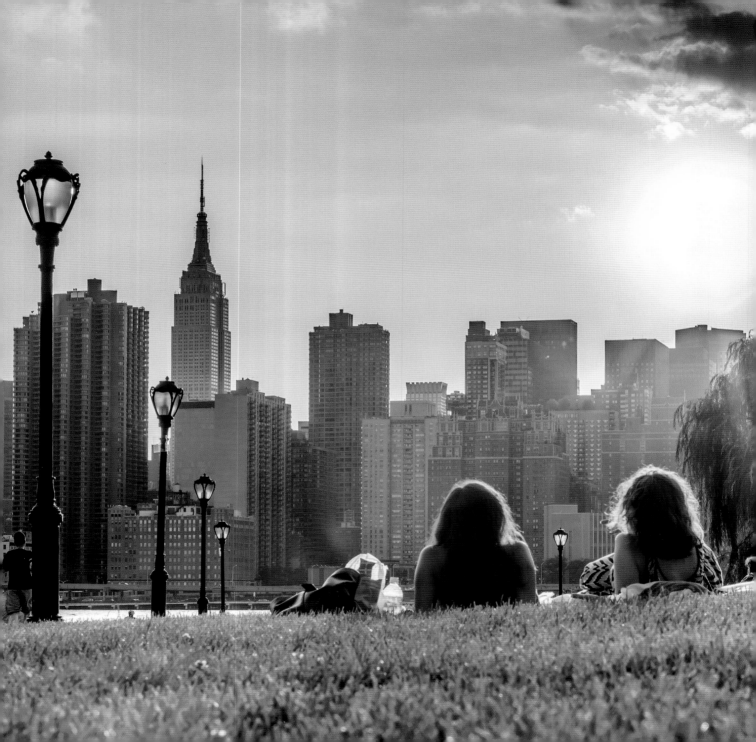

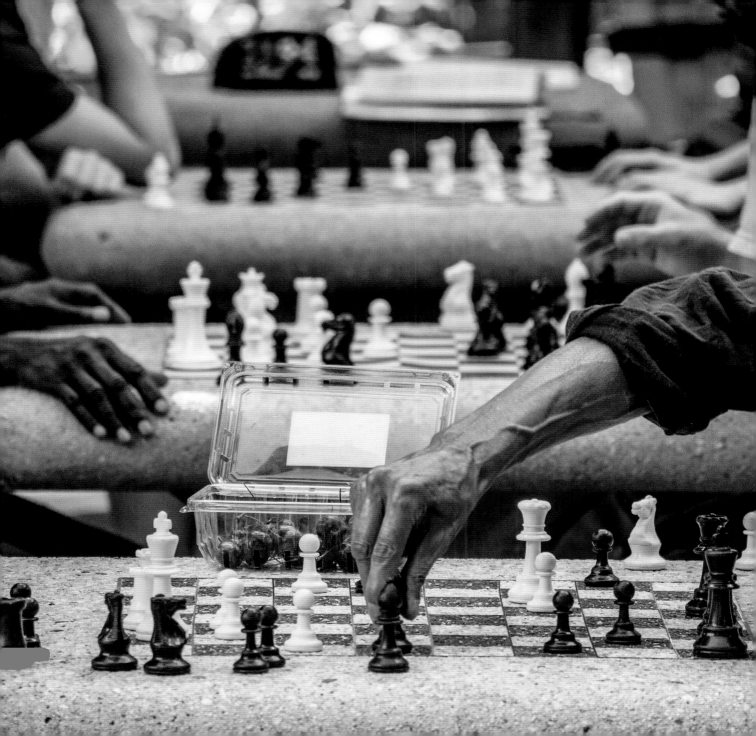

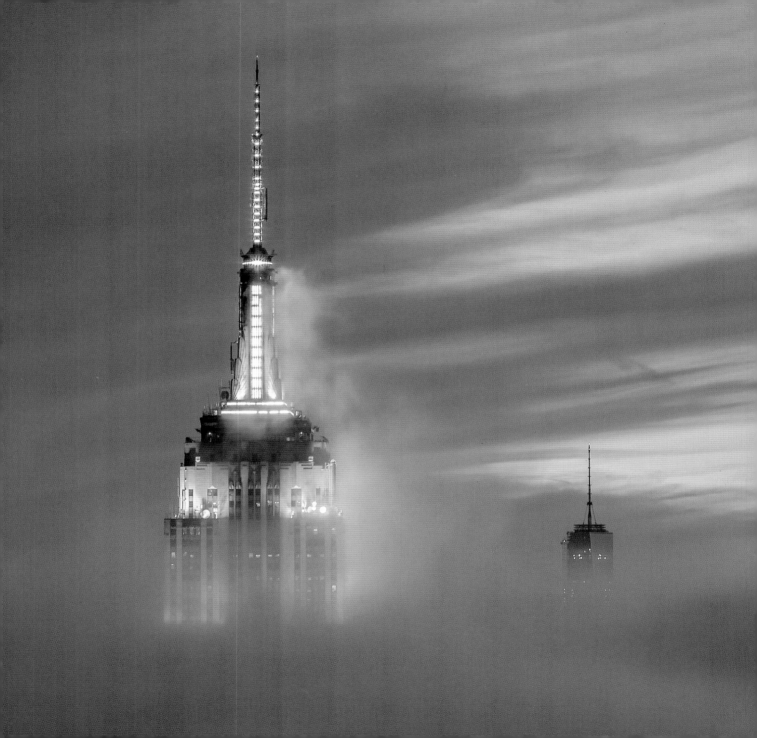

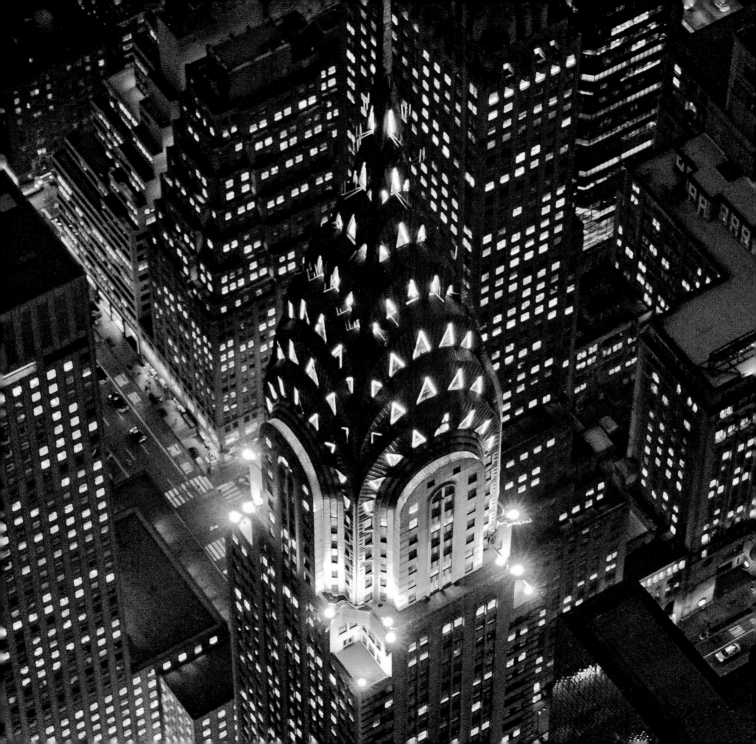

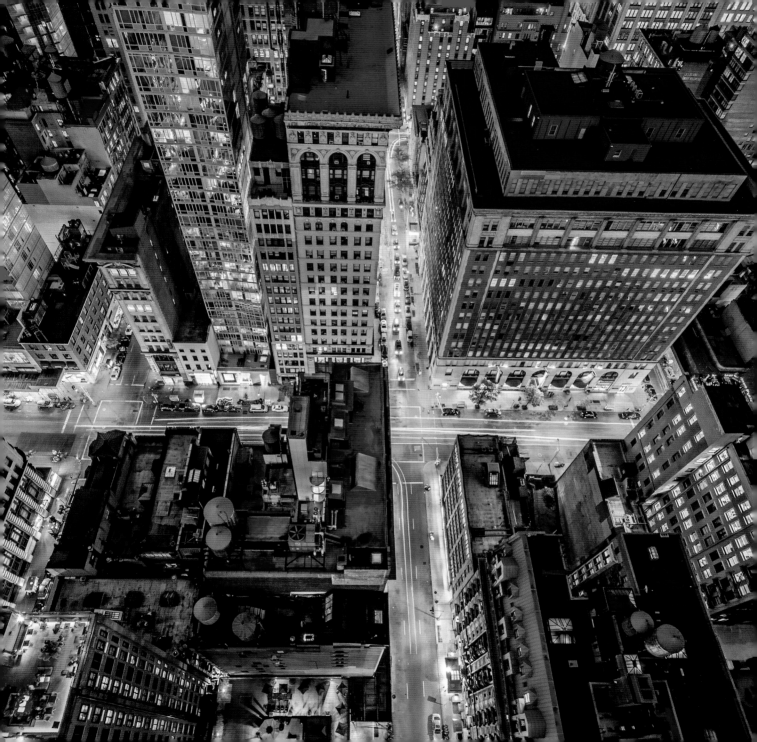

OPPOSITE: **@javan**
Bird's-eye view of Fifth
Avenue and 31st Street.

RIGHT: **@beholdingeye**
Just before dawn from
One Penn Plaza.

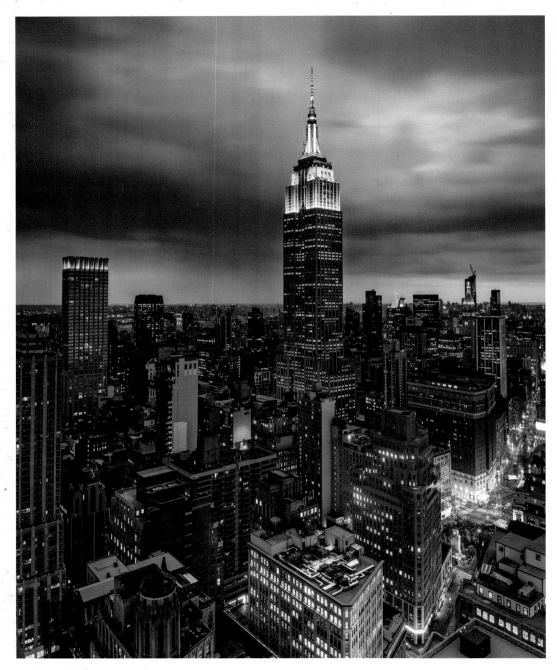

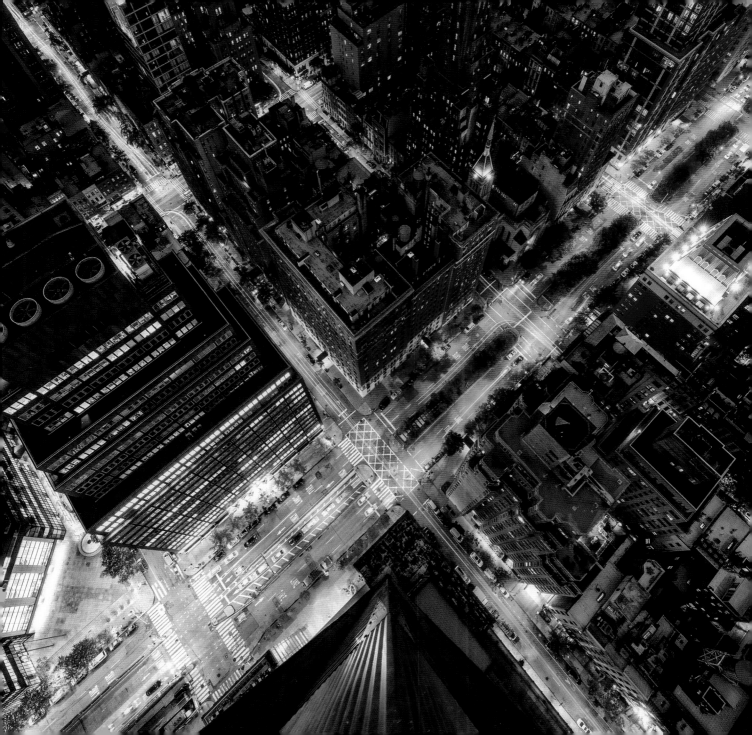

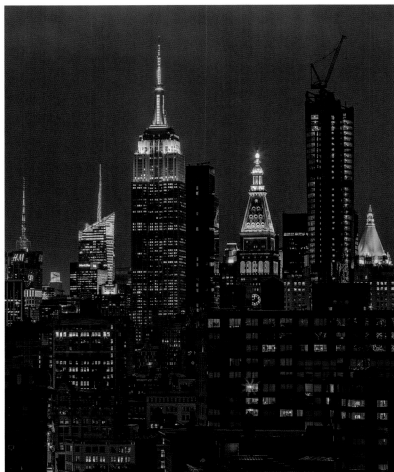

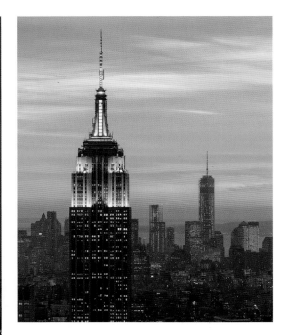

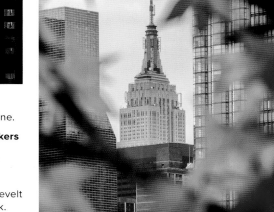

ABOVE: **@dubsonata**
An always growing skyline.

TOP RIGHT: **@johnnyyonkers**
Empire sunset from
the Top of the Rock.

RIGHT: **@nyclovesnyc**
Autumn view from Roosevelt
Island's South Point Park.

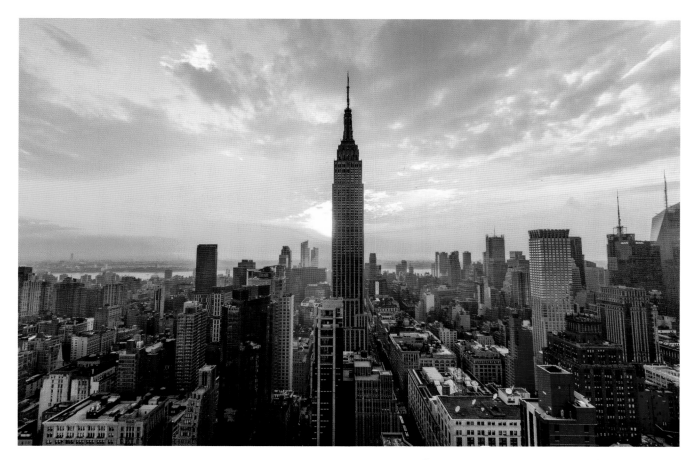

ABOVE: **@midnight.xpress**
Midtown's sunset hour.

RIGHT: **@killahwave**
Empire sunrise, seen from
Weehawken, NJ.

FAR RIGHT: **@dantvusa**
A golden city, seen from
Arthur Ashe Stadium,
Queens.

FOLLOWING SPREAD:
@jkhordi An epic display
of nature over Manhattan,
seen from Jersey City, NJ.

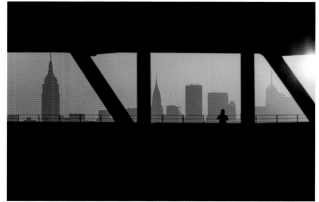

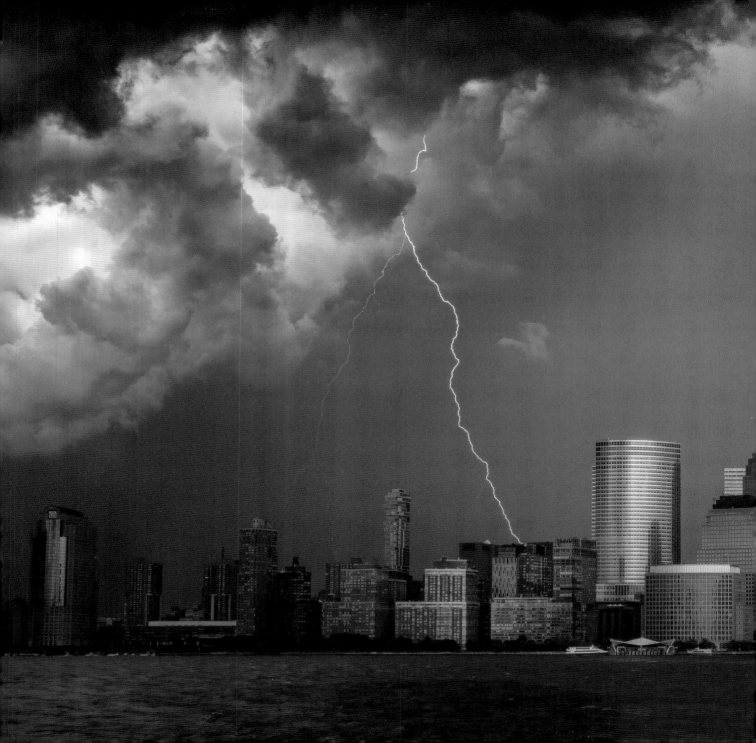

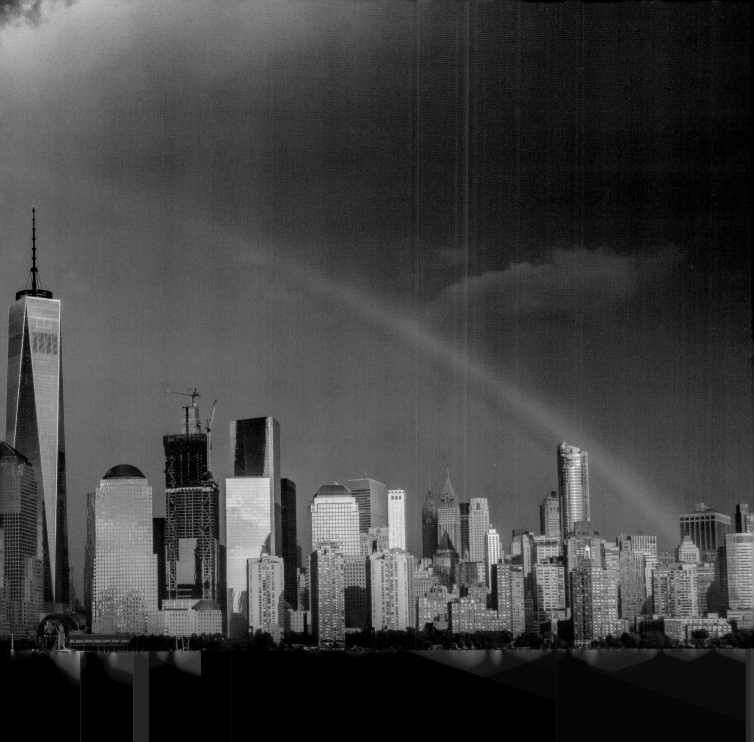

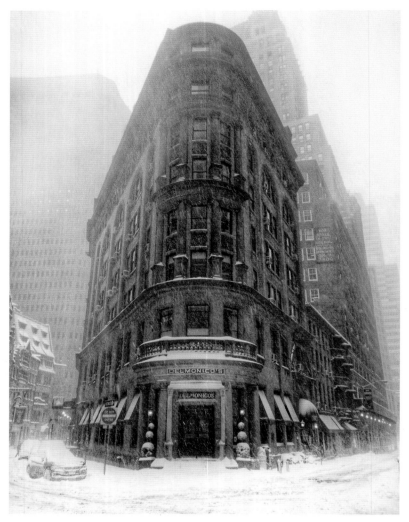

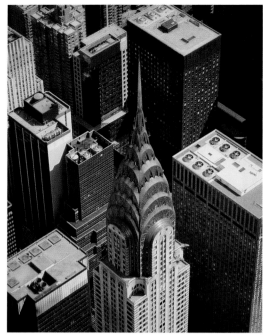

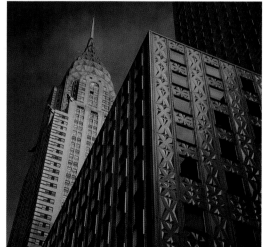

ABOVE: **@fatiography**
Nothing takes away from
the majestic beauty of
Delmonico's, not even a
severe blizzard.

TOP RIGHT: **@nyroamer**
The Chrysler Building
in shades of gray.

RIGHT: **@chief770** The
Mobil Building upstaging
the Chrysler Building.

OPPOSITE: **@2ndfloorguy**
A portrait of the land-
mark Flatiron Building on
a winter afternoon.

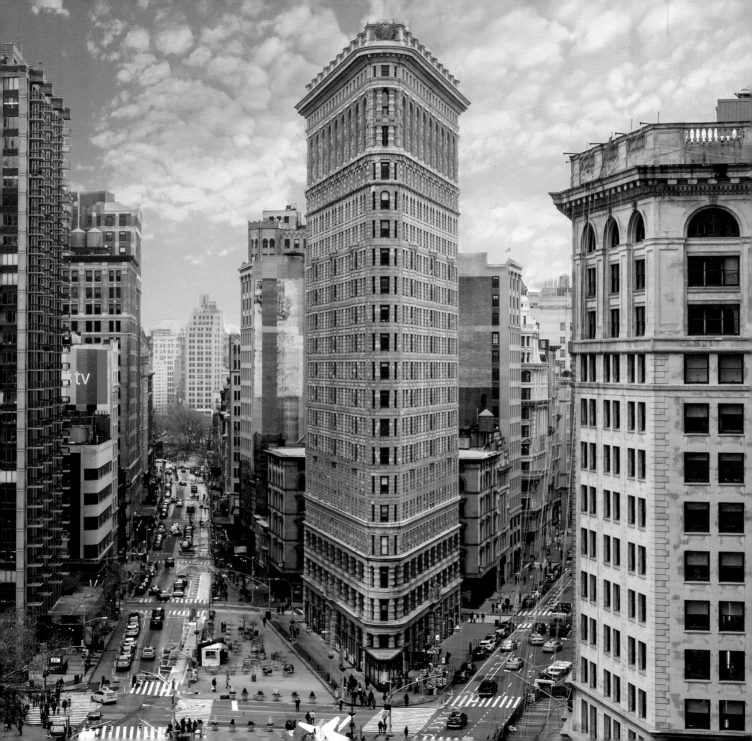

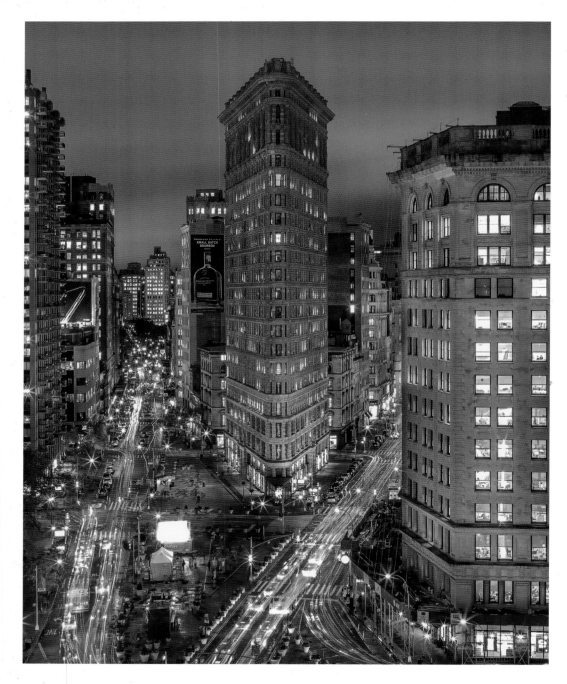

LEFT: **@killahwave**
Evening traffic passing by the Flatiron Building.

OPPOSITE: **@beholdingeye**
Street-level light trails in the Flatiron District.

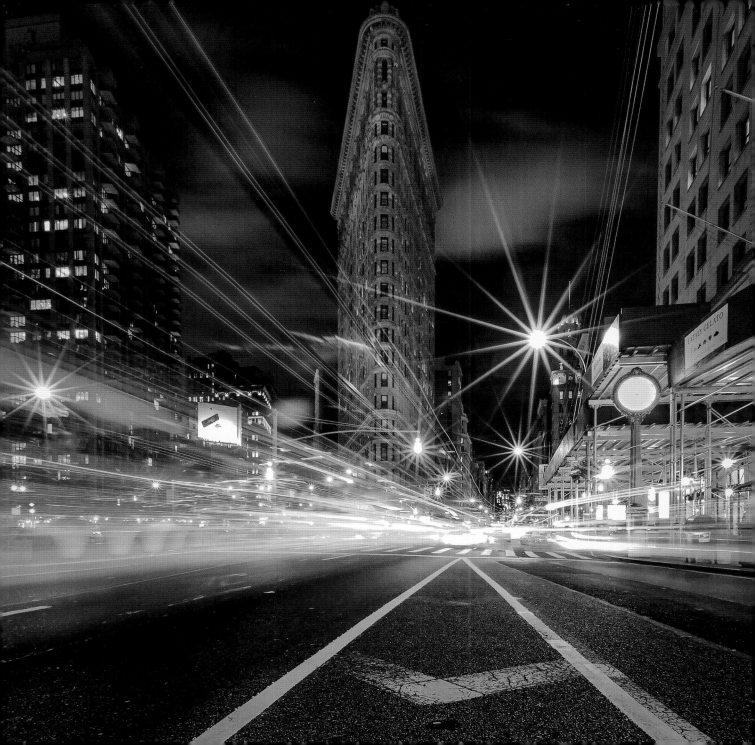

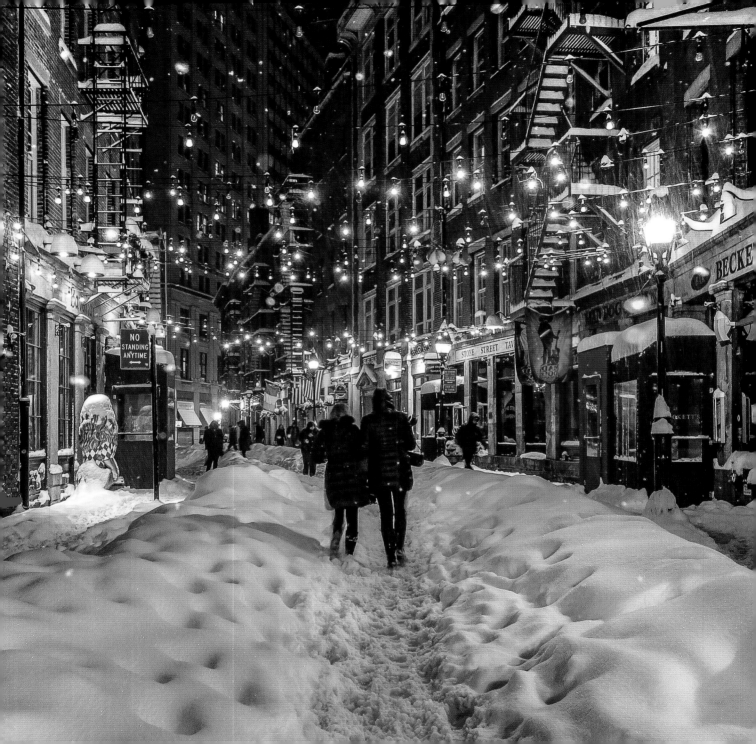

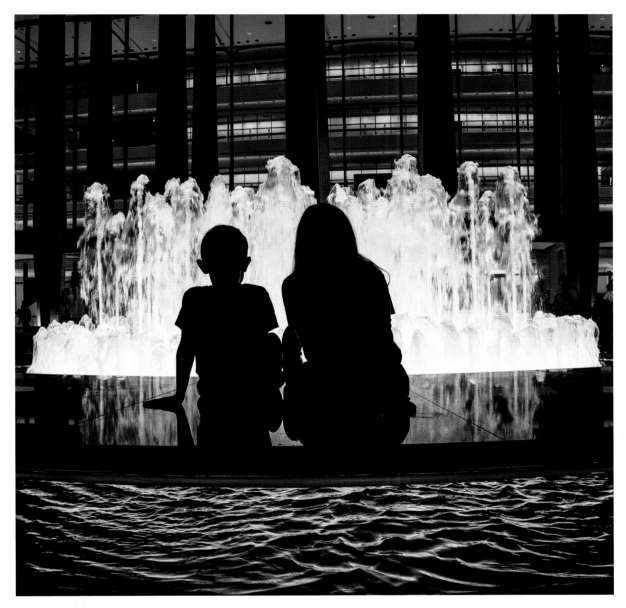

OPPOSITE: **@coryschlossimages** Walking in a winter wonderland on Stone Street.
ABOVE: **@dankurtzmanphotography** Mesmerized by Lincoln Center's Revson Fountain.

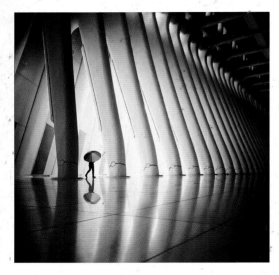

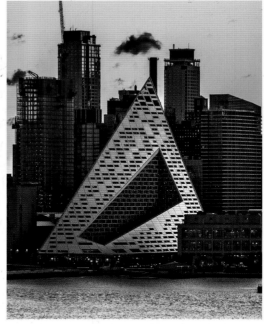

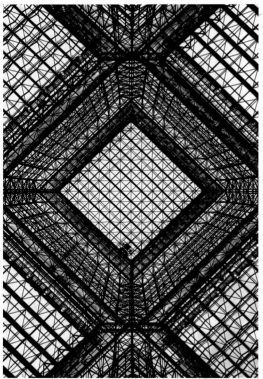

TOP LEFT: **@golden2dew**
At the World Trade
Center PATH station.

BOTTOM LEFT:
@timothyschenck
Looking up at the glass
ceiling in the Javits
Center.

ABOVE: **@beholdingeye**
Via 57 West, "The
Pyramid of NYC," from
across the Hudson River.

OPPOSITE: **@dantvusa**
Artist Tom Fruin's
Kolonihavehus shining
at Brooklyn Bridge Park.

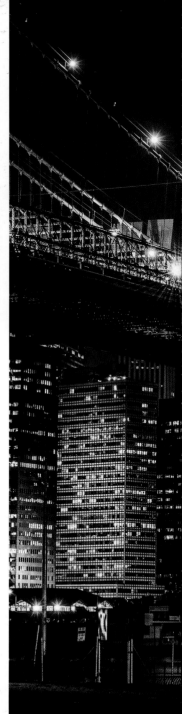

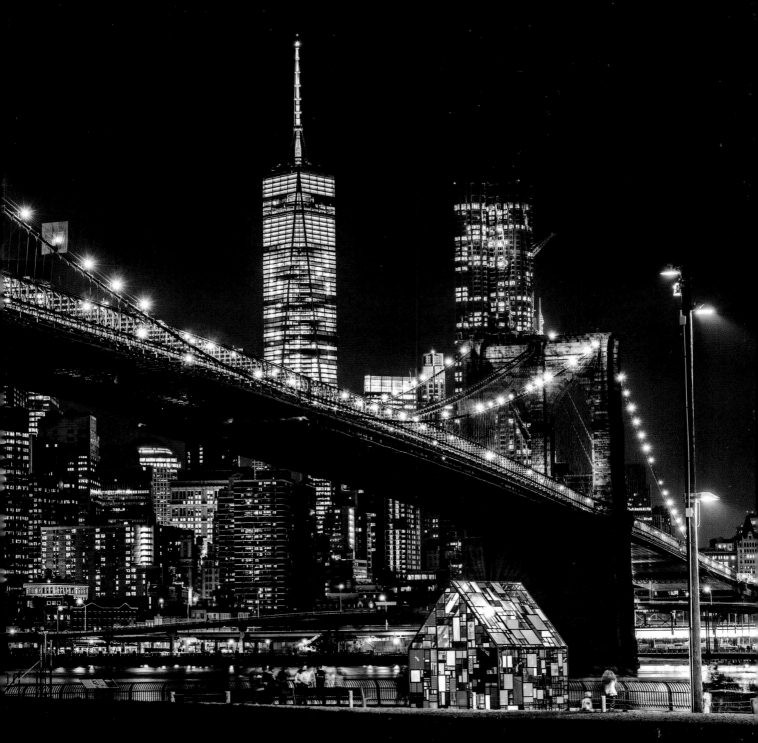

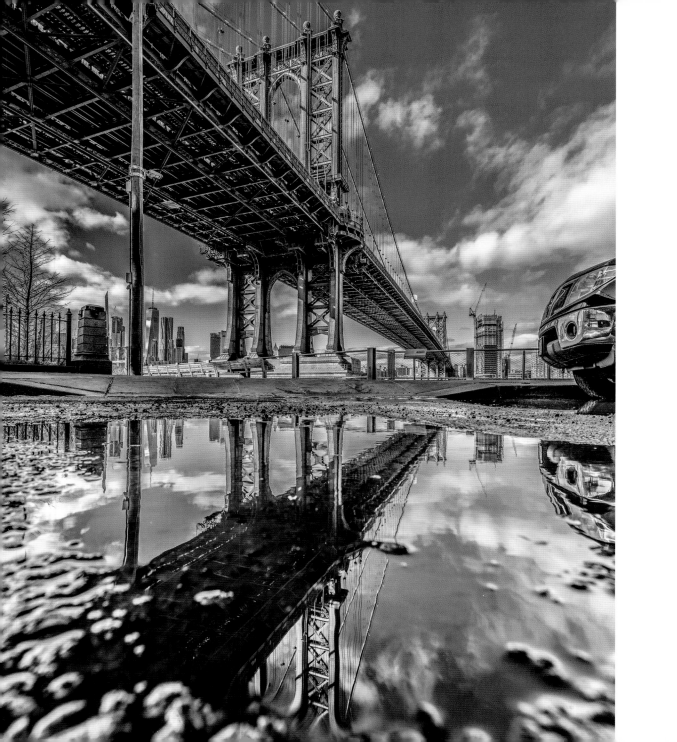

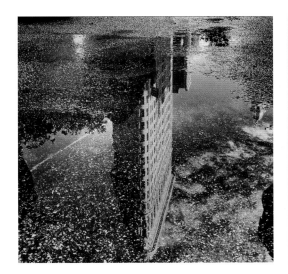

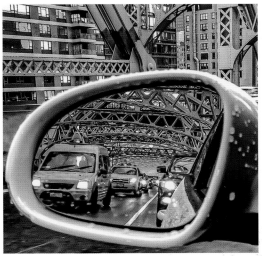

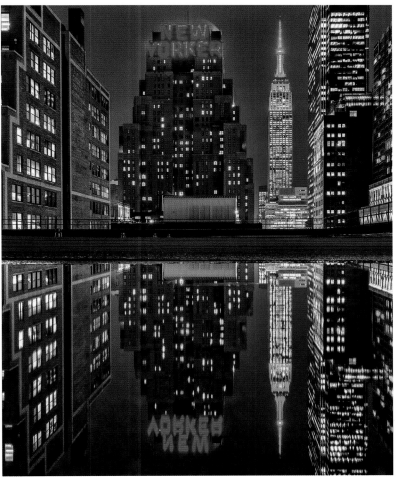

OPPOSITE: **@m_bautista330** Manhattan Bridge reflections at Brooklyn Bridge Park.

TOP LEFT: **@hindoben** Puddle view of the Flatiron Building.

BOTTOM LEFT: **@mfln.nyc** The Queensboro Bridge in a taxi's mirror.

ABOVE: **@papakila** Rooftop mirror—the New Yorker Hotel and the Empire State Building.

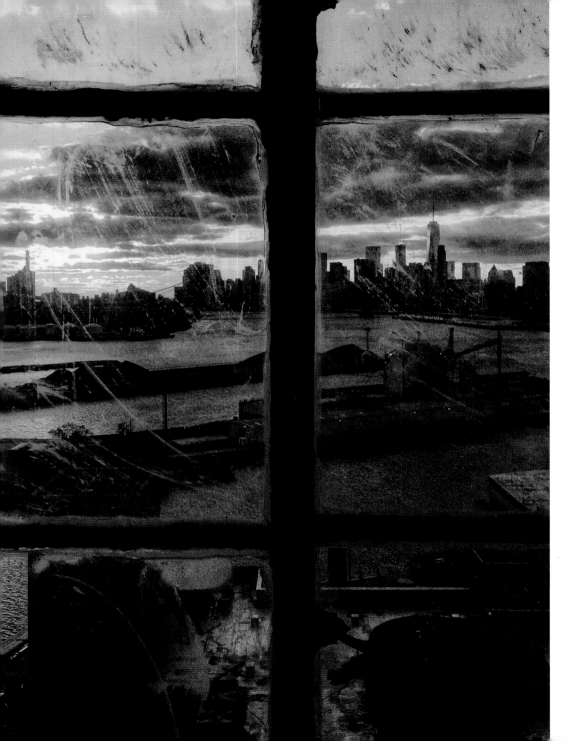

LEFT: **@fatiography**
Quintessential New York, the perfect amalgamation of grit and grandeur.

OPPOSITE: **@nyclovesnyc**
A golden moment to end the day on the Brooklyn Bridge.

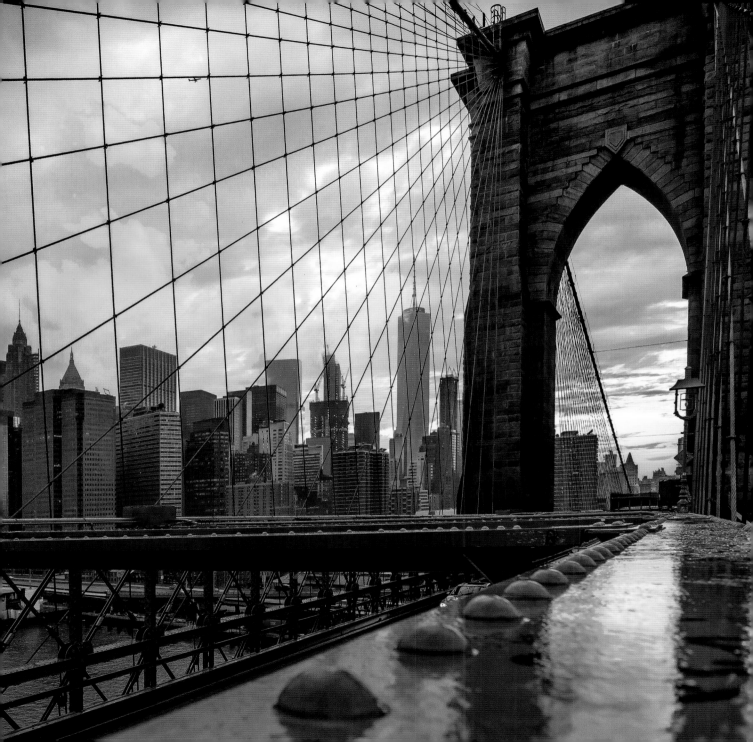

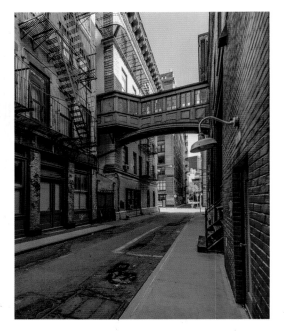

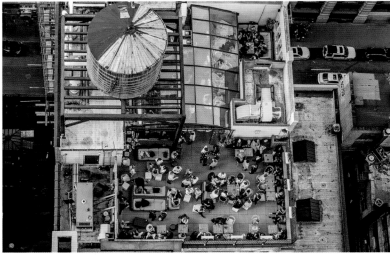

ABOVE: **@chief770**
Discovering the Staple
Street skybridge,
Tribeca.

TOP RIGHT: **@javan** Happy
hour at the Cloud Social
rooftop bar in Koreatown.

BOTTOM RIGHT: **@gmp3**
A colorful heart wall in
Freeman Alley on the
Lower East Side.

OPPOSITE: **@dantvusa**
Getting air at Castle
Point Skate Park,
Hoboken, NJ.

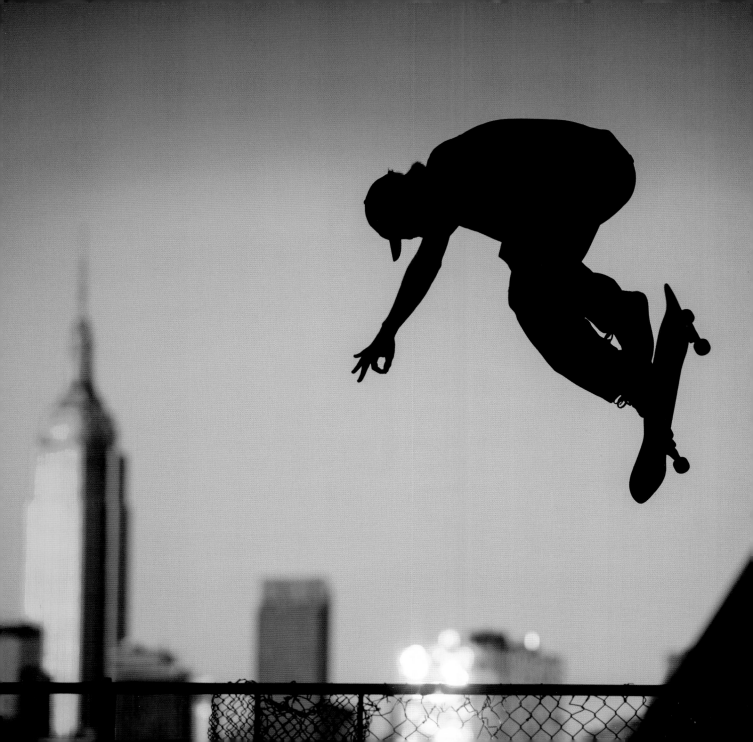

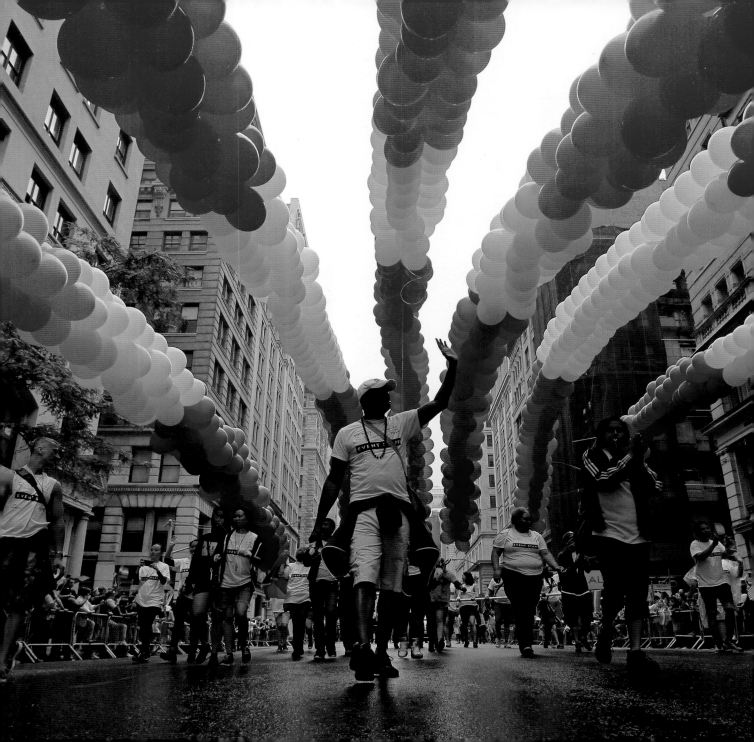

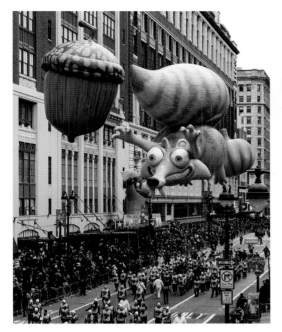

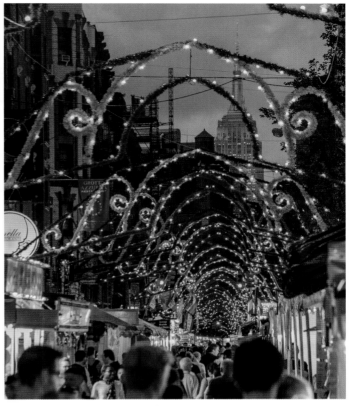

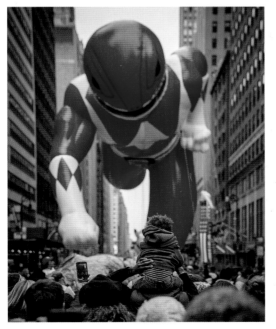

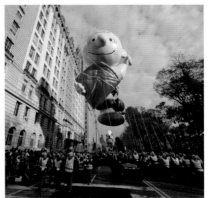

OPPOSITE: **@garyhershorn** A rainbow of balloons during the annual LGBT Pride parade.

THIS PAGE, CLOCKWISE FROM TOP LEFT: **@chief770** The Macy's Thanksgiving Day Parade. **@matthew-chimeraphotography** Feast of San Gennaro, Little Italy. **@garyhershorn** The Macy's Thanksgiving Day Parade. **@212sid** In the crowd at Macy's Thanksgiving Day Parade.

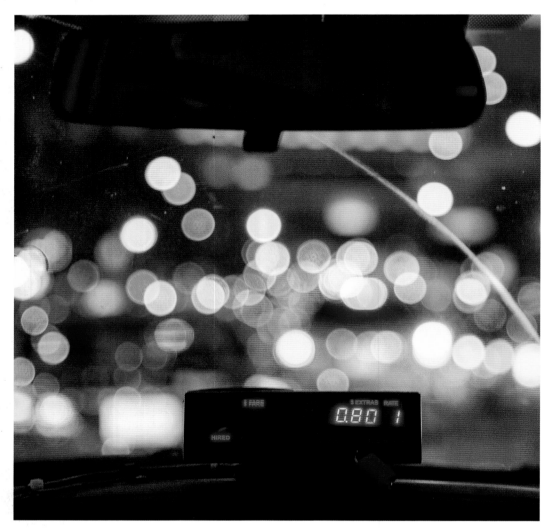

LEFT: **@thewilliamanderson**
Inside a New York City taxicab.

OPPOSITE: **@jenirizarry**
Rush hour on First Avenue.

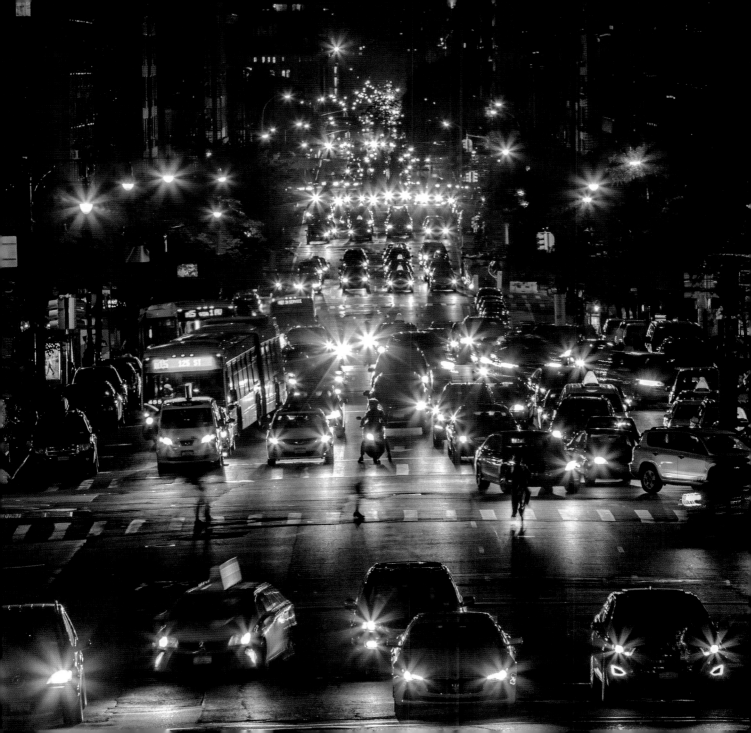

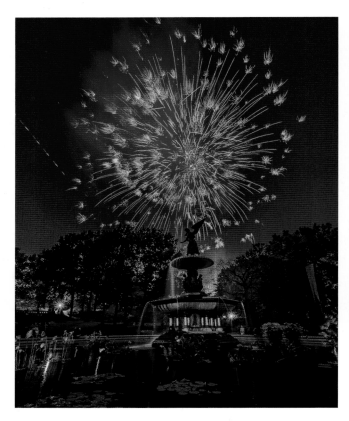

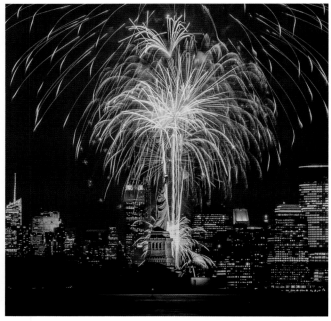

LEFT: **@killianmoore**
Fireworks over Bethesda
Fountain, Central Park

ABOVE: **@johnnyyonkers**
A prime view of fireworks
over New York Harbor.

OPPOSITE: **@beholdingeye**
Chinese New Year
fireworks, from Hamilton
Park in Weehawken, NJ.

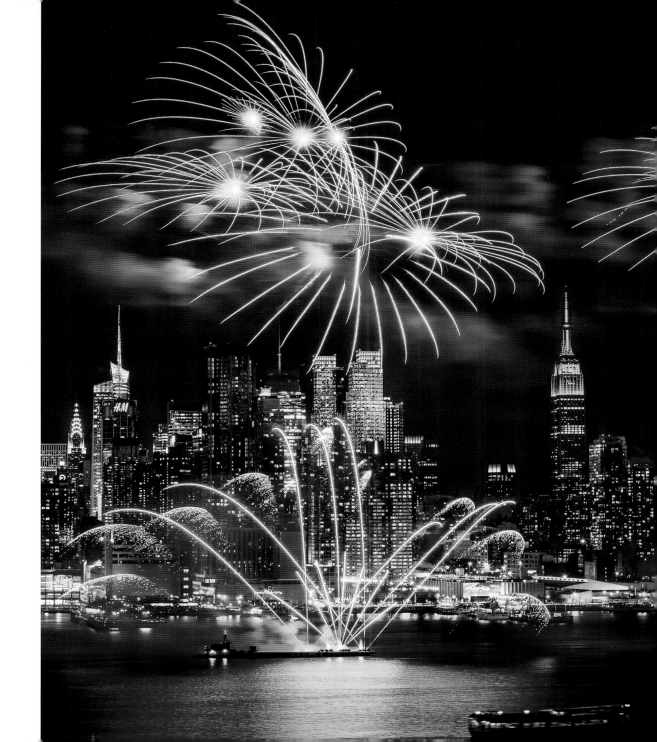

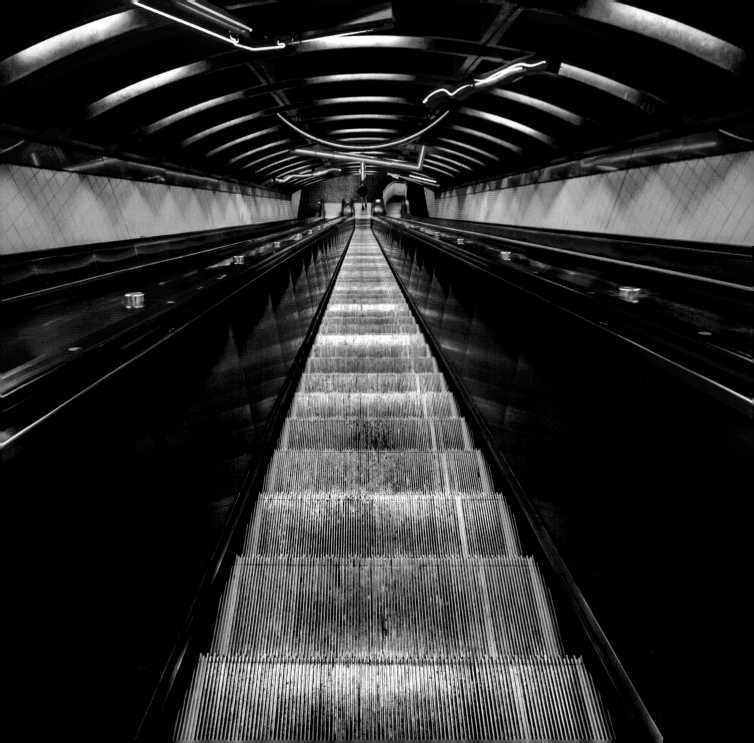

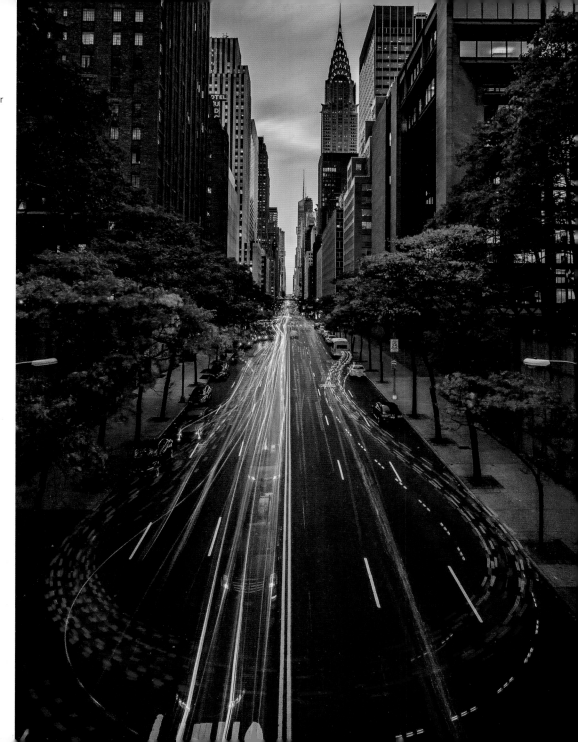

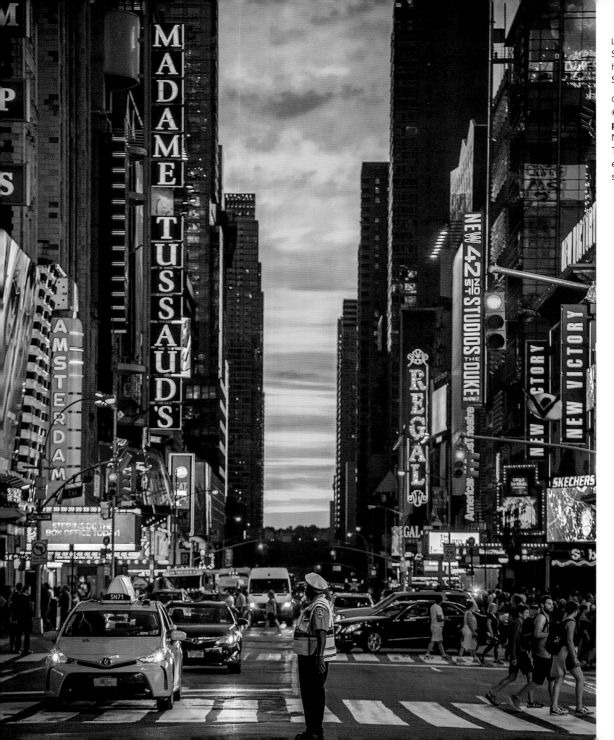

LEFT: **@212sid**
Summer's last hurrah on 42nd Street.

OPPOSITE:
@dankurtzman-photography
Neon lights in Times Square electrifying a summer evening.

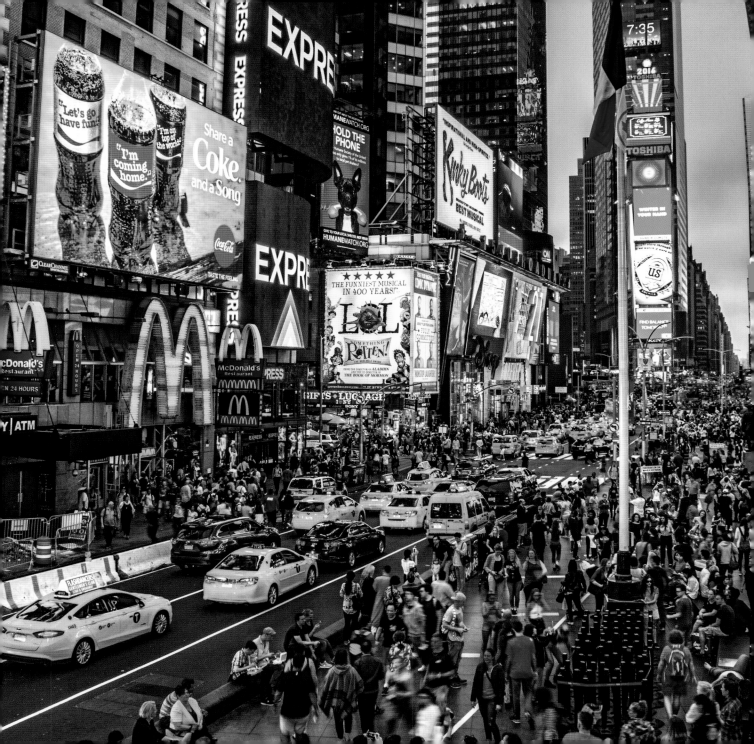

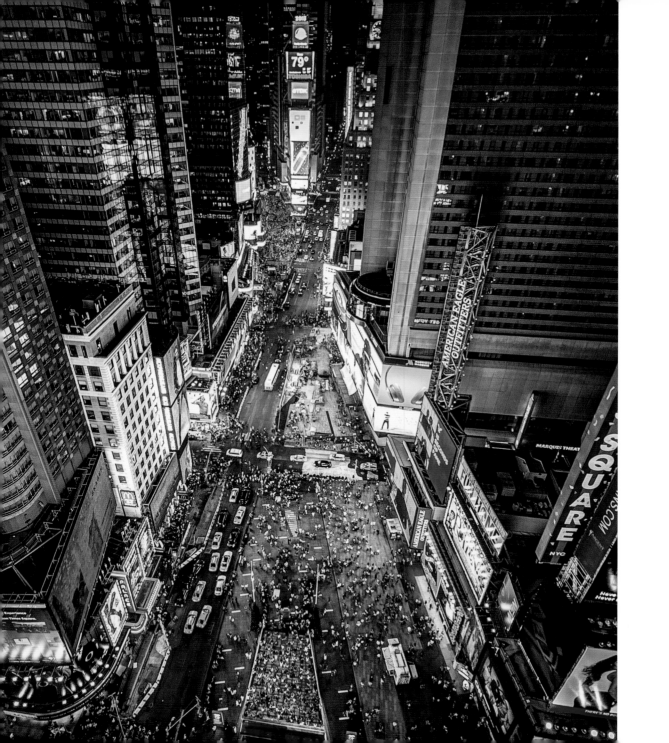

Times Square on the go, day and night, rain or shine.

OPPOSITE: **@gmathewsva** "The Crossroads of the World."

THIS PAGE, CLOCKWISE FROM TOP LEFT: **@nyctme** After midnight. **@nyroamer** Warding off snow and wind. **@thewilliamanderson** Always bustling— even in a snowstorm. **@nyclovesnyc** A rainy autumn evening.

FOLLOWING SPREAD: *(left)* **@gigi.nyc** Confetti and fireworks ringing in the New Year. *(right)* **@garyhershorn** After New Year's Eve.

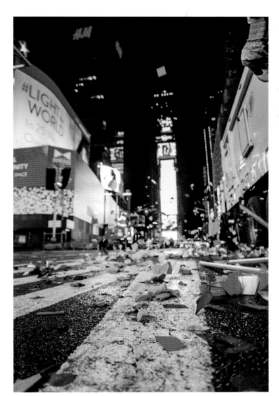

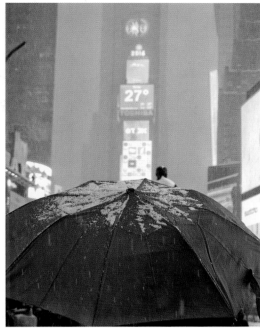

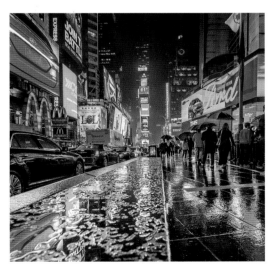

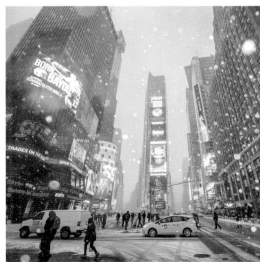

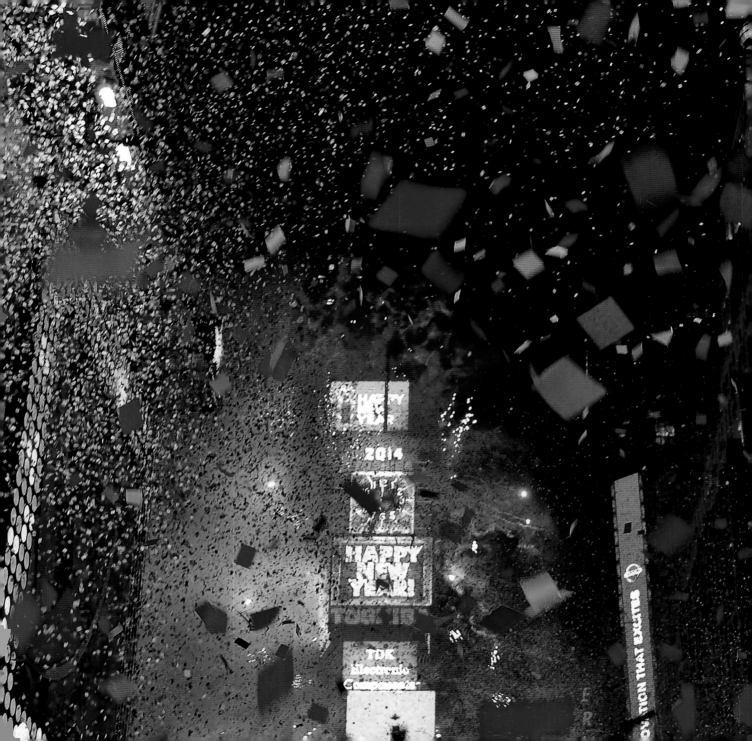

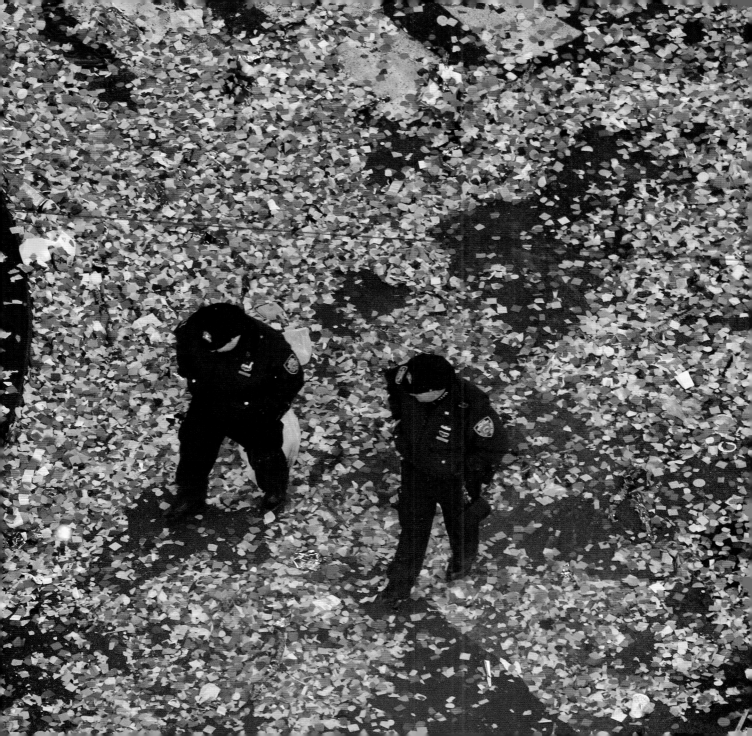

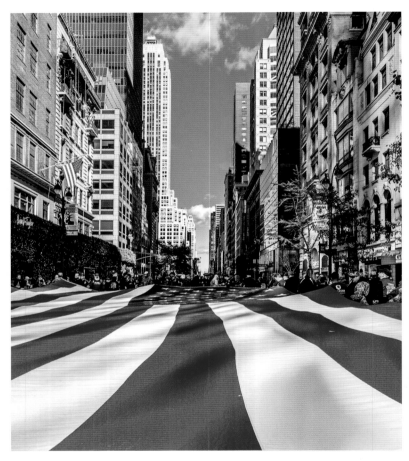

LEFT: **@javan** A giant American flag floating down Fifth Avenue on Veterans Day.

BELOW: **@hindoben** Red, white, and blue at the U.S. Armed Forces Recruiting Station in Times Square.

OPPOSITE: **@dankurtzmanphotography** Passing cars on Broadway reflecting the Stars and Stripes.

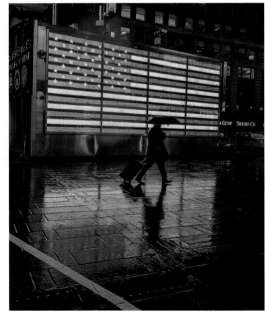

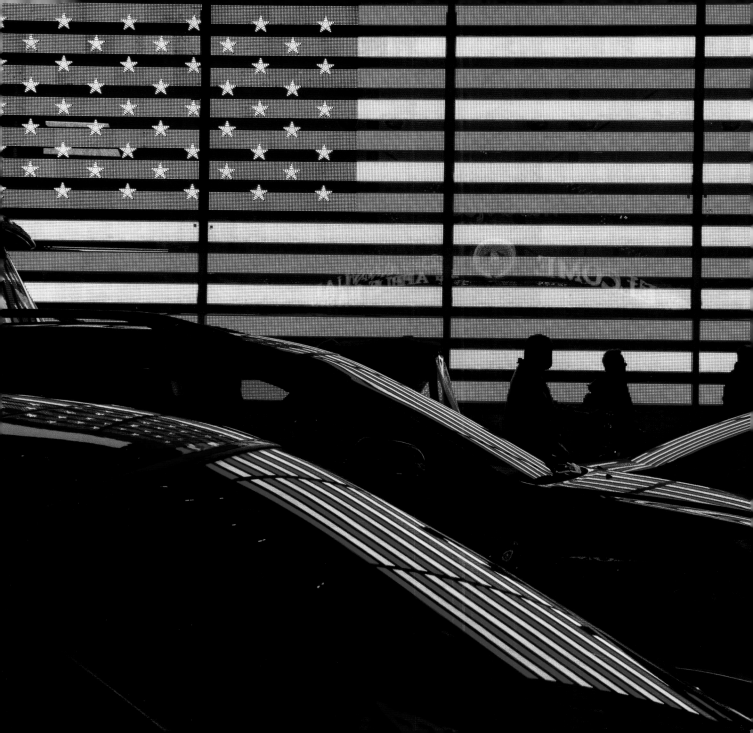

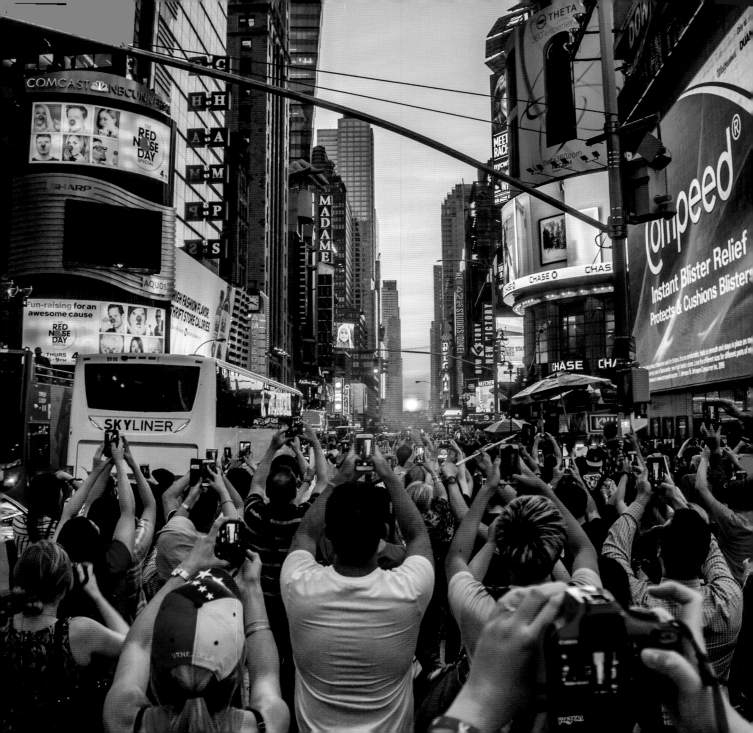

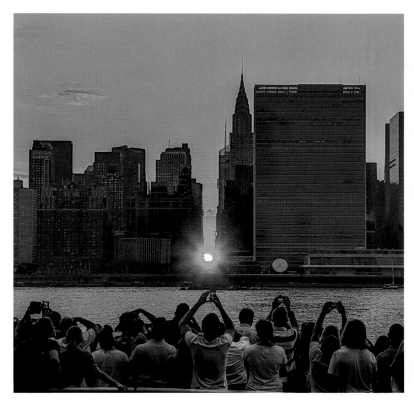

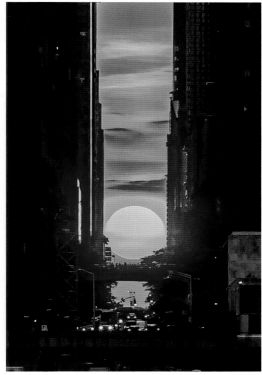

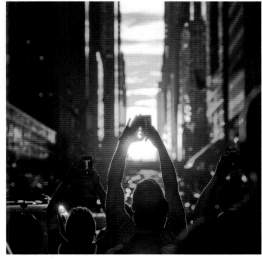

Annual "Manhattanhenge" worshippers gathering to capture the setting sun as it aligns perfectly with Manhattan's street grid.

OPPOSITE: **@newyorkcitykopp** Capturing the elusive moment on 42nd Street.

ABOVE: **@nyclovesnyc** Gathering in Long Island City, Queens, as the sun sets across the East River on 42nd Street.

TOP RIGHT: **@javan** Zooming in on 42nd Street.

RIGHT: **@thewilliamanderson** Reaching above to get the shot.

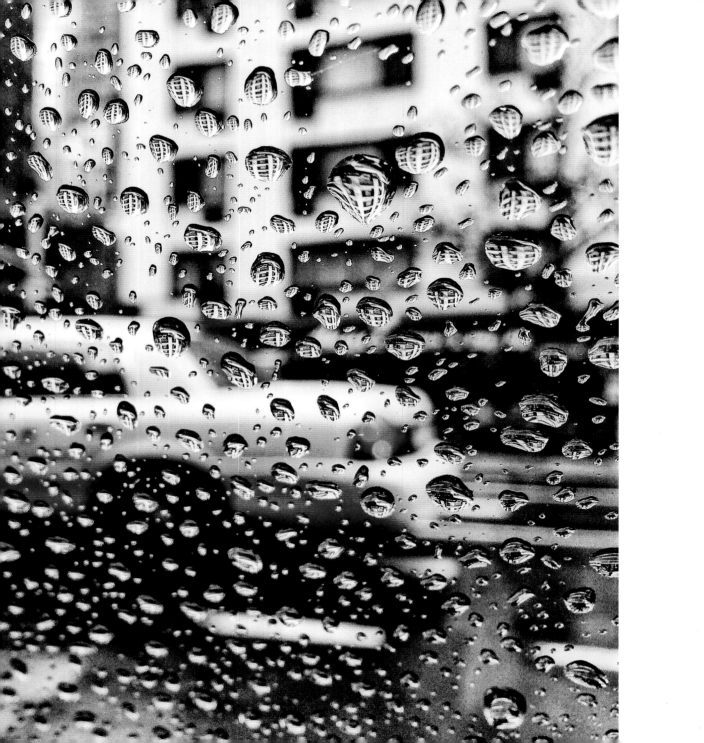

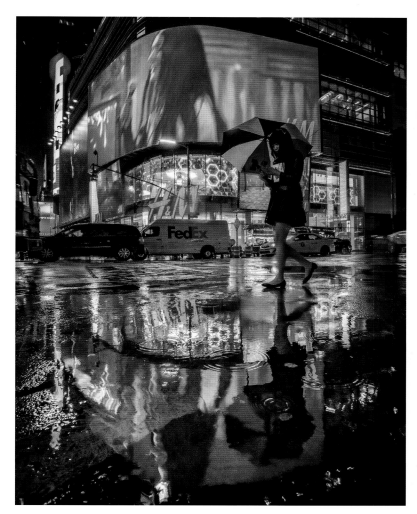

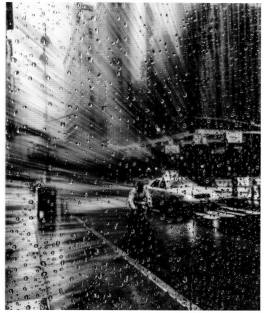

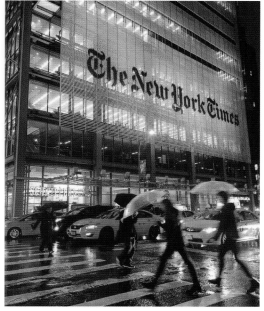

OPPOSITE: **@gmp3**
Finding magic in raindrops.

ABOVE: **@212sid**
Neon-colored puddles
on 42nd Street.

TOP RIGHT: **@golden2dew**
A rainy autumn day on
Fifth Avenue.

BOTTOM RIGHT:
@pictures_of_newyork
Rainy night crossing at the
New York Times Building.

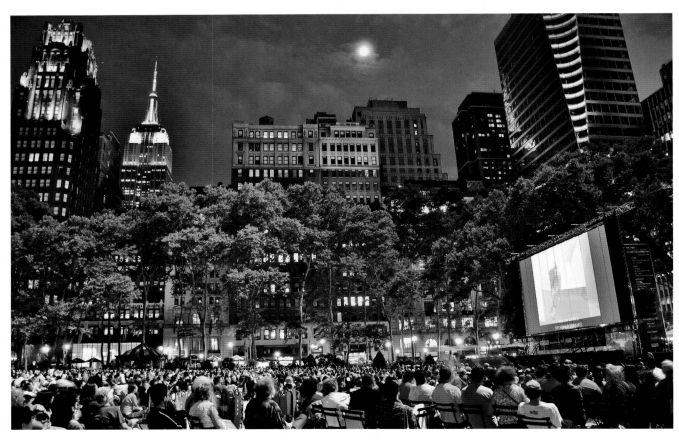

ABOVE: **@gigi.nyc** Movie
night in the city during
the annual Bryant Park
Summer Film Festival.

OPPOSITE: **@midnight.xpress**
An urban oasis—moviegoers
filling up Bryant Park on a
summer evening.

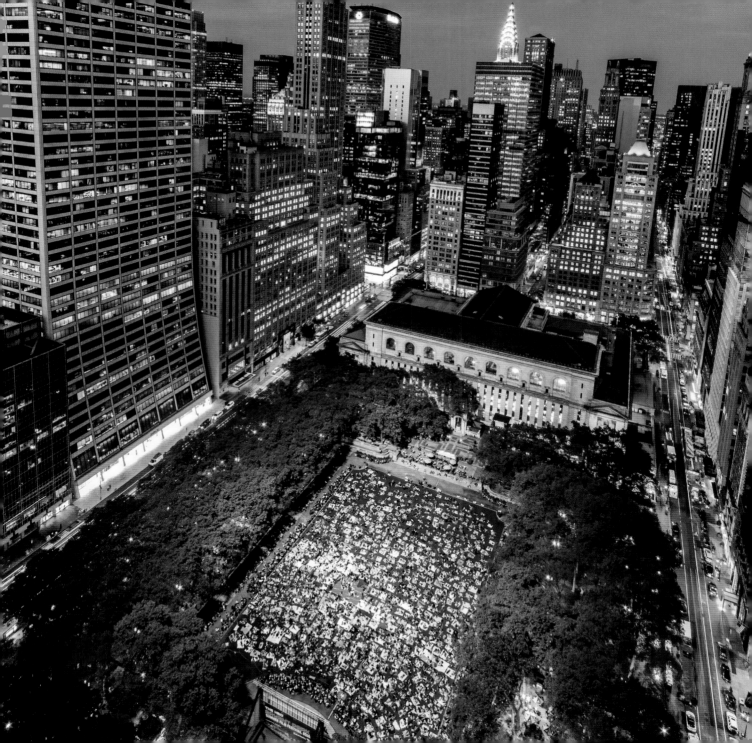

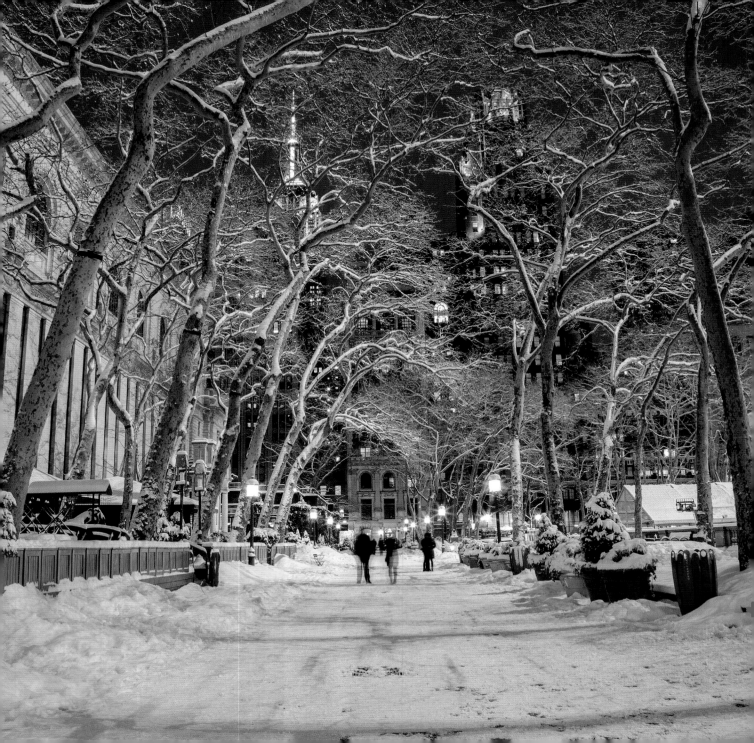

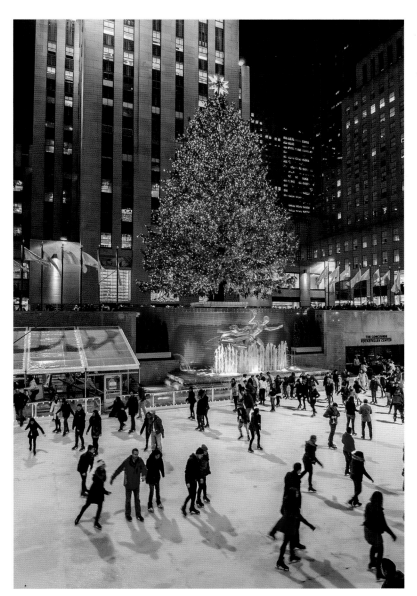

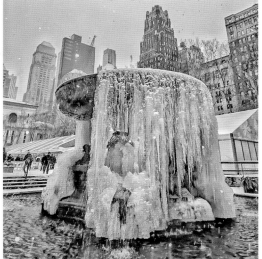

OPPOSITE: **@matthew-chimeraphotography** Winter night in Bryant Park.

LEFT: **@nyclovesnyc** Ice skating at Rockefeller Center.

ABOVE: **@milan2ny** Frozen in Bryant Park.

FOLLOWING SPREAD: *(left)* **@gmathewsva** View of Grand Central Terminal from the catwalks. *(right)* **@javan** Morning rush hour at Grand Central Terminal.

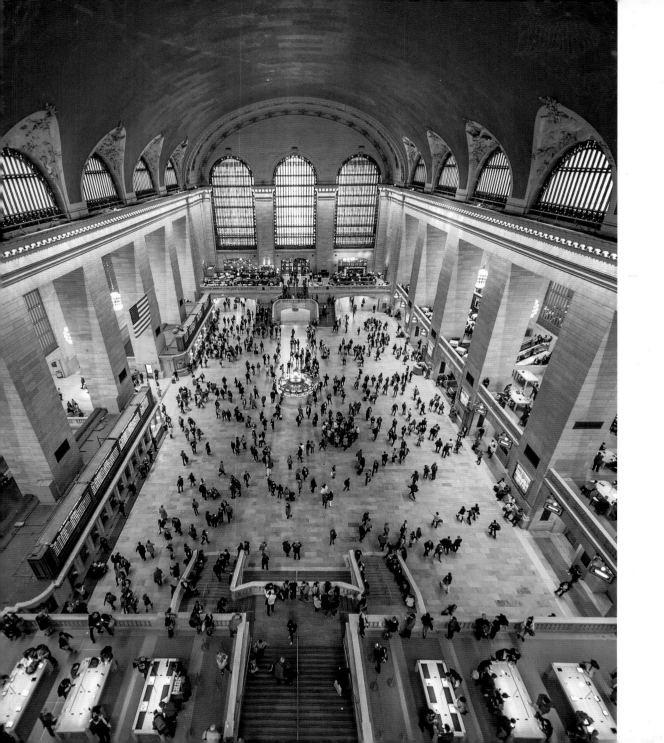

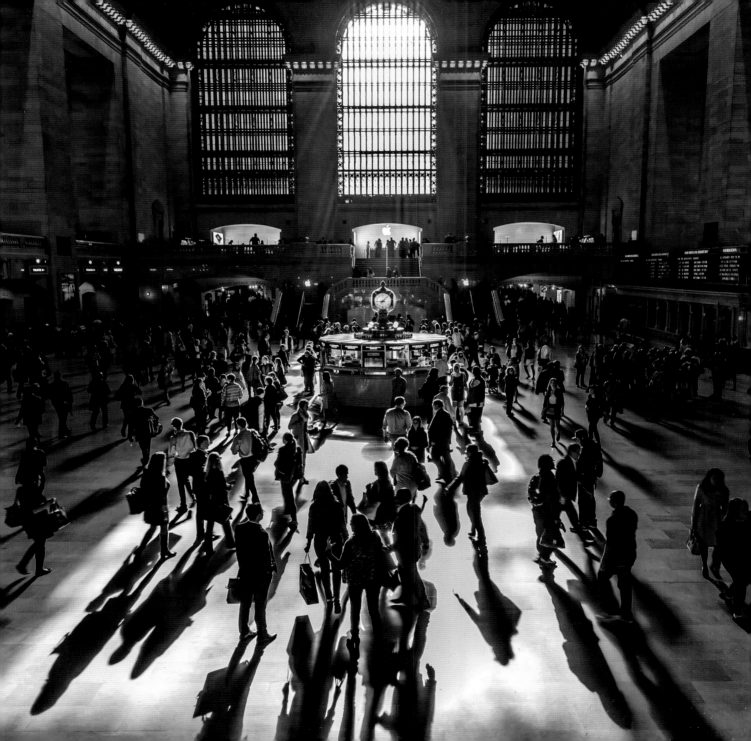

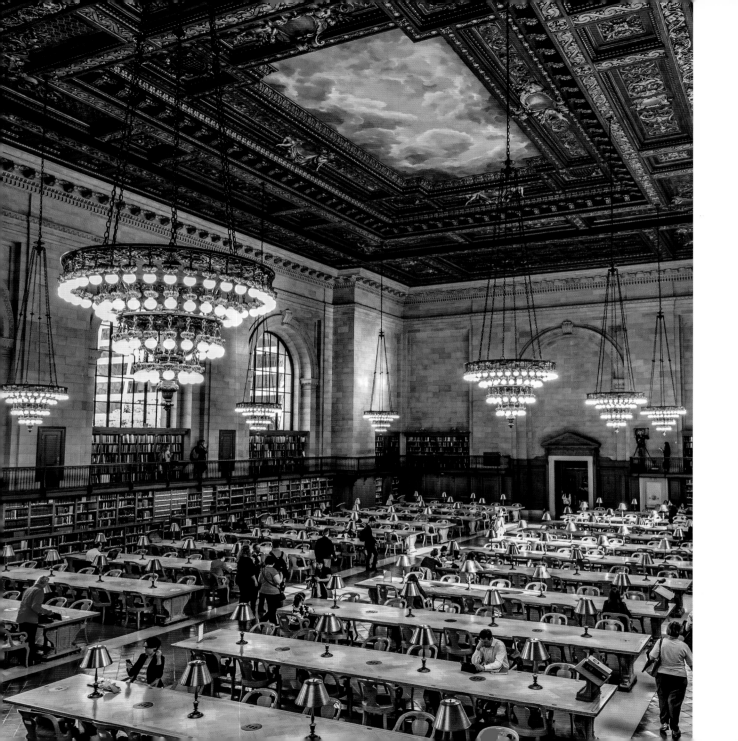

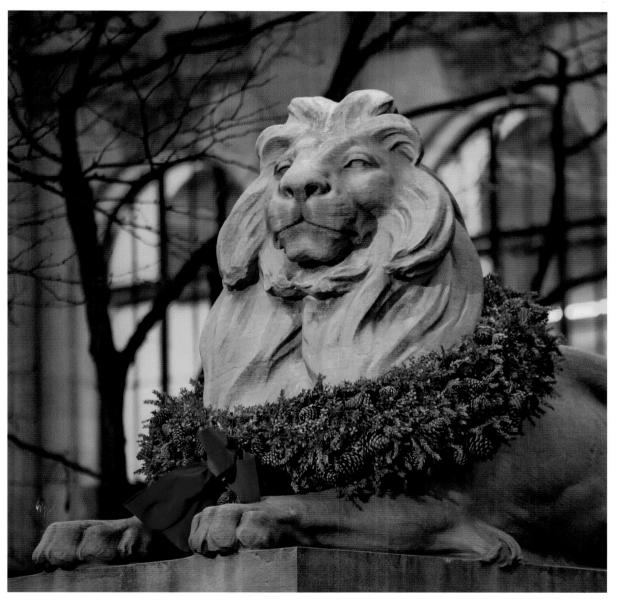

OPPOSITE: **@javan** Inside the main branch of the New York Public Library's grand Rose Main Reading Room.
ABOVE: **@i_am_lacombe** Patience, one of the two marble lions flanking the New York Public Library's steps, during the holidays.

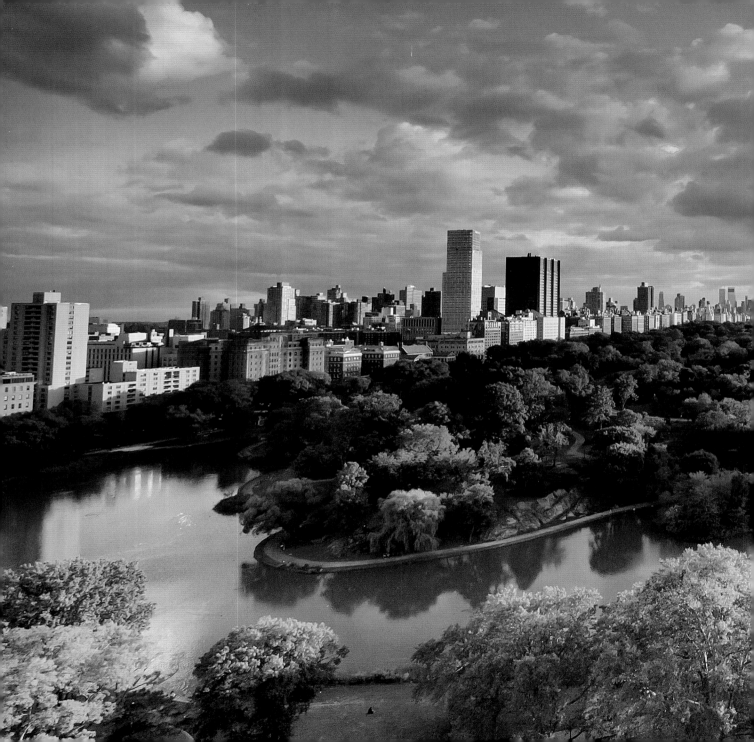

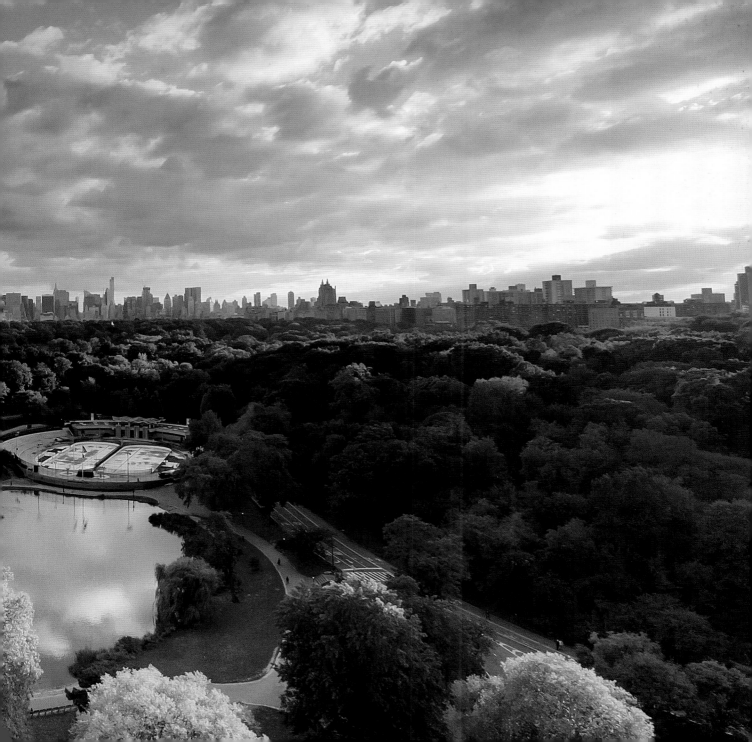

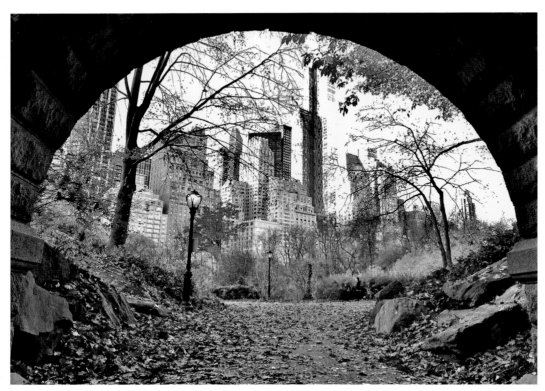

The hidden nooks and calm vistas of Central Park.

PRECEDING SPREAD: **@bklyn_block** Aerial view of the Harlem Meer in Central Park.

THIS PAGE, CLOCKWISE FROM TOP LEFT: **@gigi.nyc** The last days of autumn from Inscope Arch. **@gigi.nyc** Sunset over the Reservoir. **@gigi.nyc** Reflections of Bow Bridge on an autumn morning. **@gigi.nyc** Afternoon shadows at Sheep Meadow.

OPPOSITE: **@dankurtzman-photography** Gapstow Bridge and the Pond.

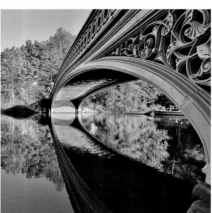

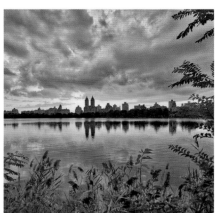

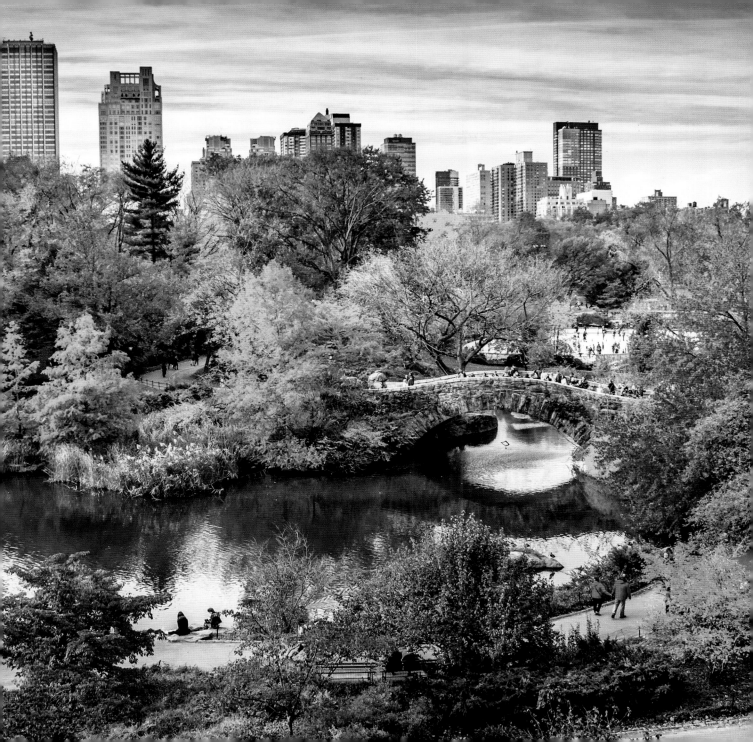

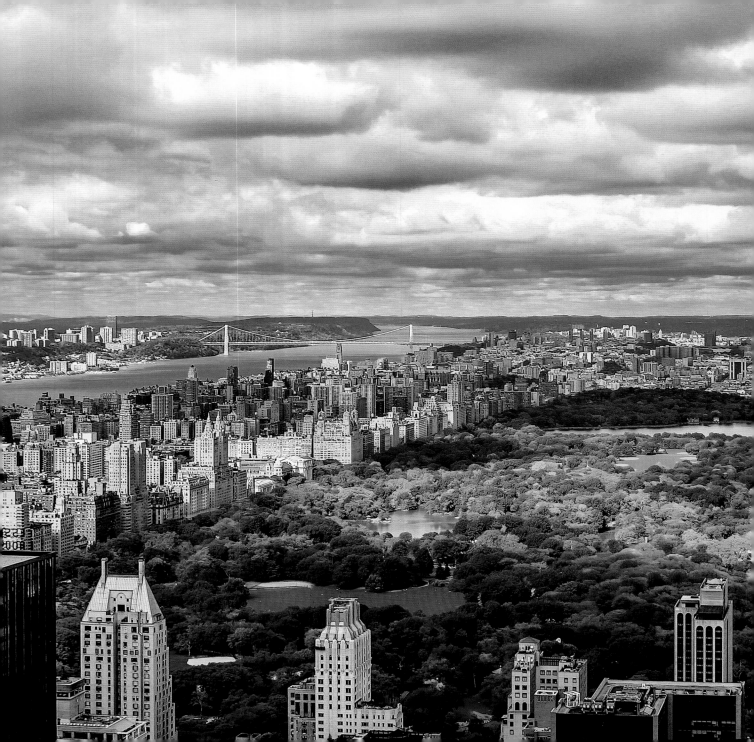

The oasis of Central Park, from green horizons to still waters.

OPPOSITE:
@coryschlossimages A look to the north from the Top of the Rock— from Central Park to the George Washington Bridge and beyond.

THIS PAGE, CLOCKWISE FROM TOP LEFT: **@newyorkcitykopp** Father and daughter watching the rowboats. **@gigi.nyc** A girl and a goose at the Lake. **@nyclovesnyc** Fall comes to the Mall and Literary Walk. **@kaaren_citaa** Autumn leaves pave the path under Pine Bank Arch.

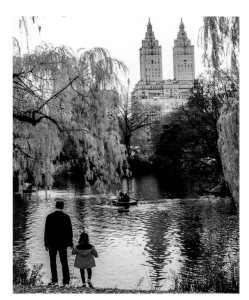

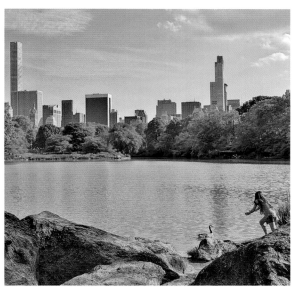

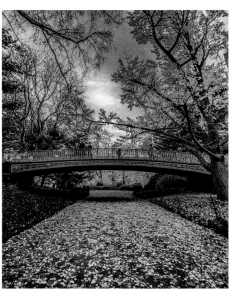

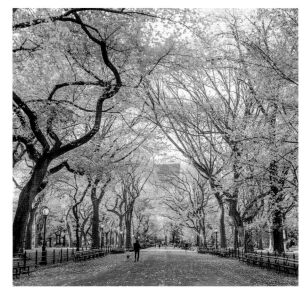

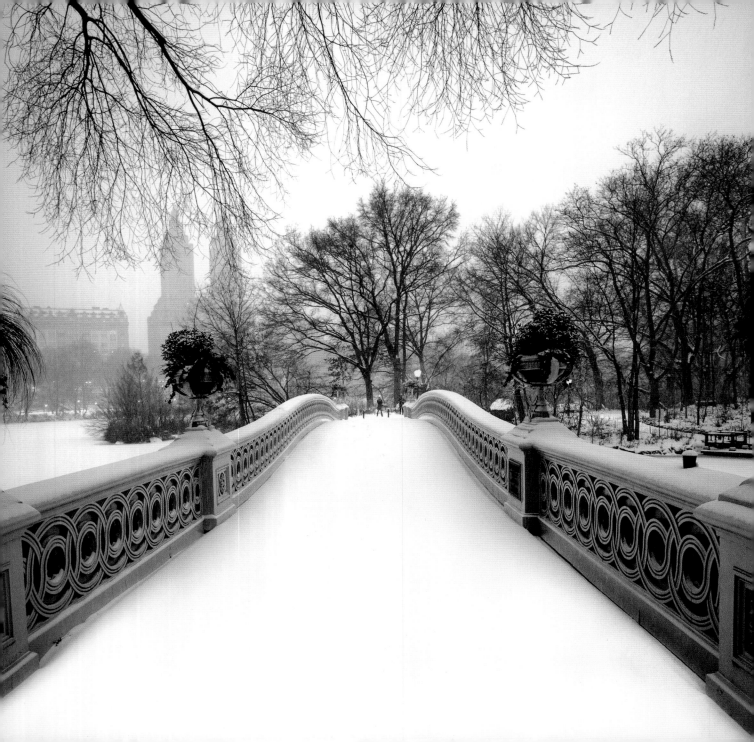

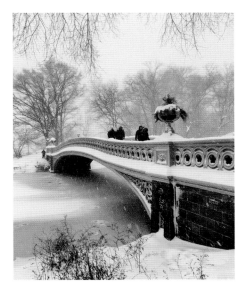

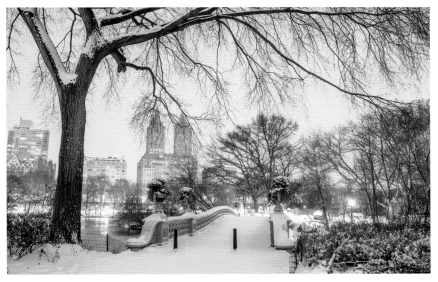

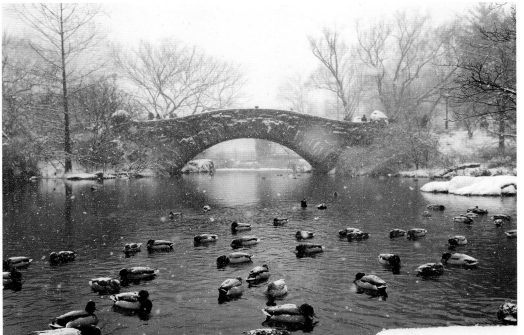

Central Park after snowfall.

OPPOSITE: **@m_bautista330** A pristine path over Bow Bridge.

ABOVE LEFT: **@hindoben** Walking into a snowy storybook on Bow Bridge.

ABOVE RIGHT: **@newyorkcitykopp** A peaceful winter evening overlooking Bow Bridge and the San Remo.

LEFT: **@hindoben** Ducks at Gapstow Bridge.

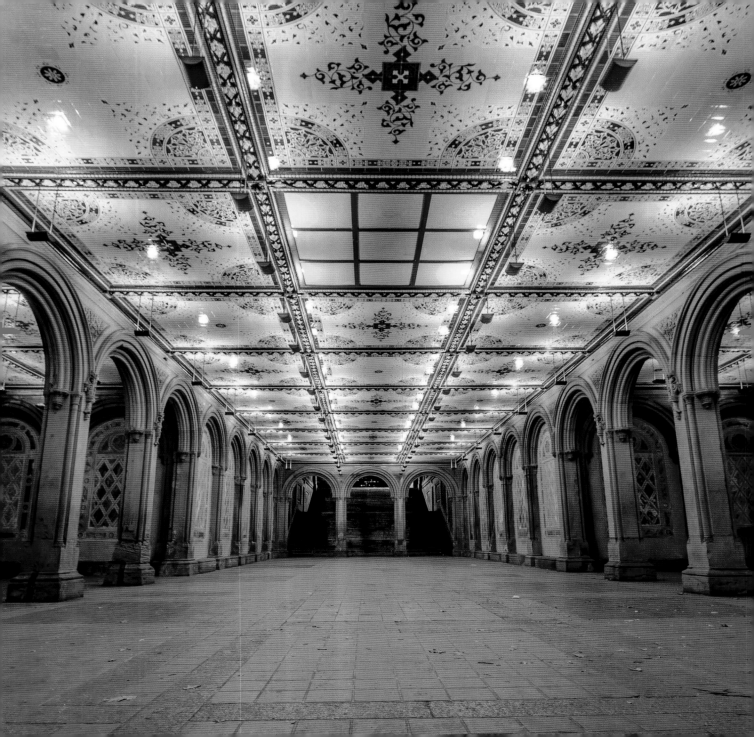

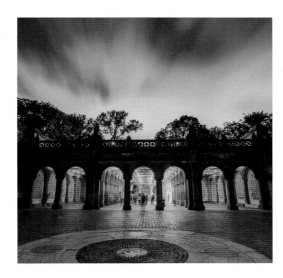

Central Park transforming at night.

OPPOSITE: **@i_am_lacombe**
After dark at Bethesda Terrace.

ABOVE: **@clearbluskyes**
Bethesda Terrace glowing in the summer twilight.

RIGHT:
@matthewchimeraphotography
"Blue hour" at Bethesda Terrace, seen from across the Lake.

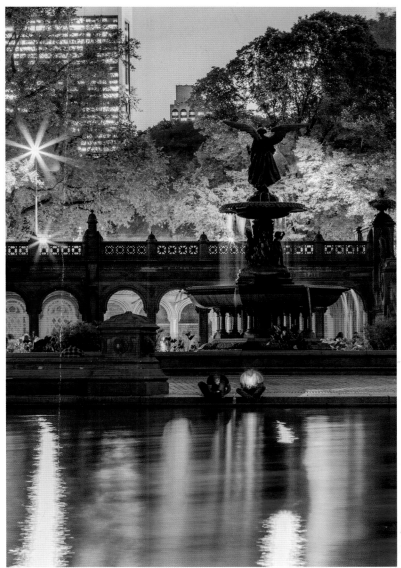

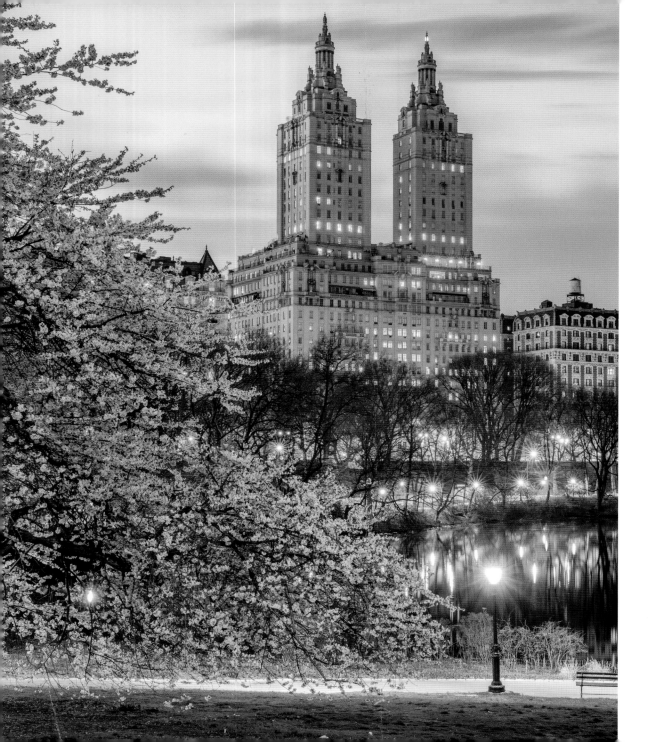

Capturing Central Park's evening hours.

OPPOSITE: **@matthew-chimeraphotography** A vibrant springtime at Cherry Hill.

ABOVE LEFT: **@matthewchimera-photography** Midtown reflections in the Pond on a winter evening.

ABOVE RIGHT: **@matthewchimera-photography** Lit-up Belvedere Castle.

BOTTOM: **@nyctme** Winter sunset above the Central Park Reservoir.

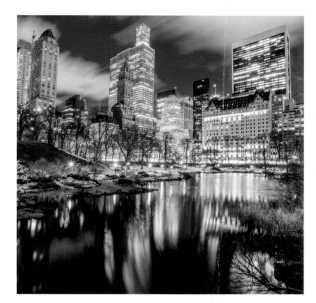

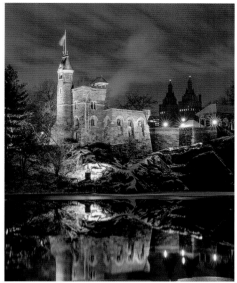

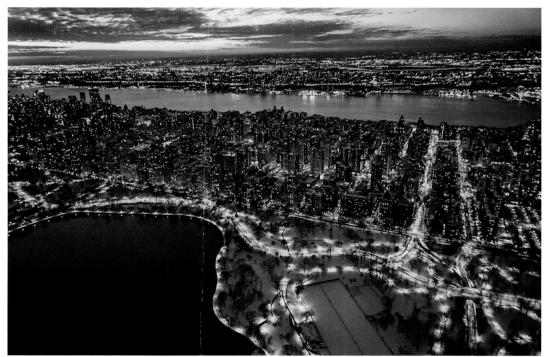

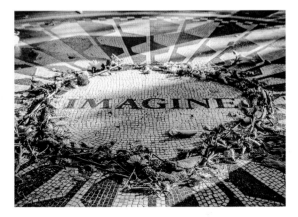

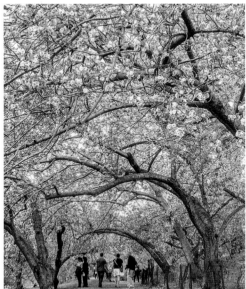

Central Park magic in all seasons.

THIS PAGE, CLOCKWISE FROM TOP LEFT: **@coryschlossimages** Mosaic memorial to John Lennon in Strawberry Fields. **@newyorkcitykopp** A canopy of cherry blossoms. **@newyorkcitykopp** A trumpeter against the backdrop of Midtown Manhattan. **@mc_gutty** The Mall in all its best fall colors.

OPPOSITE: **@2ndfloorguy** Central Park from above Midtown on a summer evening.

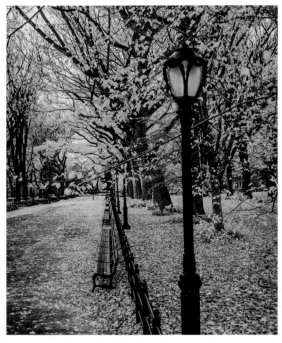

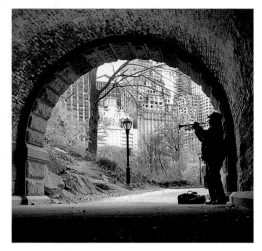

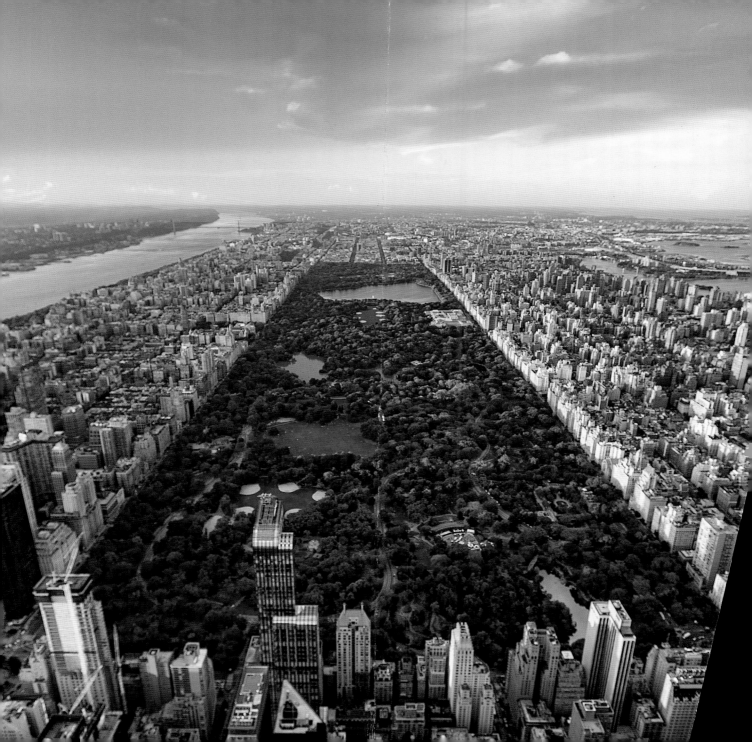

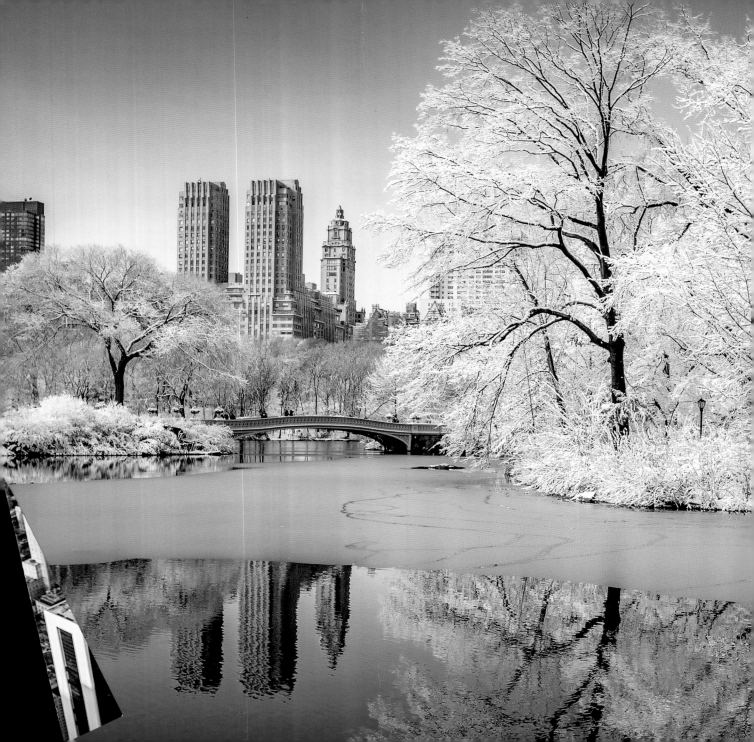

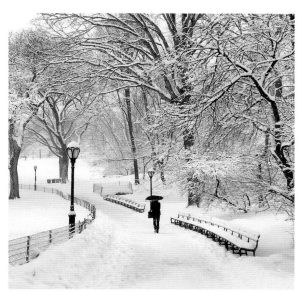

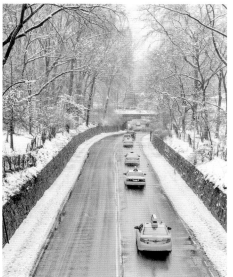

After a winter storm in Central Park.

OPPOSITE: **@beholdingeye** Frozen beauty at Bow Bridge and the Lake.

THIS PAGE, CLOCKWISE FROM TOP LEFT: **@newyorkcitykopp** A journey through drifts. **@gmp3** Cutting across Manhattan on the 66th Street transverse, a shortcut through the Park. **@nyroamer** Tracing paths from above in the Upper East Side's Pierre Hotel. **@nyclovesnyc** Carriages at Cherry Hill.

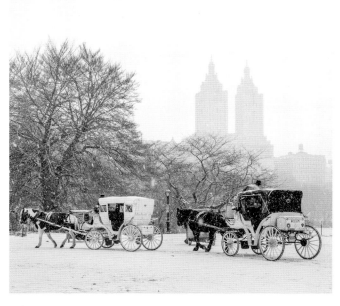

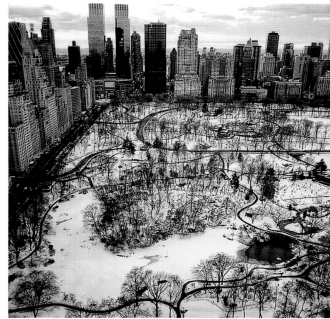

Reflecting autumn colors at Central Park's Bow Bridge and the Lake.

THIS PAGE AND RIGHT:

RIGHT: **@nyclovesnyc** Flame-red trees.

BELOW RIGHT: **@212sid** Boats on Central Park's Lake.

FAR RIGHT: **@nikonej** Sunrise sparking a palette of color at Bow Bridge.

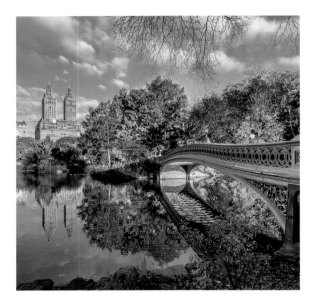

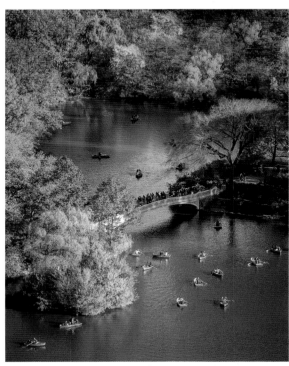

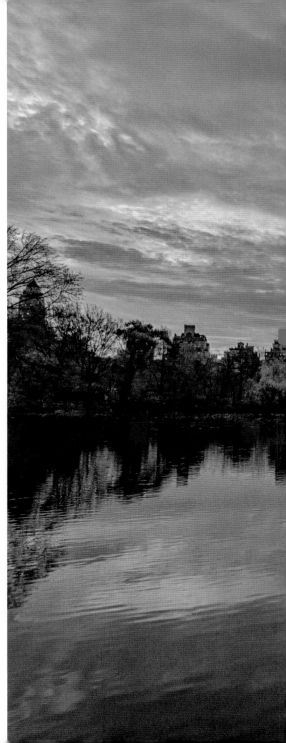

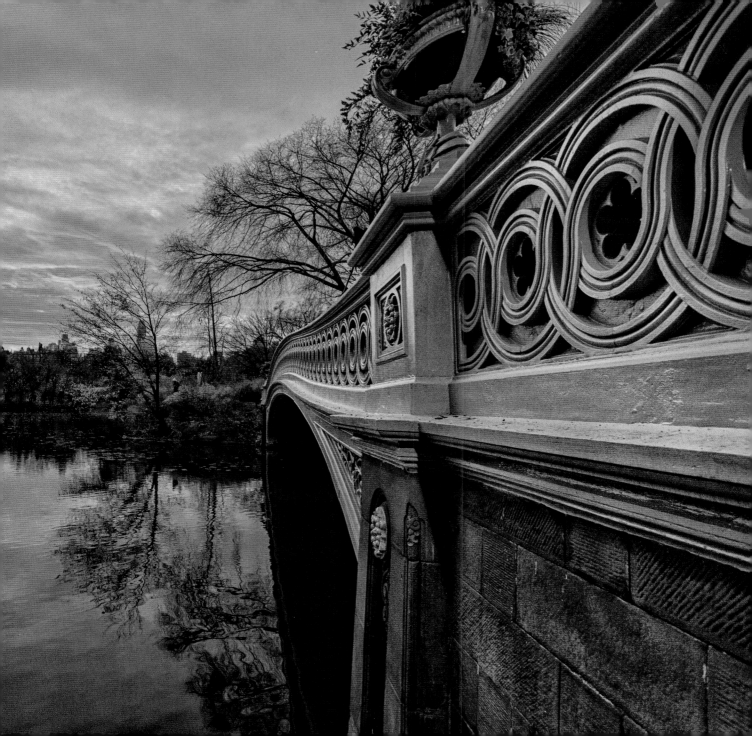

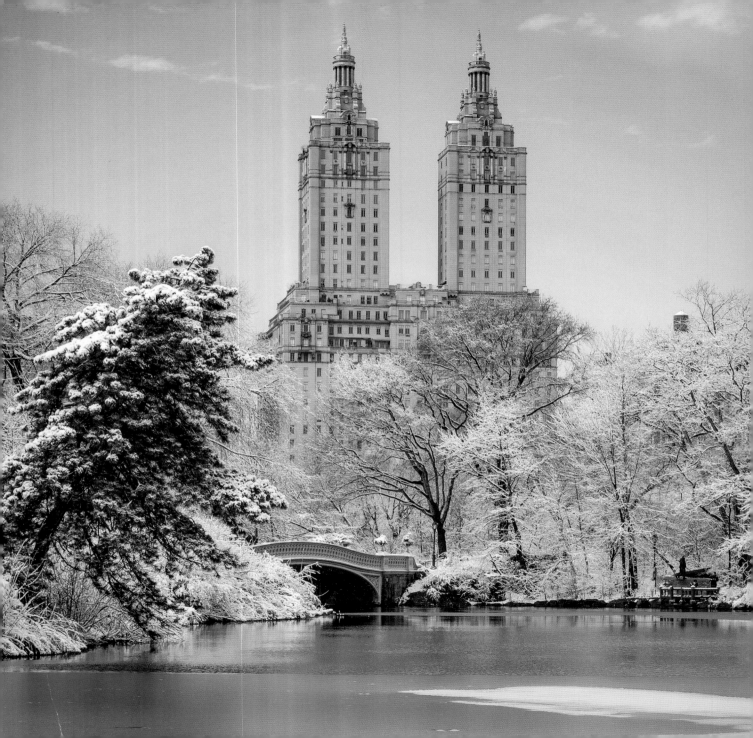

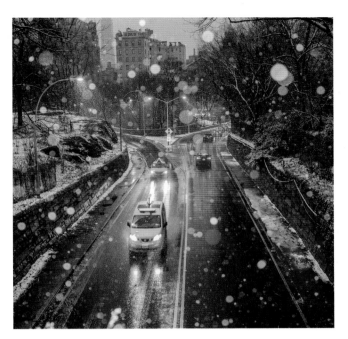

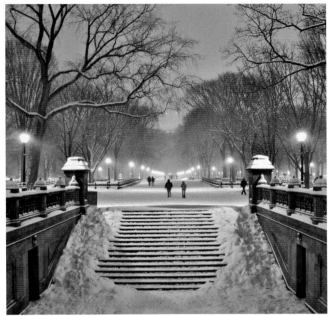

OPPOSITE: **@gmathewsva** The San Remo and the Lake in Central Park on a winter morning.

ABOVE LEFT: **@matthew-chimeraphotography** Dashing across the 66th Street transverse.

ABOVE RIGHT: **@gigi.nyc** Snowing at the Mall, from Central Park's Bethesda Terrace.

RIGHT: **@dario.nyc** Twilight at the Ladies Pavilion in Central Park.

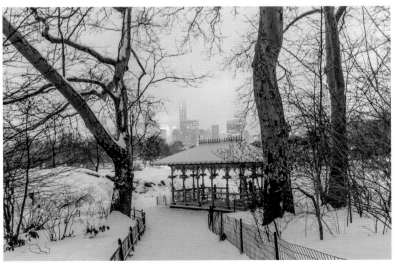

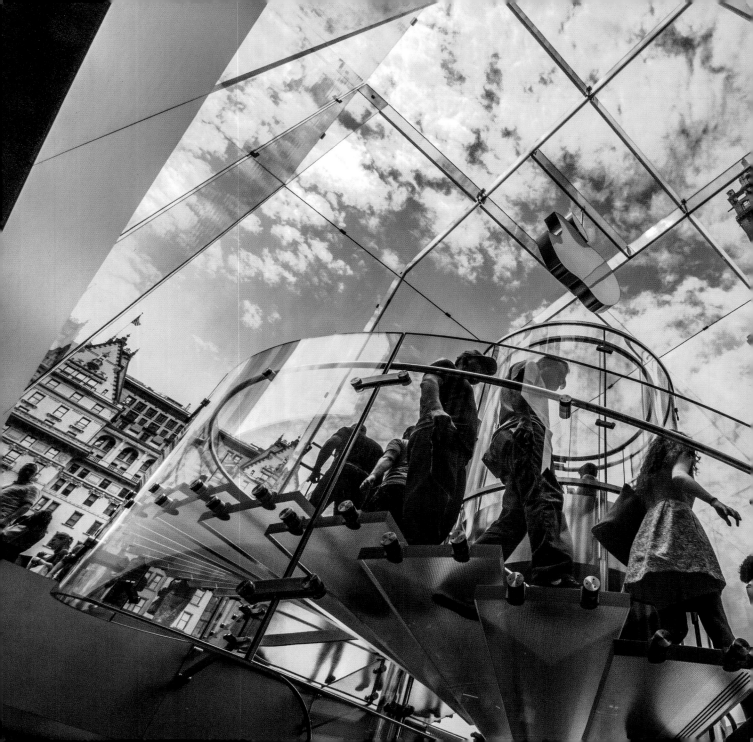

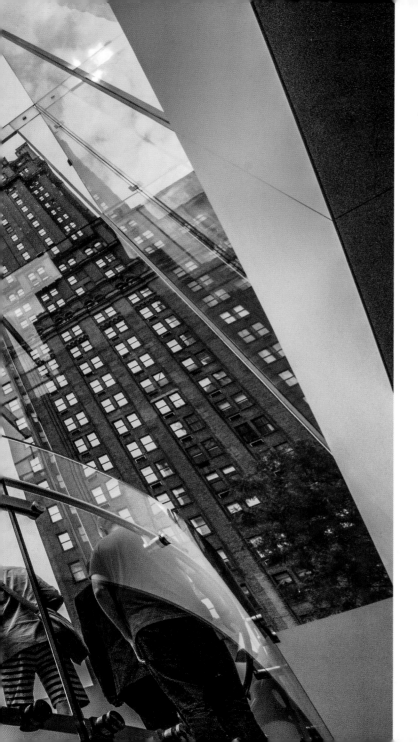

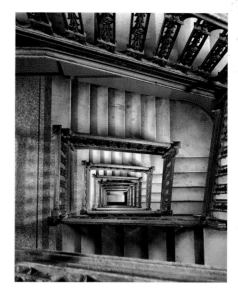

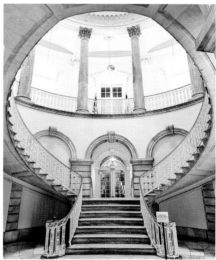

OPPOSITE: **@dankurtzmanphotography** The spiraling glass staircase inside the Apple store on Fifth Avenue in Midtown.

TOP: **@nyroamer** A geometrical composition, looking down a staircase in a Flatiron District hotel.

ABOVE: **@gmp3** Space and light at a New York City Hall staircase.

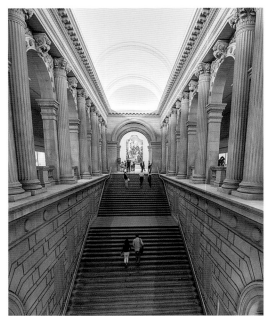

TOP LEFT: **@dankurtzman-photography** A classic view from the grand staircase at the Metropolitan Museum of Art.

BOTTOM LEFT: **@i_am_lacombe** Tail lights streaking past the Solomon R. Guggenheim Museum.

BELOW: **@chief770** Fountain reflecting the Metropolitan Museum of Art's Beaux-Arts Fifth Avenue facade.

OPPOSITE: **@dankurtzman-photography** Reflections of fall at the Temple of Dendur in the Metropolitan Museum of Art.

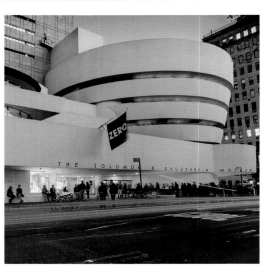

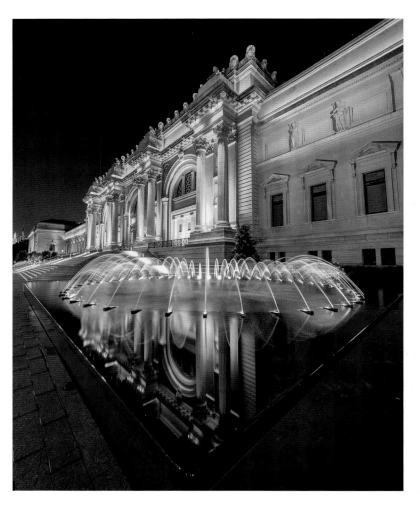

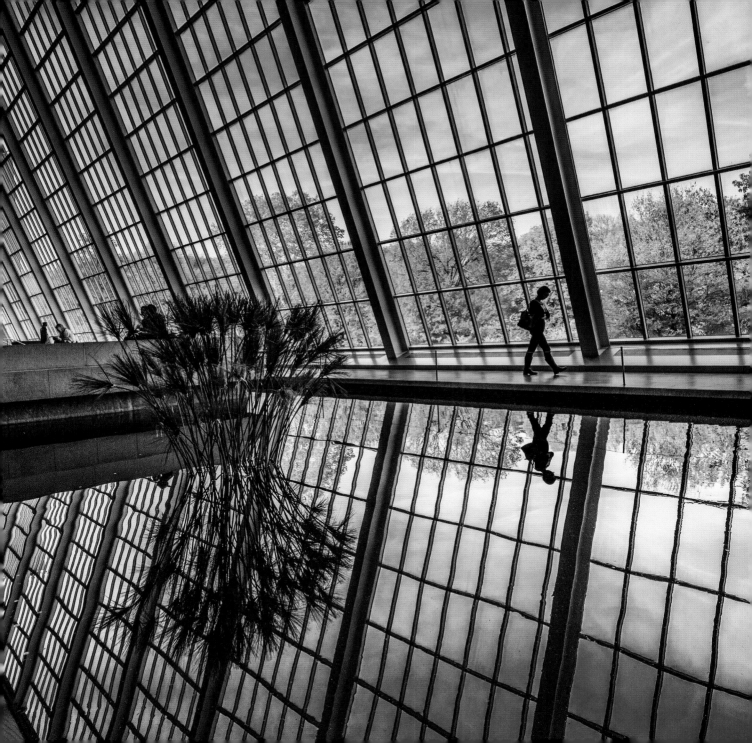

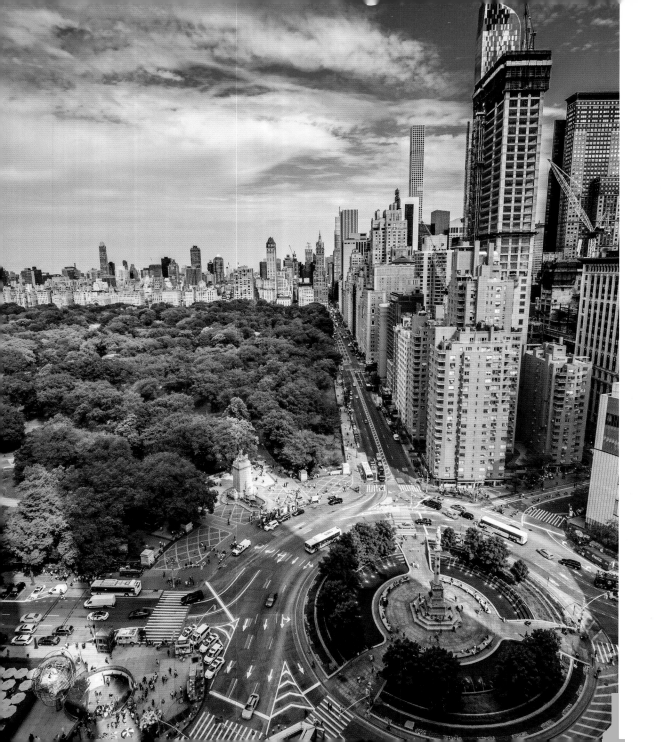

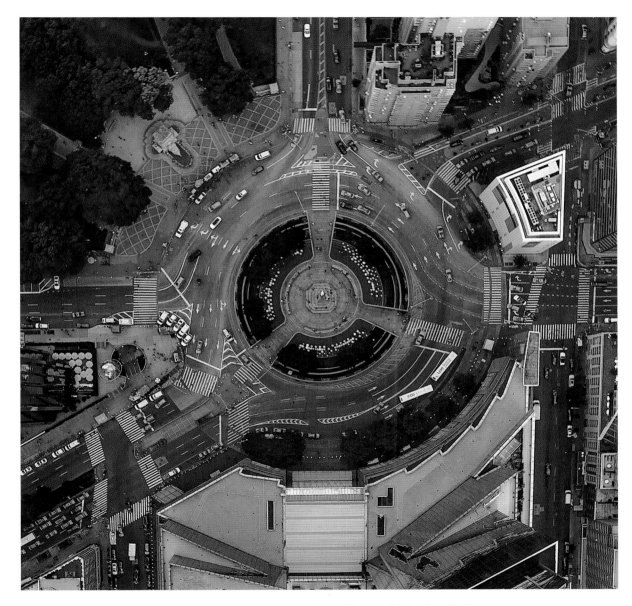

OPPOSITE: **@dankurtzmanphotography** Summer afternoon at Central Park and Columbus Circle, seen from the Mandarin Oriental Hotel.
ABOVE: **@2ndfloorguy** Aerial city geometry from above Columbus Circle.

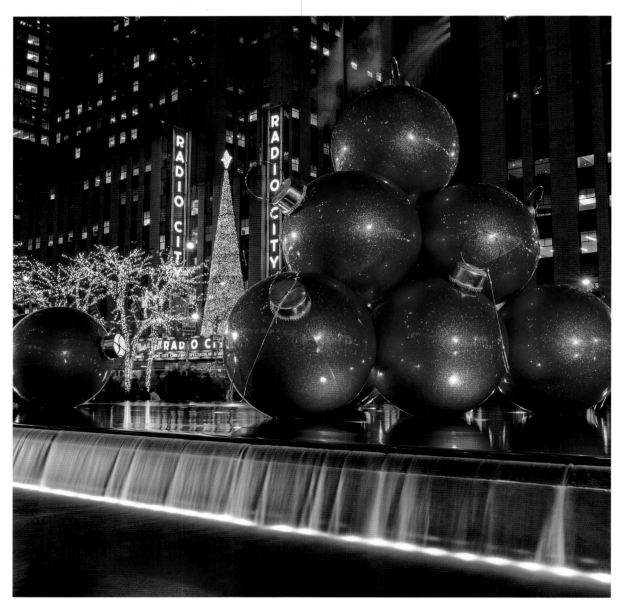

ABOVE: **@matthewchimeraphotography** Giant Christmas ornaments lighting up the holidays near Radio City Music Hall.
OPPOSITE: **@dankurtzmanphotography** A spectacular Christmastime at Radio City Music Hall.

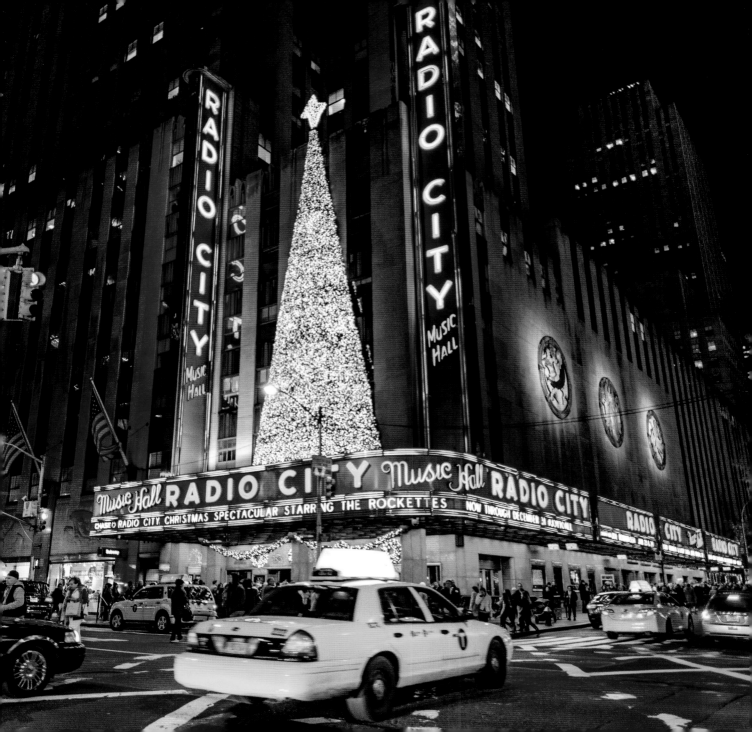

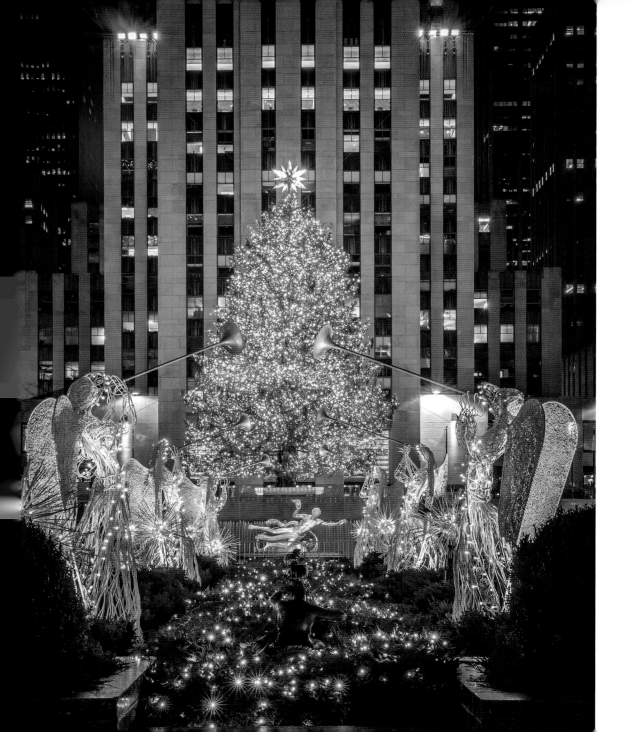

OPPOSITE: **@212sid**
Season's greetings from Rockefeller Center.

THIS PAGE, CLOCKWISE FROM TOP LEFT:
@killianmoore Vivid reflections of the Rockefeller Center Christmas tree and skating rink.
@killianmoore Rockefeller Center's *Atlas*, by Lee Lawrie and Rene Chambellan, and St. Patrick's Cathedral at Christmastime.
@pictures_of_newyork Holiday decorations at Time Warner Center.
@matthewchimera-photography Holiday lights on Wall Street.

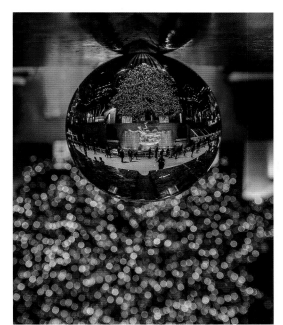

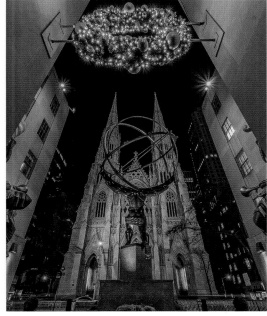

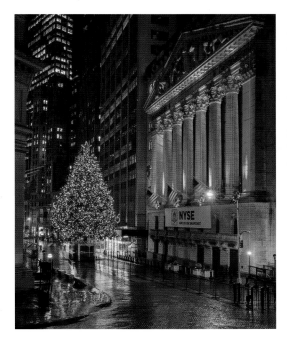

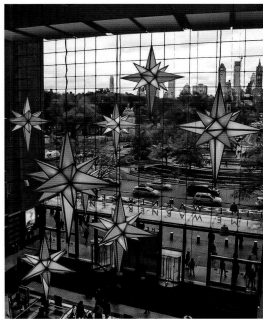

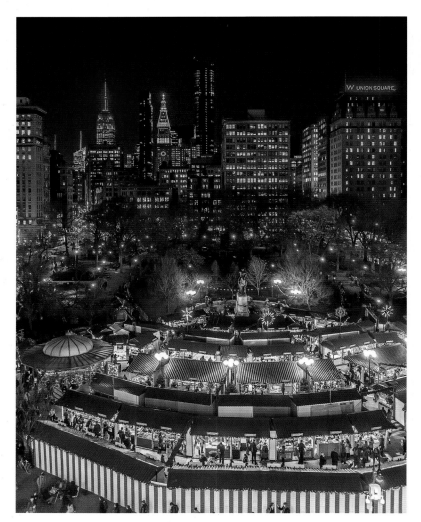

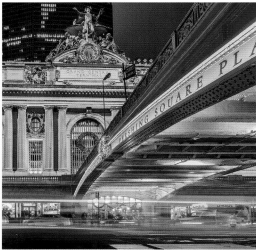

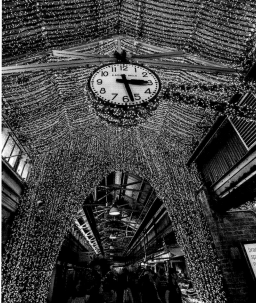

ABOVE: **@killahwave** Shopping at Union Square's Holiday Market.

TOP RIGHT: **@nyclovesnyc** Hanukkah lights on the Pershing Square viaduct at Grand Central Terminal.

BOTTOM RIGHT: **@dankurtzmanphotography** The clock at Chelsea Market.

OPPOSITE: **@dantvusa** Last light over Manhattan during the holiday season, seen from Newport, NJ.

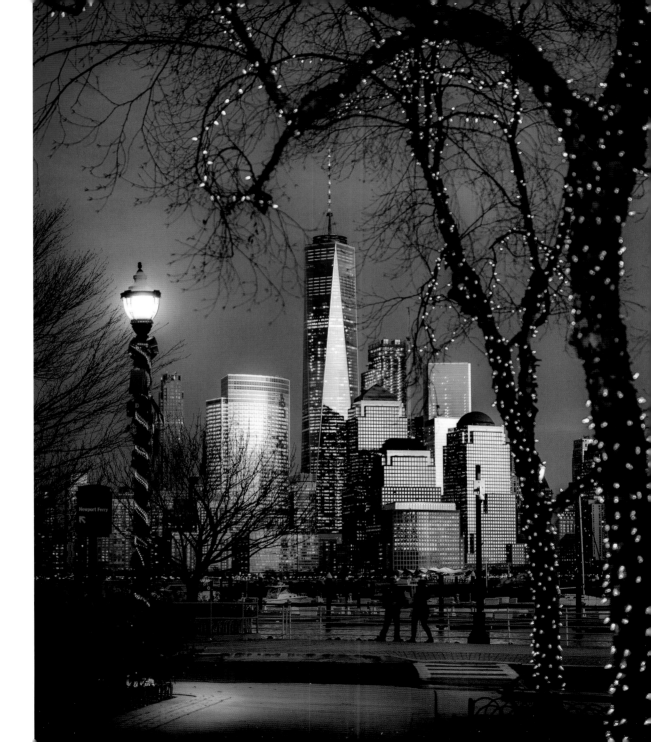

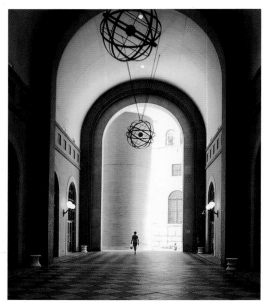

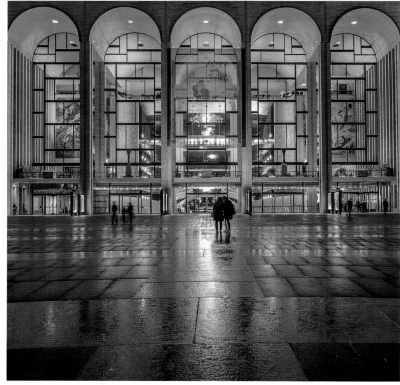

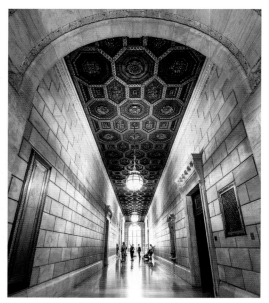

THIS PAGE, CLOCKWISE FROM TOP LEFT: **@nyroamer** A dramatic entrance in the Financial District. **@nyclovesnyc** A rainy night at Lincoln Center's Metropolitan Opera House. **@gigi.nyc** Passing through the Old City Hall subway station. **@dankurtzmanphotography** Archway in the New York Public Library's main branch.

OPPOSITE: **@b911bphoto** Commuters in the Oculus at the World Trade Center Transportation Hub.

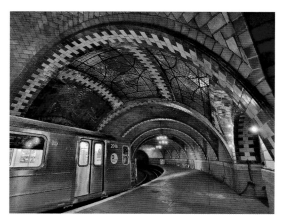

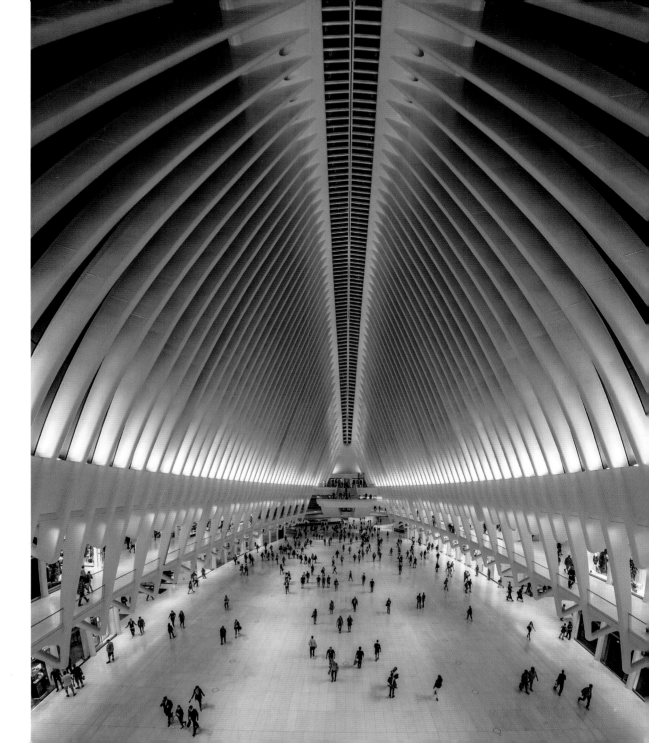

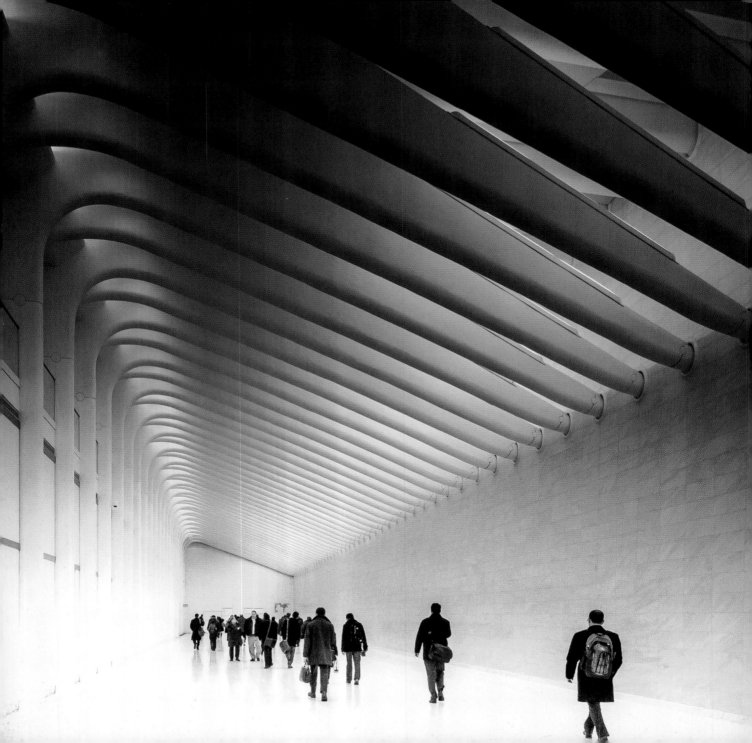

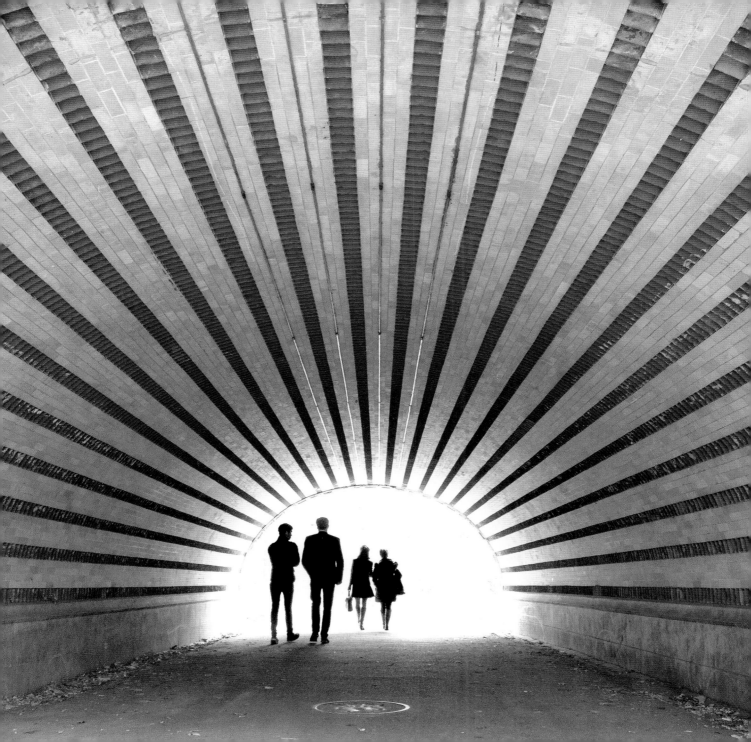

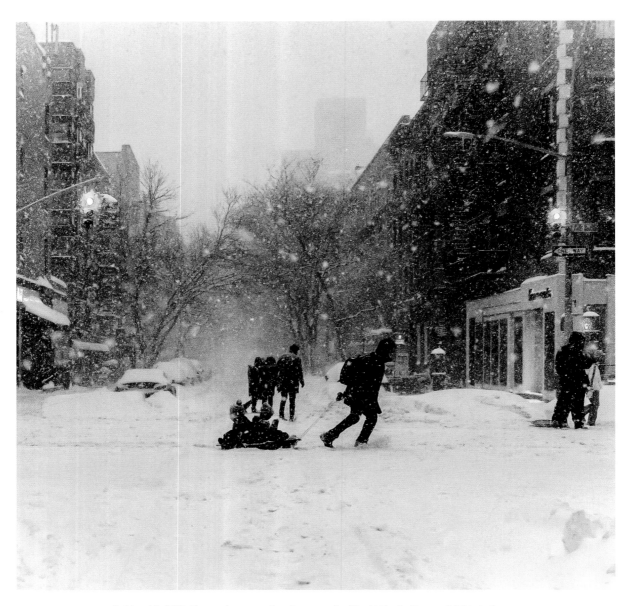

PRECEDING SPREAD: *(left)* **@chief770** The underground walkway at the World Trade Center PATH station.
(right) **@dankurtzmanphotography** Playmates Arch in Central Park. ABOVE: **@killianmoore** Snow day on the Upper East Side.
OPPOSITE: **@gmp3** Early morning blizzard at Central Park's Mall and Literary Walk.

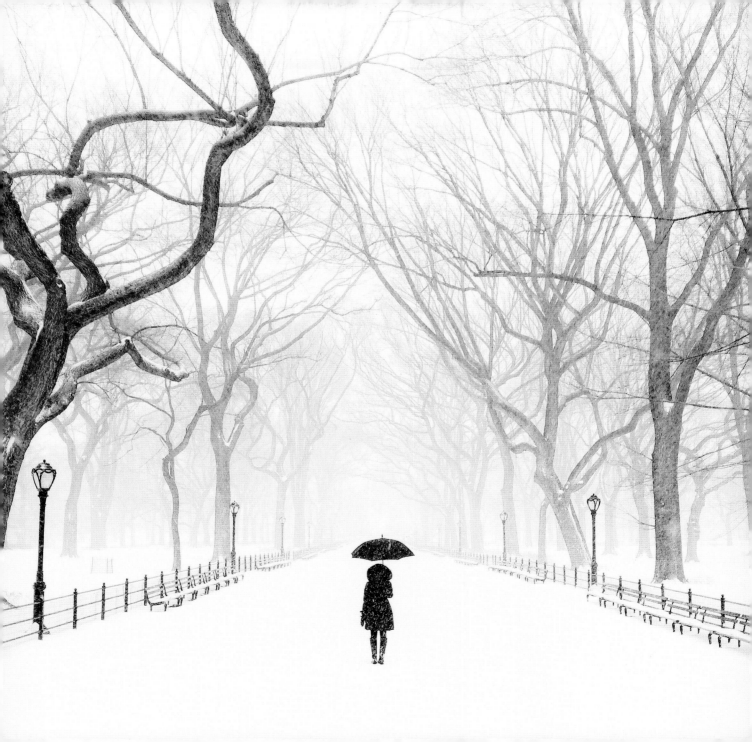

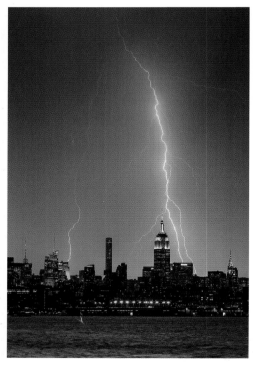

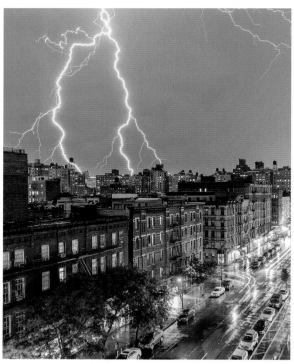

Chasing lightning during the summer thunderstorm season.

THIS PAGE, CLOCK-WISE FROM TOP LEFT: **@dubsonata** Midtown lightning, from Jersey City, NJ. **@gmp3** Lightning on the Upper West Side. **@javan** Wild weather, from Long Island City, Queens. **@jkhordi** Red, white, and blue, from Jersey City, NJ.

OPPOSITE: **@jkhordi** Lightning strike, from Jersey City, NJ.

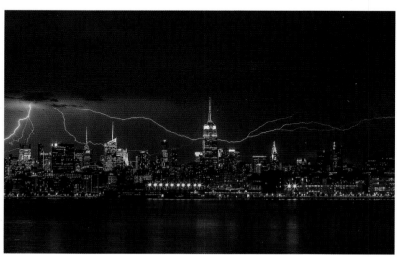

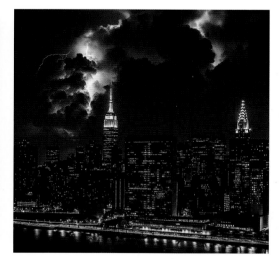

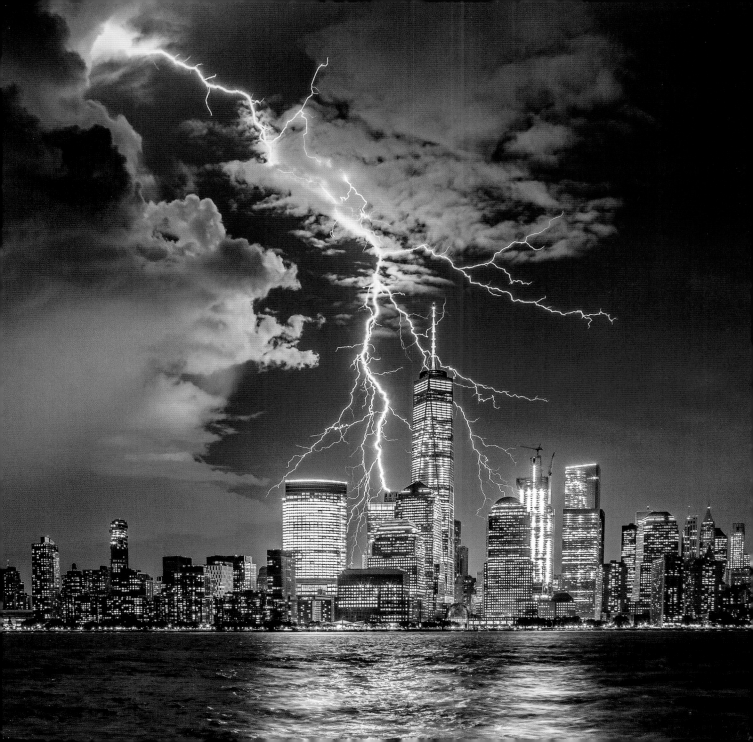

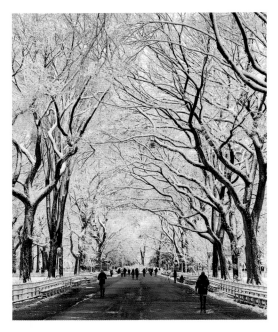

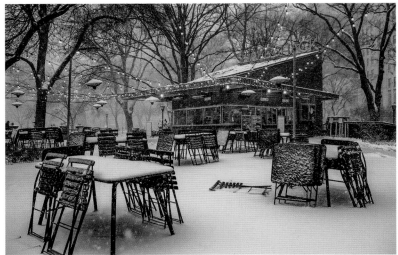

New York City snow days.

THIS PAGE, CLOCKWISE FROM TOP LEFT: **@johnnyyonkers** A cathedral-like canopy of American elms at Central Park's Mall. **@hindoben** A frosty Shake Shack in Madison Square Park. **@nyroamer** A cyclist braving the snow near the Ansonia on the Upper West Side. **@golden2dew** Sledding in Fort Greene, Brooklyn.

OPPOSITE: **@golden2dew** Mid-blizzard at the historic Alwyn Court building in Midtown.

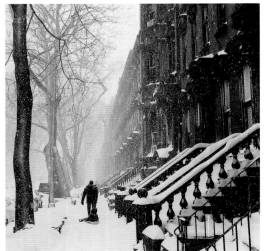

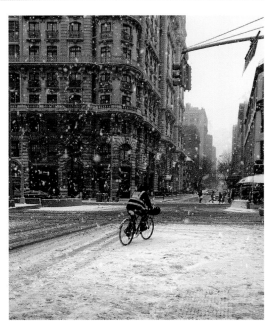

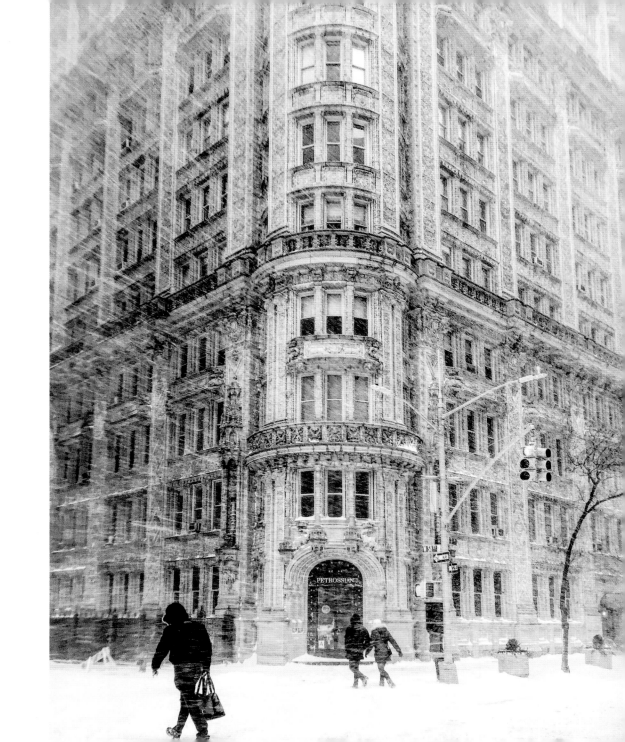

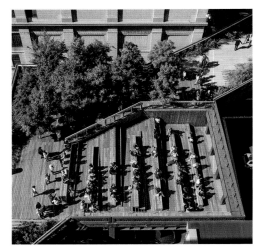

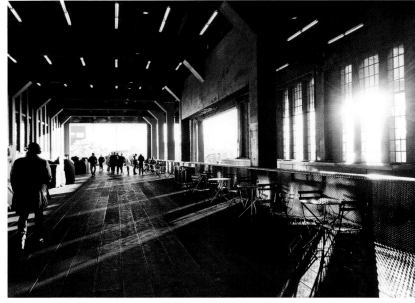

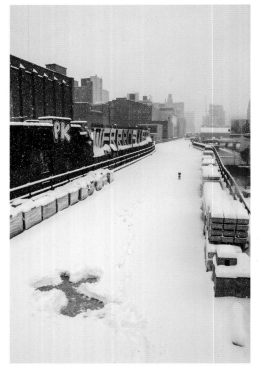

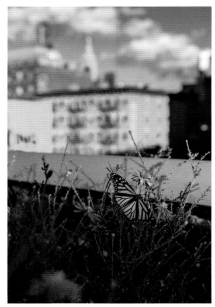

Nature in the middle of the
city on the High Line.

THIS PAGE, CLOCKWISE
FROM TOP LEFT:
@timothyschenck
Tenth Avenue Square
at the High Line.
@timothyschenck
Late afternoon shadows
above Chelsea Market.
@timothyschenck
Nature in the city—
a High Line butterfly.
@timothyschenck
Snow angel after
a blizzard.

OPPOSITE: **@gigi.nyc**
Walking through autumn
colors on the High Line.

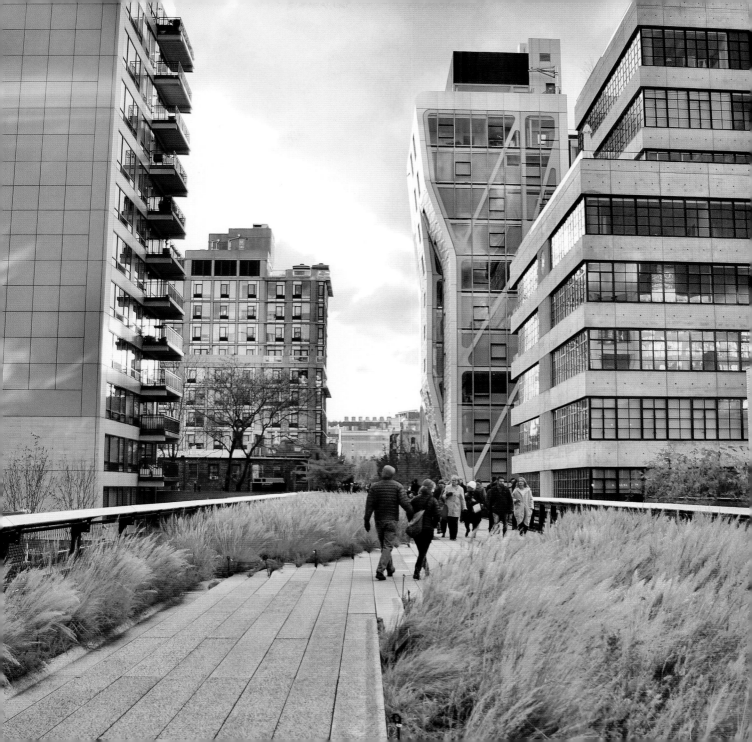

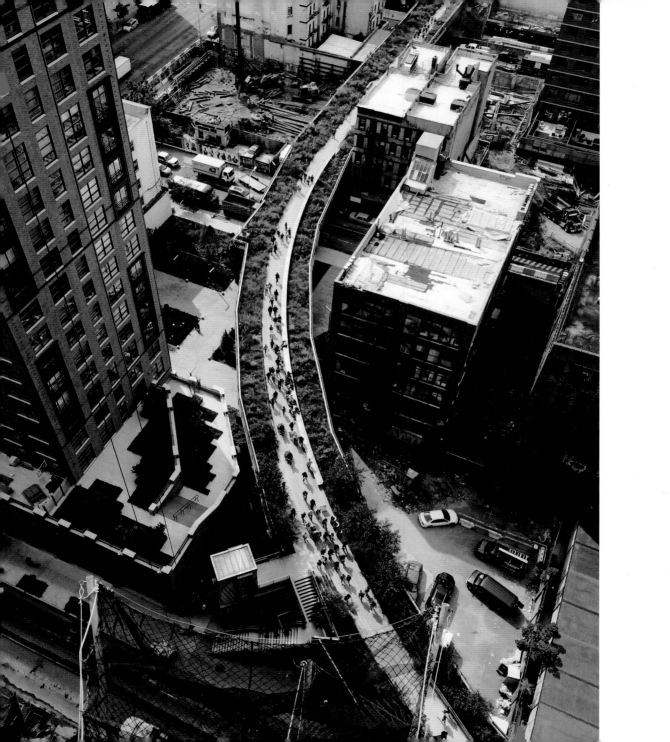

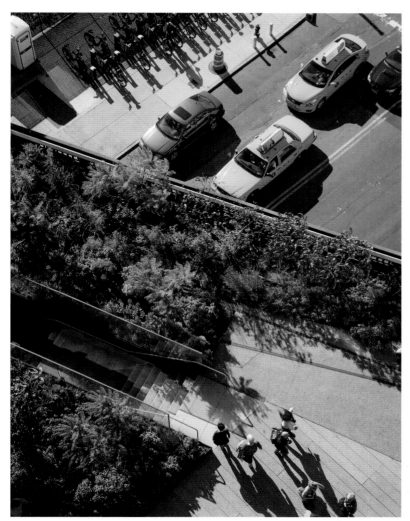

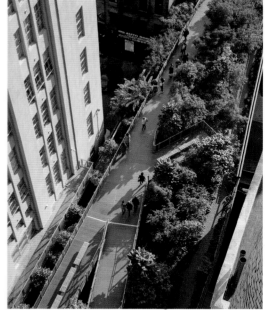

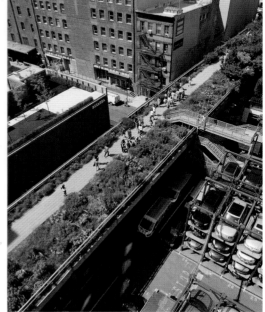

Overlooking the High Line, the only elevated park in New York City.

OPPOSITE: **@timothyschenck**
A promenade arcing through Chelsea.

ABOVE: **@timothyschenck**
A suspended garden above the city.

TOP RIGHT: **@timothyschenck**
From a rooftop vantage point.

BOTTOM RIGHT: **@timothyschenck**
High Line walking.

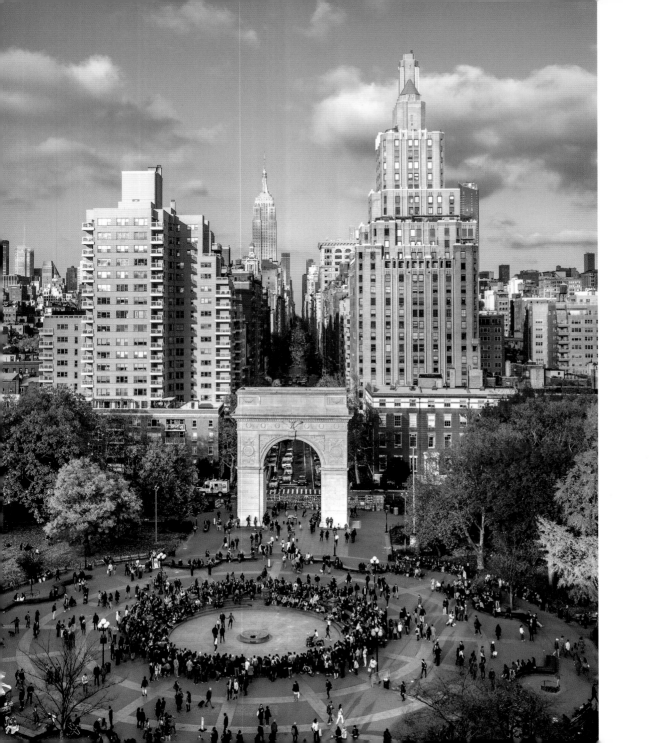

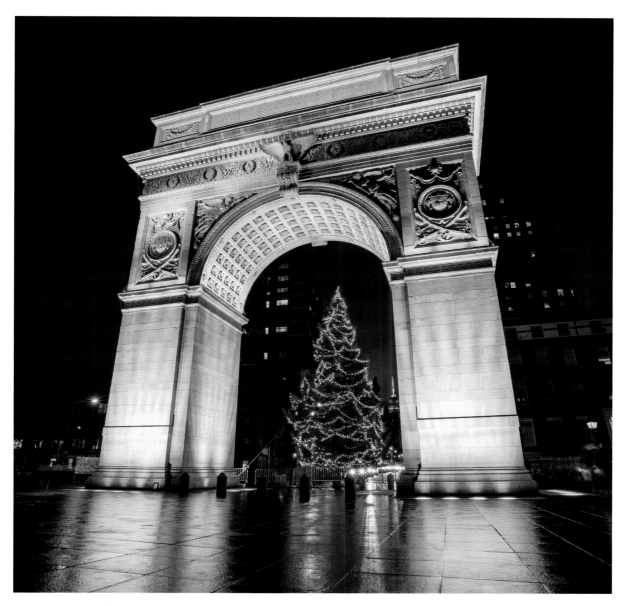

OPPOSITE: **@212sid** Circle in the square at Washington Square Park.
ABOVE: **@matthewchimeraphotography** Christmastime at the Washington Square Arch.

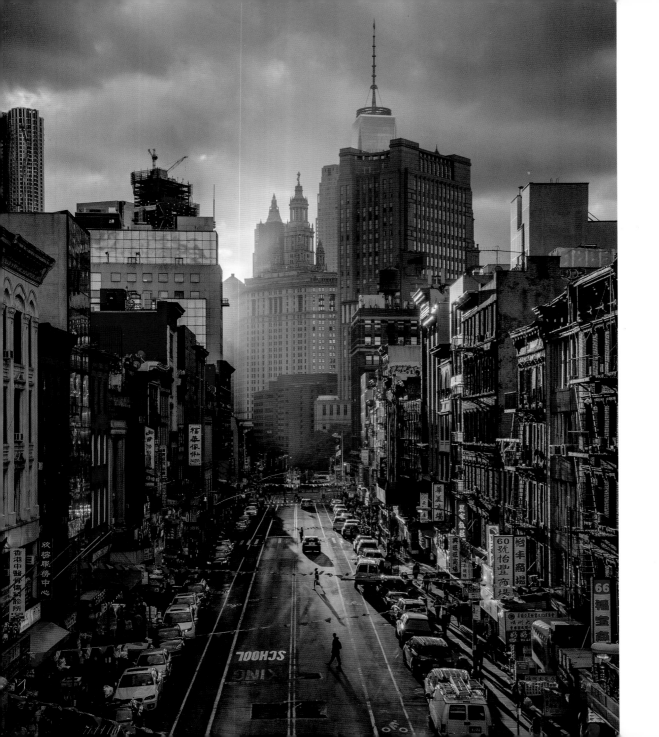

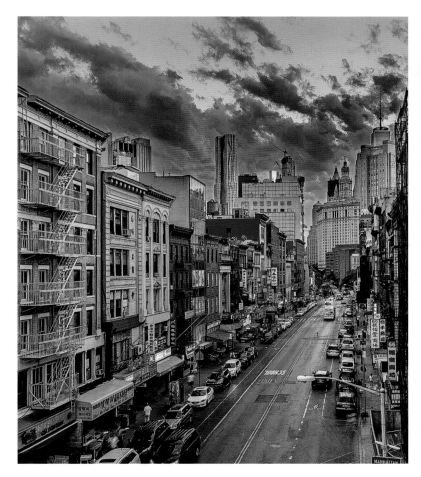

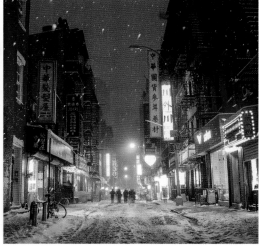

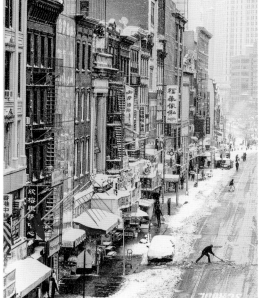

OPPOSITE: **@papakila**
Late afternoon light casting
long shadows on East
Broadway in Chinatown.

ABOVE: **@killahwave**
Vivid sky over Chinatown.

TOP RIGHT: **@matthew-
chimeraphotography**
Snowy Pell Street.

BOTTOM RIGHT:
@golden2dew East
Broadway after a blizzard.

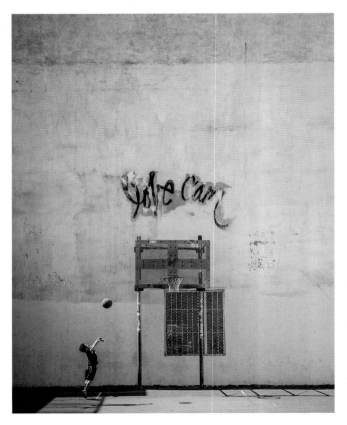

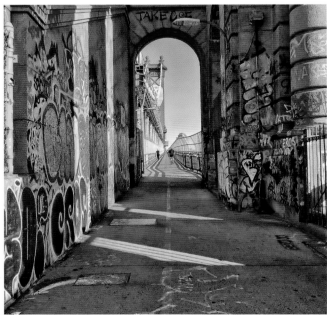

LEFT: **@212sid** Young ambition in Lower Manhattan.

ABOVE: **@gigi.nyc** Late afternoon along the Manhattan Bridge walkway.

OPPOSITE: **@clearbluskyes** Graffiti sunset in Chinatown, seen from the Manhattan Bridge.

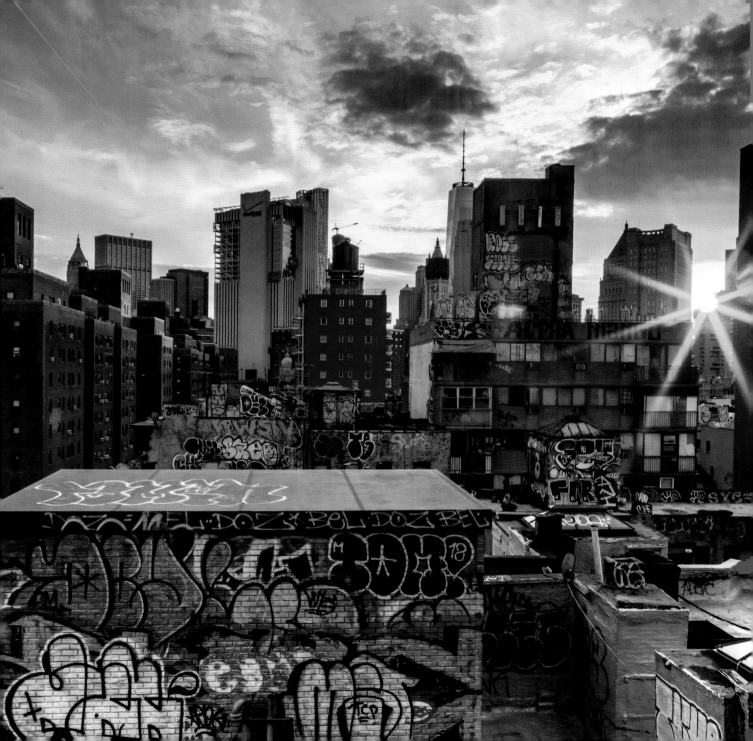

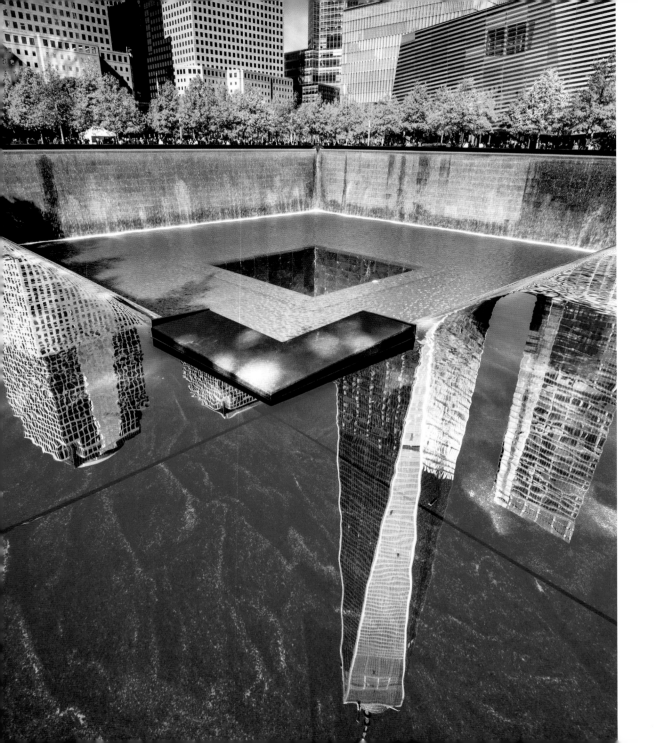

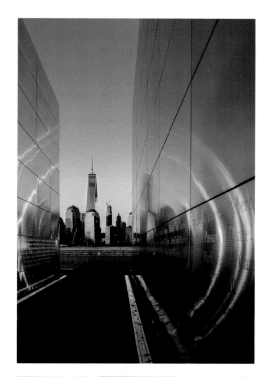

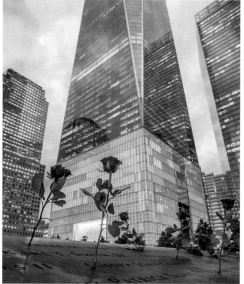

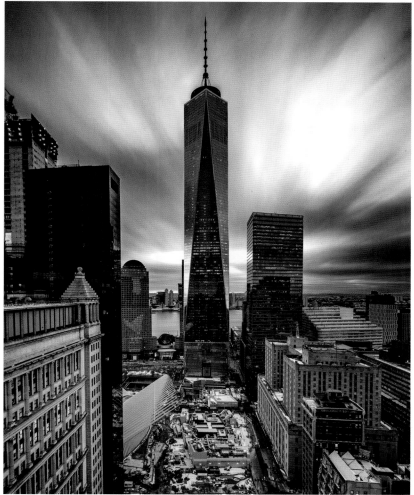

OPPOSITE: **@dankurtzman-photography** Reflecting pool at the 9/11 Memorial.

TOP LEFT: **@b911bphoto** Sunset at the Empty Sky Memorial in Liberty State Park, Jersey City, NJ.

LEFT: **@nyclovesnyc** A day of remembrance at the 9/11 Memorial.

ABOVE: **@beholdingeye** Clouds streaking over One World Trade Center.

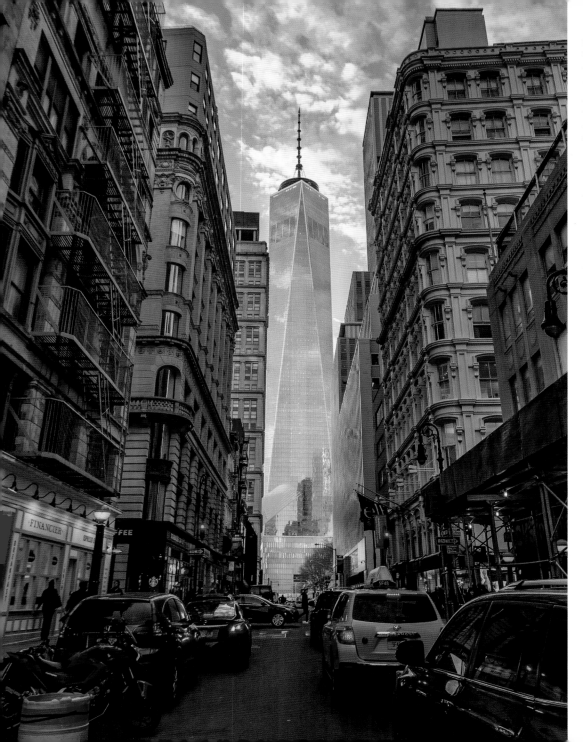

LEFT: **@chief770** One World Trade Center towering above Fulton Street.

OPPOSITE: **@clearbluskyes** Twilight aerial view of One World Trade Center, the Hudson River, and New Jersey.

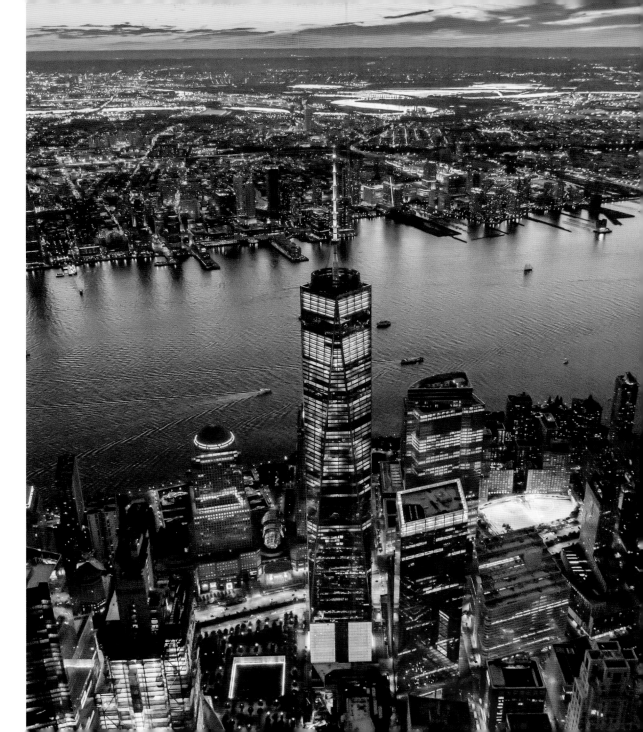

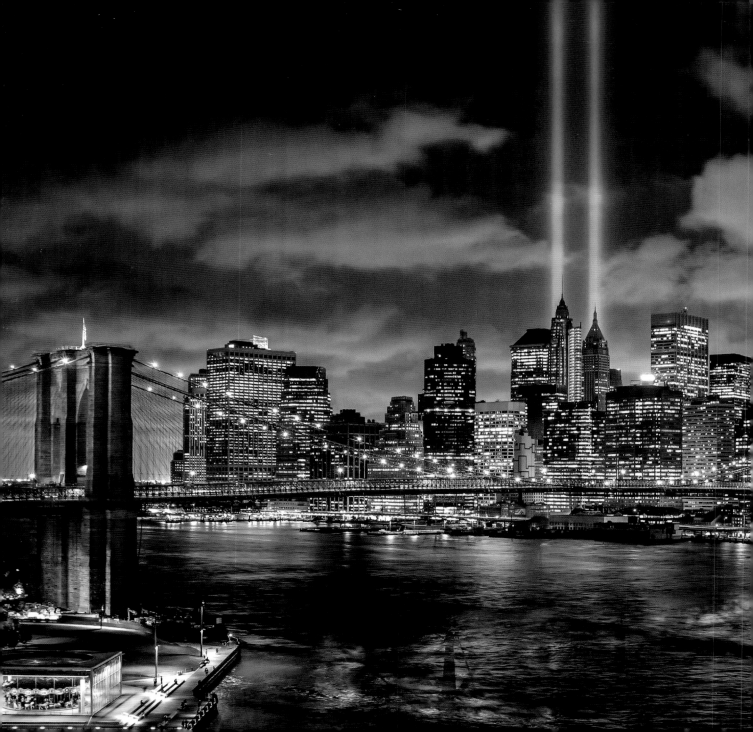

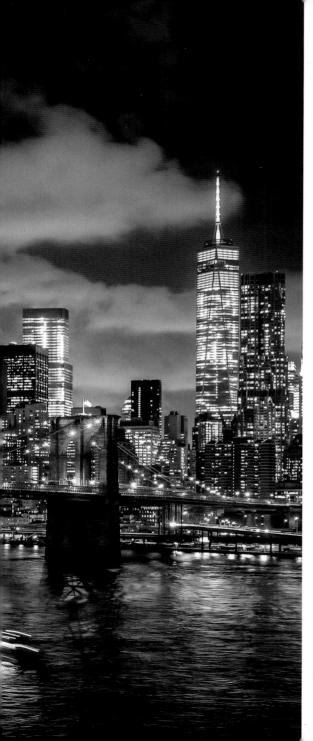

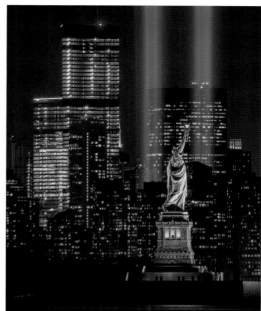

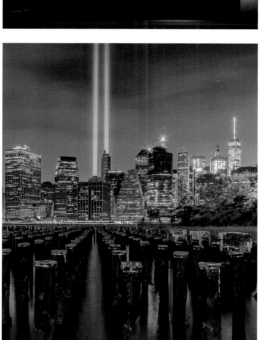

The annual Tribute in Light marking the anniversary of 9/11.

FAR LEFT: **@coryschlossimages** Lower Manhattan, seen from the walkway of the Manhattan Bridge.

TOP LEFT: **@chief770** Shining above New York Harbor.

BOTTOM LEFT: **@killahwave** Reflecting in the waters of Brooklyn Bridge Park.

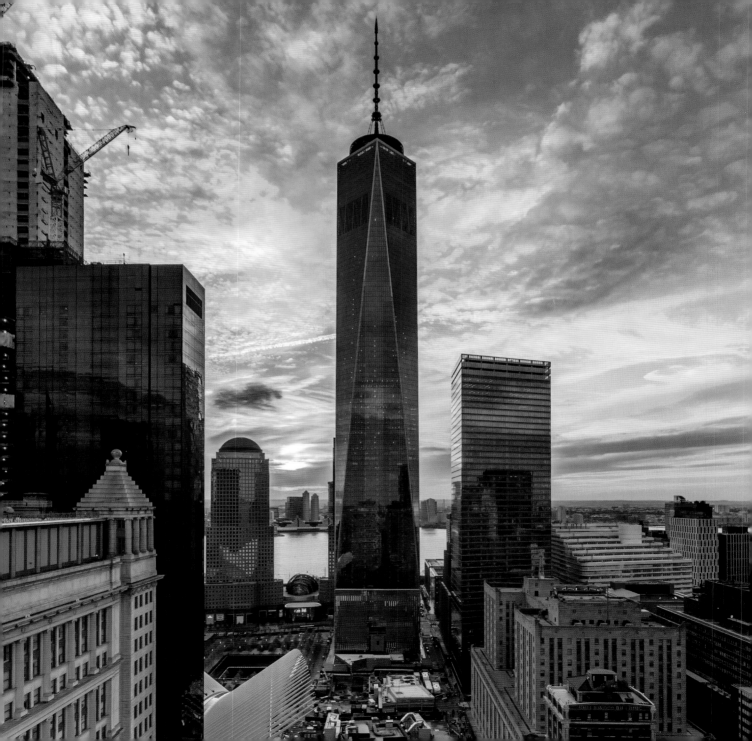

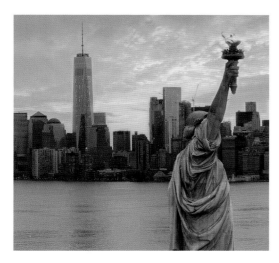

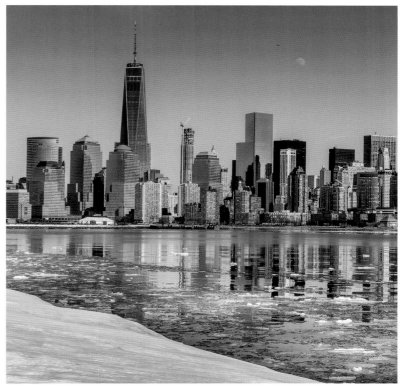

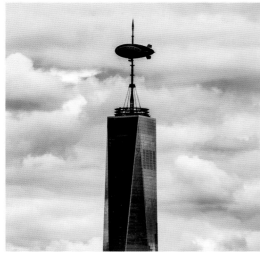

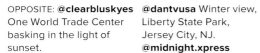

OPPOSITE: **@clearbluskyes** One World Trade Center basking in the light of sunset.

THIS PAGE, CLOCKWISE FROM TOP LEFT: **@2ndfloorguy** Freedom and Liberty together. **@dantvusa** Winter view, Liberty State Park, Jersey City, NJ. **@midnight.xpress** A Lower Manhattan sunrise. **@dankurtzman-photography** A skewered blimp at One World Trade Center.

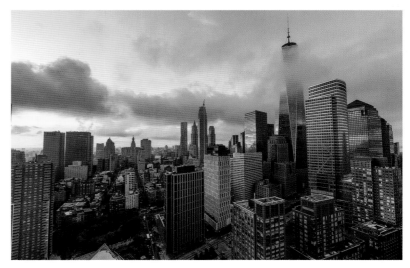

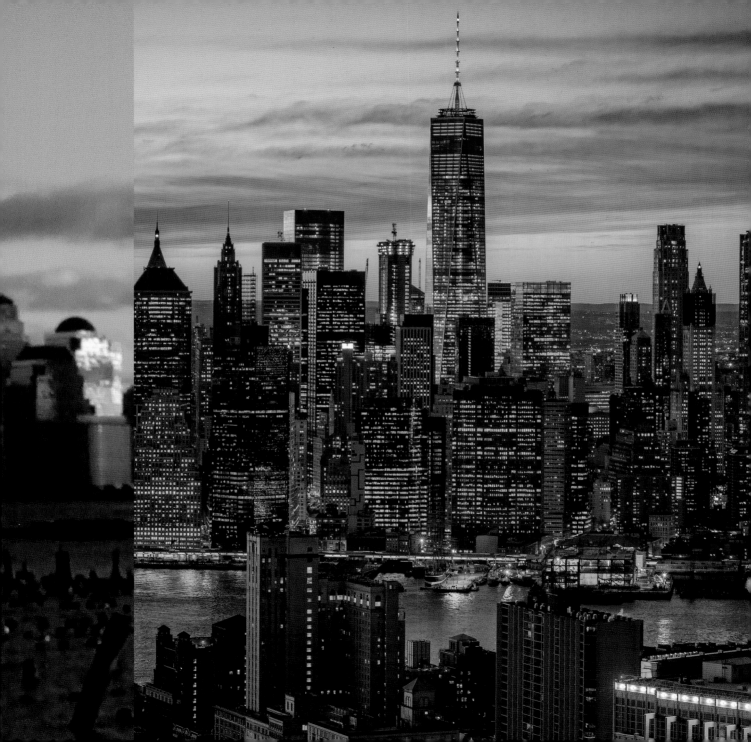

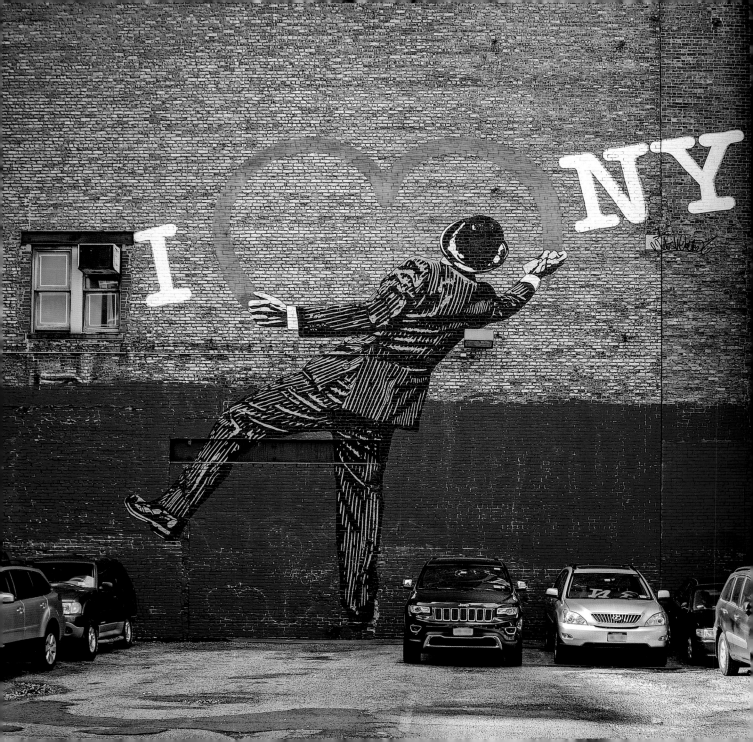

PRECEDING SPREAD: *(left)* **@garyhershorn** Seagull selfie at Hoboken, NJ. *(right)* **@chief770** A Brooklyn view of One World Trade Center and Lower Manhattan.

OPPOSITE: **@coryschlossimages** *Love Vandal* mural by Nick Walker, 17th Street and Sixth Avenue.

RIGHT: **@papakila** Rainbow arcing over Park Slope, Brooklyn.

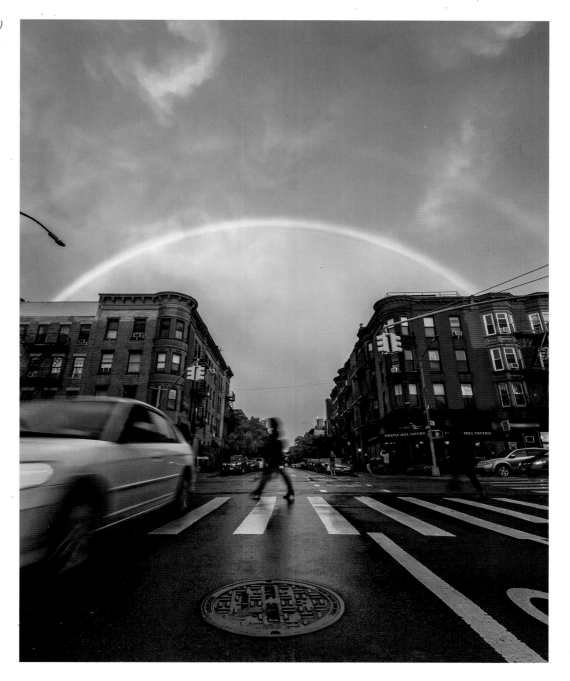

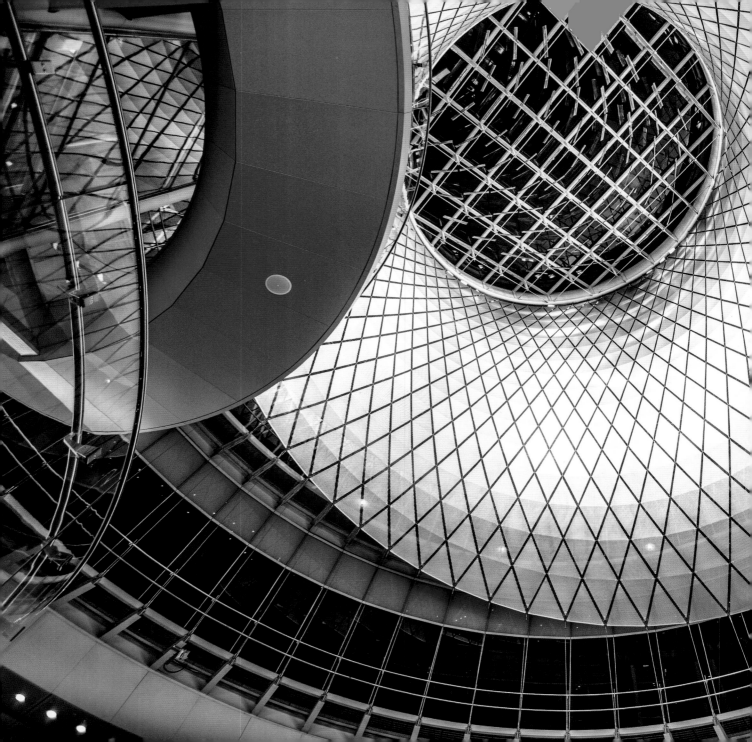

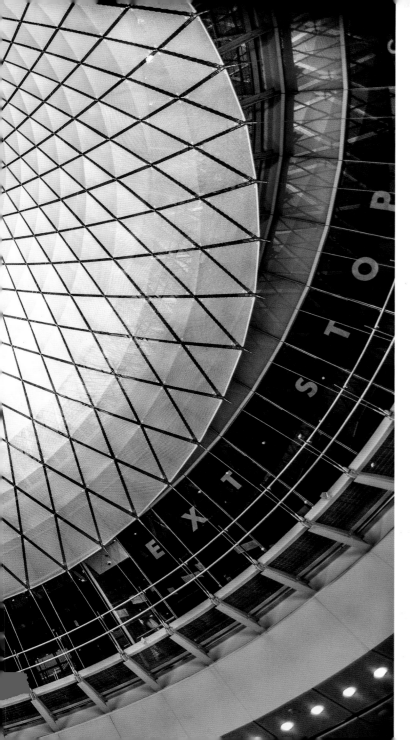

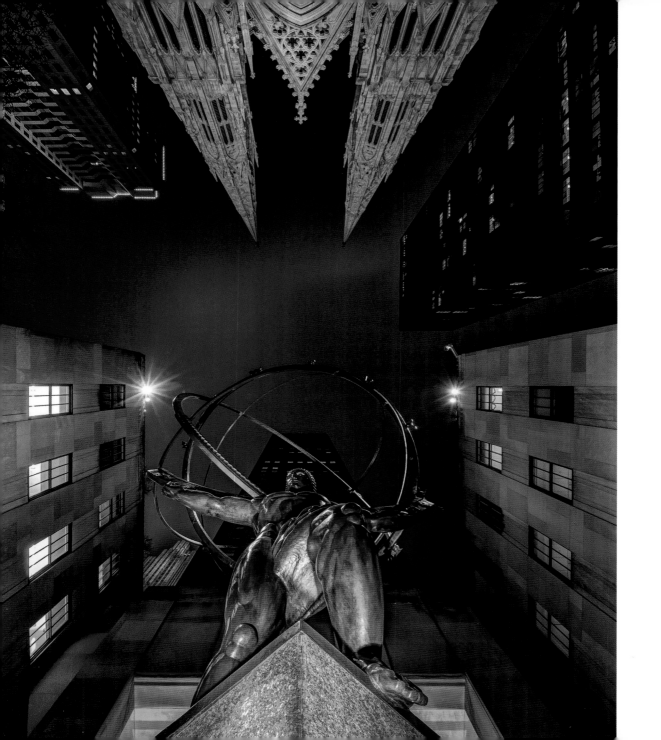

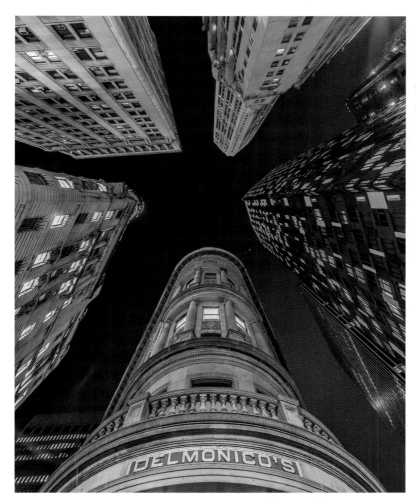

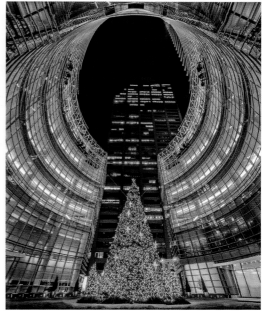

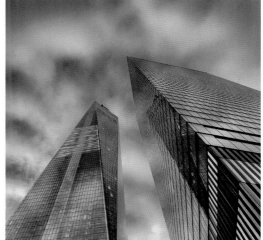

OPPOSITE: **@chief770**
Below Rockefeller
Center's *Atlas*, by
Lee Lawrie and Rene
Chambellan, and
St. Patrick's Cathedral.

ABOVE: **@killianmoore**
Looking up at Delmonico's
and surrounding buildings
in the Financial District.

TOP RIGHT: **@killianmoore**
Christmastime at 731
Lexington Avenue, aka
"Bloomberg Tower."

BOTTOM RIGHT: **@vincent-jamesphotography**
Clouds streaming above
One World Trade Center.

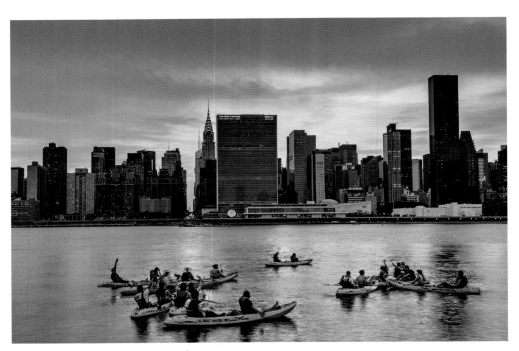

LEFT: **@b911bphoto**
Kayakers at sunset at
Gantry Plaza State Park,
Long Island City.

BELOW LEFT:
@newyorkcitykopp
The Statue of Liberty,
seen from Battery Park.

BELOW RIGHT: **@matthew-
chimeraphotography**
Summer afternoon on
Governors Island.

OPPOSITE: **@2ndfloorguy**
Reflecting New York City
above the East River.

FOLLOWING SPREAD:
@jkhordi A clearing
storm lights up the
sky over Lower
Manhattan, seen
from Jersey City, NJ.

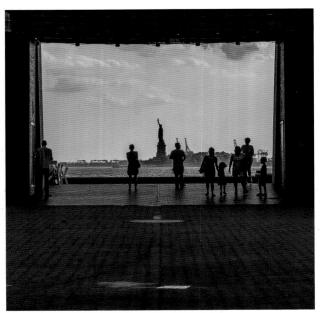

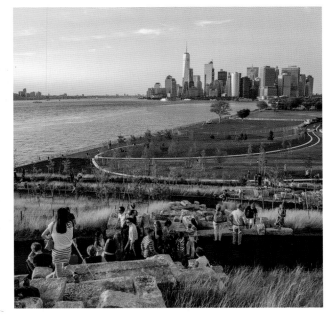

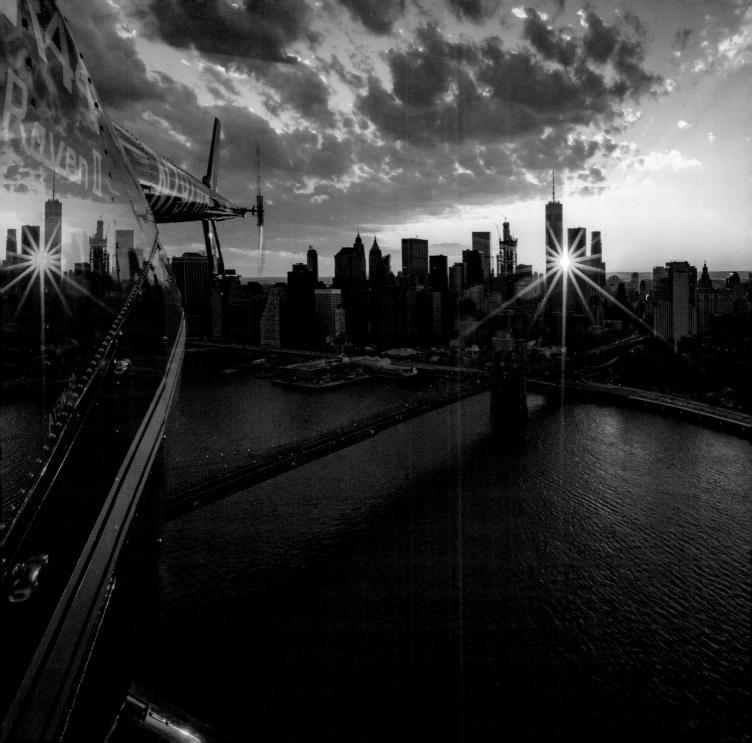

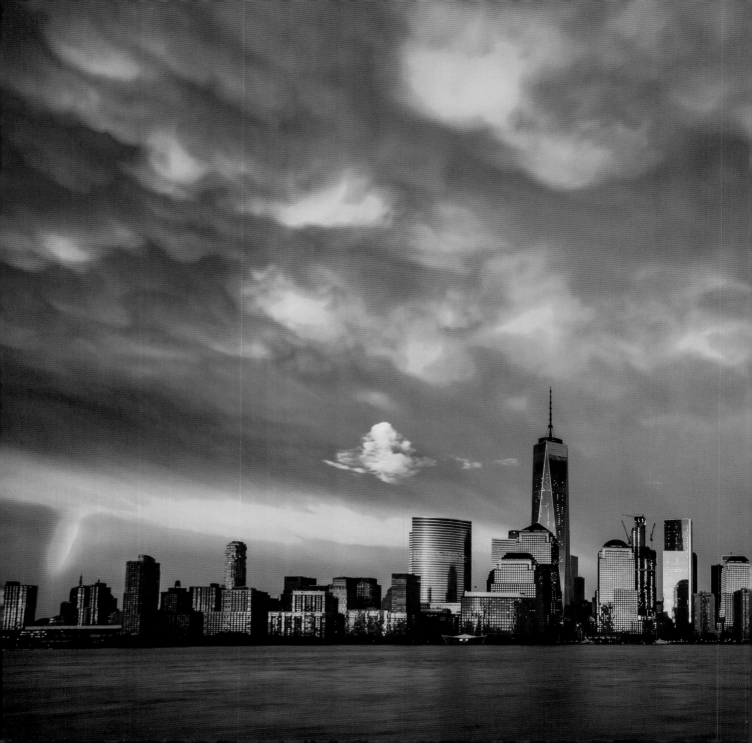

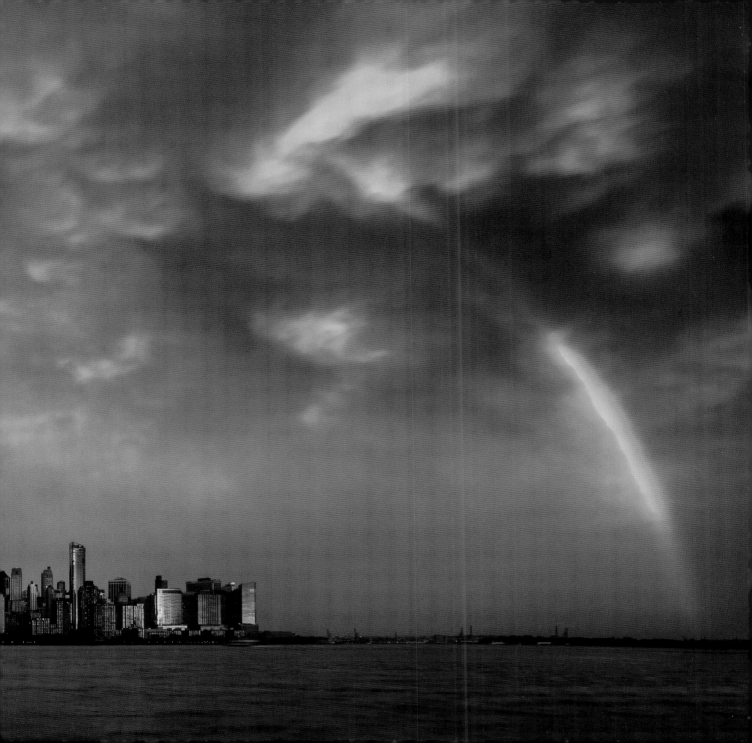

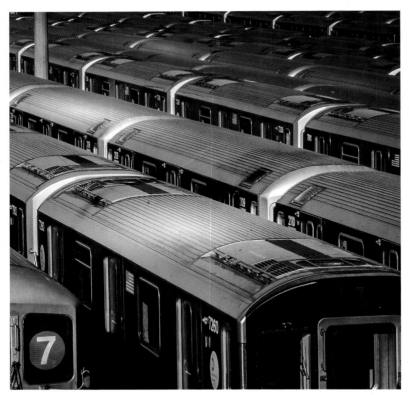

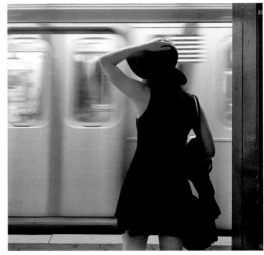

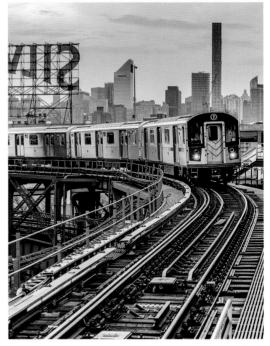

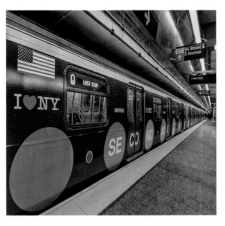

THIS PAGE, CLOCKWISE FROM TOP LEFT: **@dantvusa** The 7 line subway train yard in Flushing, Queens. **@fatiography** Dressed to the nines even while catching a train. **@javan** A 7 train approaching Queensboro Plaza station, Long Island City. **@milan2ny** The Second Avenue subway station.

OPPOSITE: **@papakila** Lower Manhattan at sunset, from an elevated subway platform in Brooklyn.

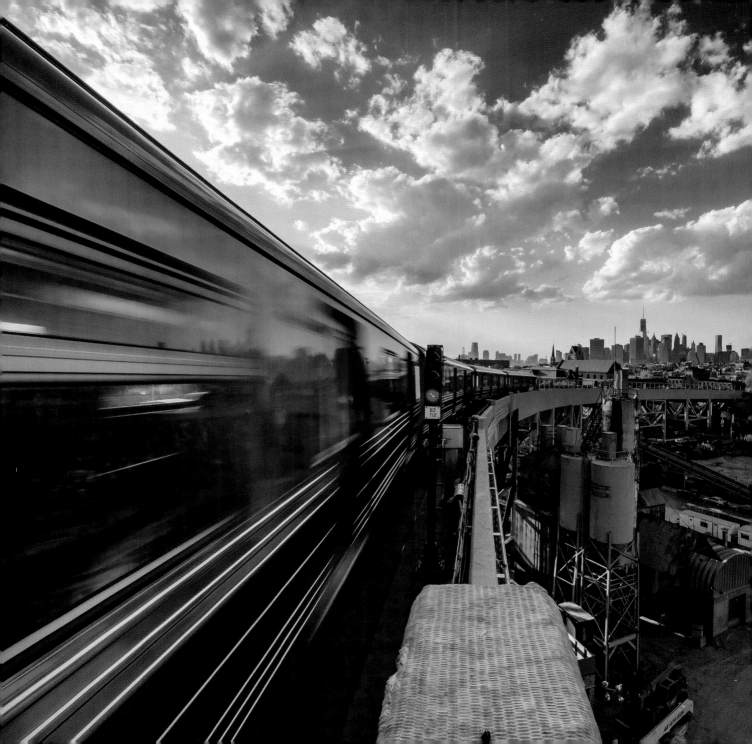

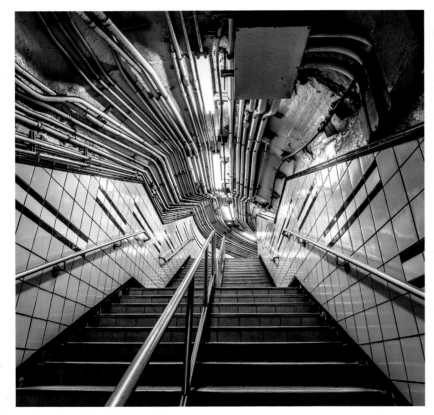

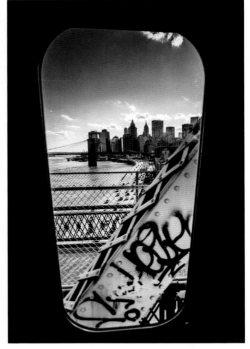

THIS PAGE, CLOCKWISE FROM TOP LEFT: **@dankurtzmanphotography** The Ninth Street PATH Station, Greenwich Village. **@dankurtzmanphotography** Lower Manhattan and FDR Drive through the window of a subway train on the Manhattan Bridge. **@dario.nyc** The 7 line subway train yard in Flushing, Queens. **@gigi.nyc** The Hudson Yards redevelopment project.

OPPOSITE: **@papakila** Ground-level view of train leaving elevated subway station in Brooklyn.

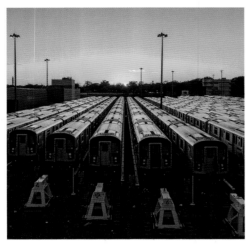

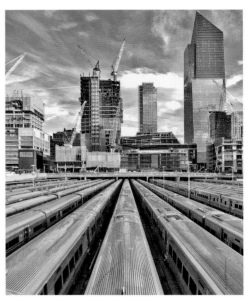

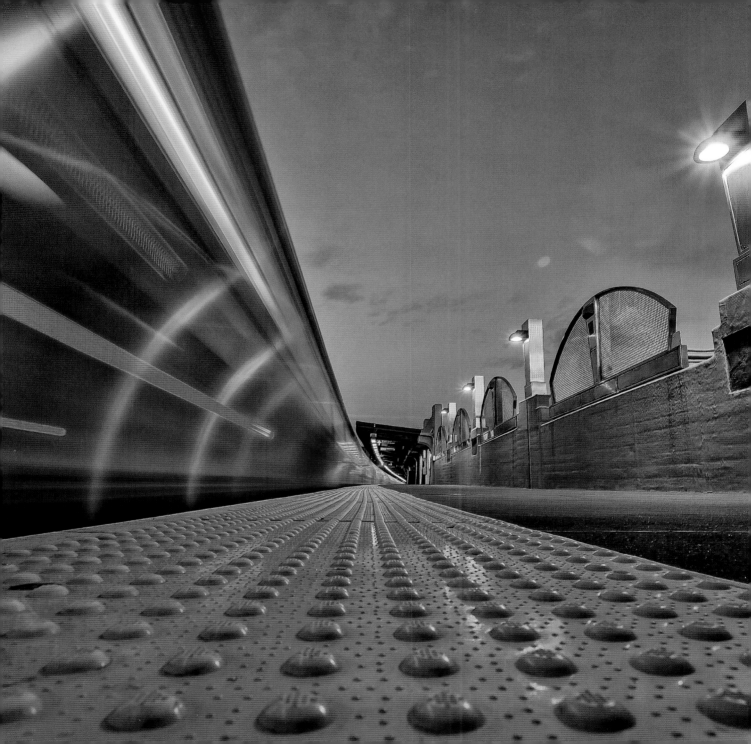

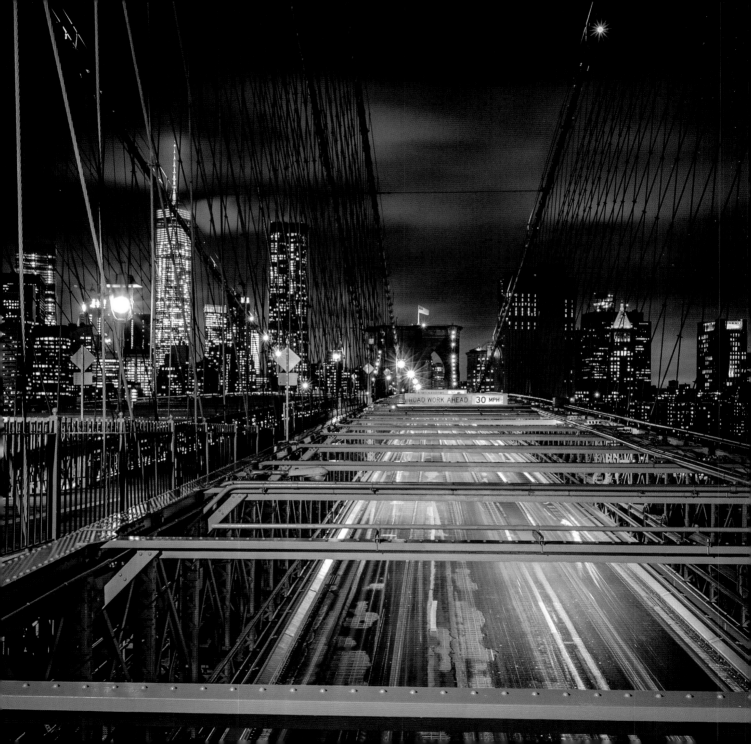

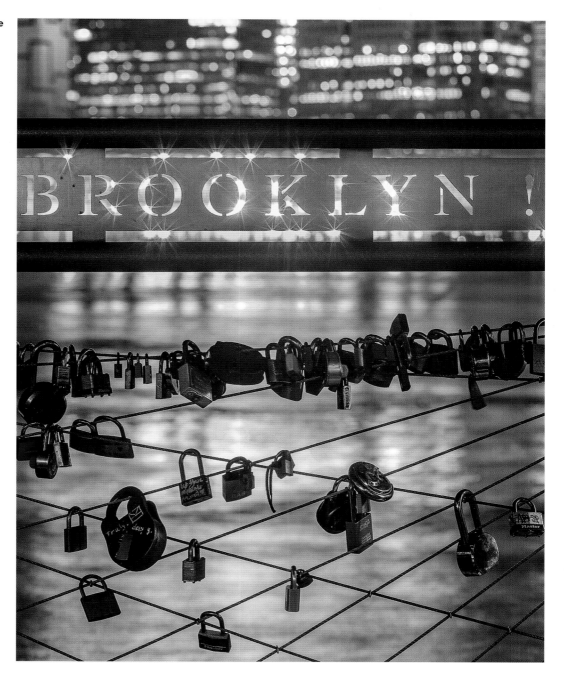

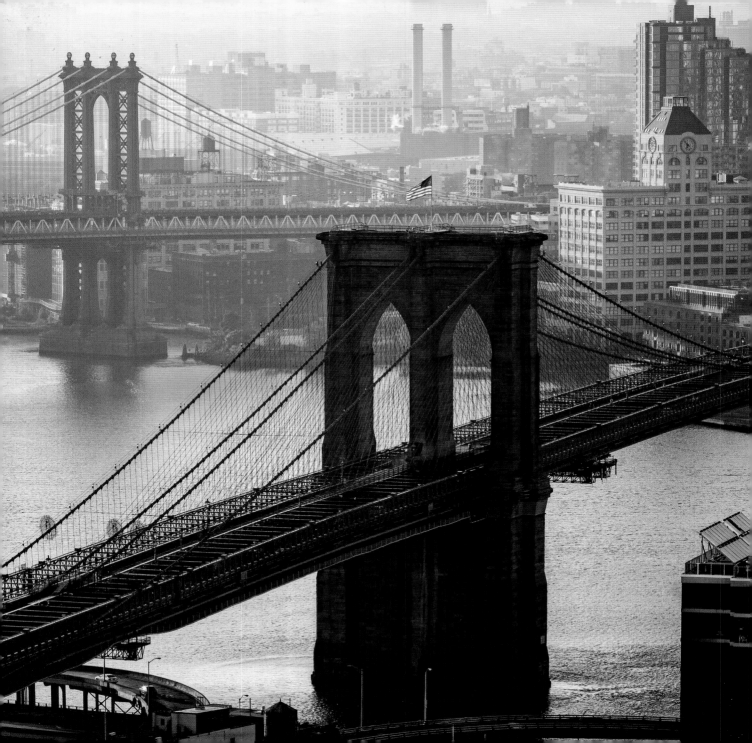

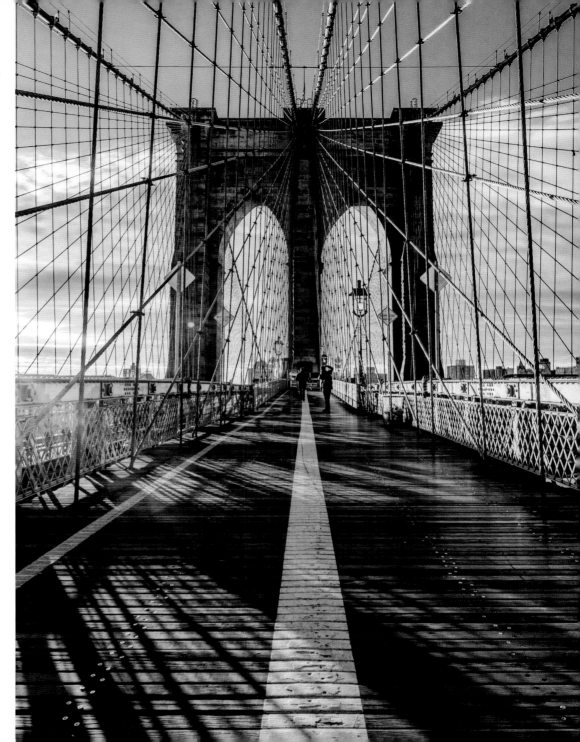

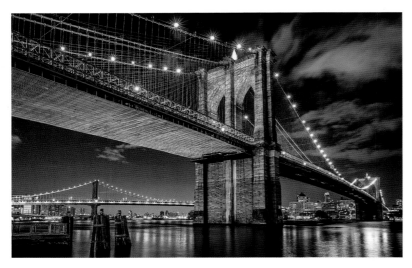

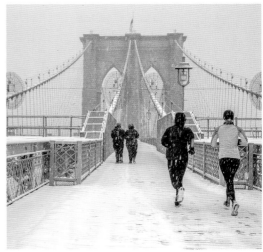

Crossing the East River on the iconic Brooklyn Bridge.

THIS PAGE, CLOCKWISE FROM TOP LEFT: **@coryschlossimages** The Brooklyn and Manhattan Bridges from the South Street Seaport. **@nyclovesnyc** Joggers crossing the Brooklyn Bridge. **@matthewchimeraphotography** Bridge lights on a snowy night. **@thewilliamanderson** A solitary moment.

OPPOSITE: **@papakila** Golden light at sunset filtered through the arches of the Brooklyn Bridge.

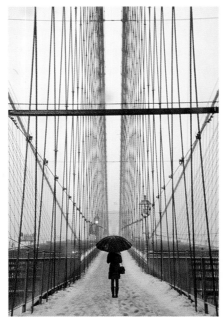

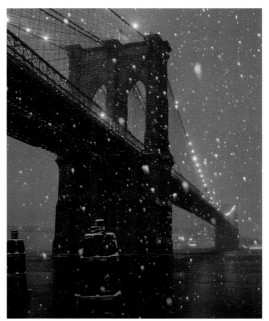

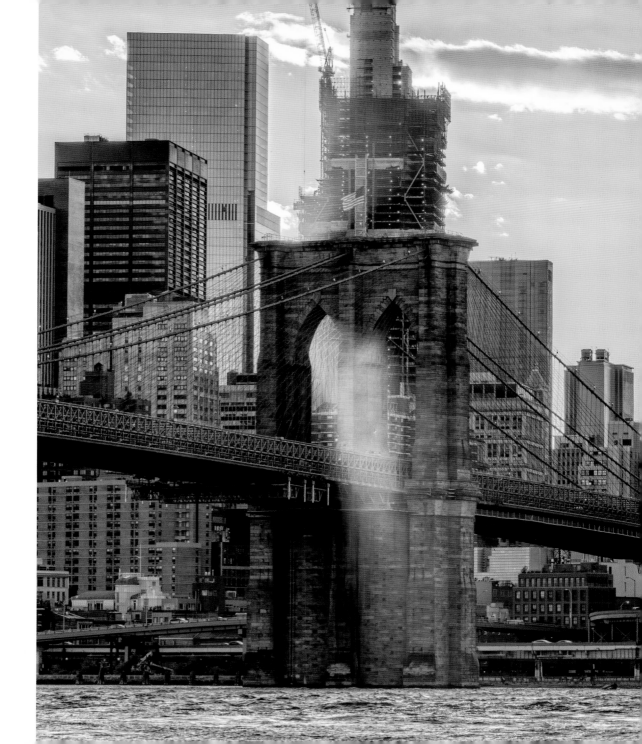

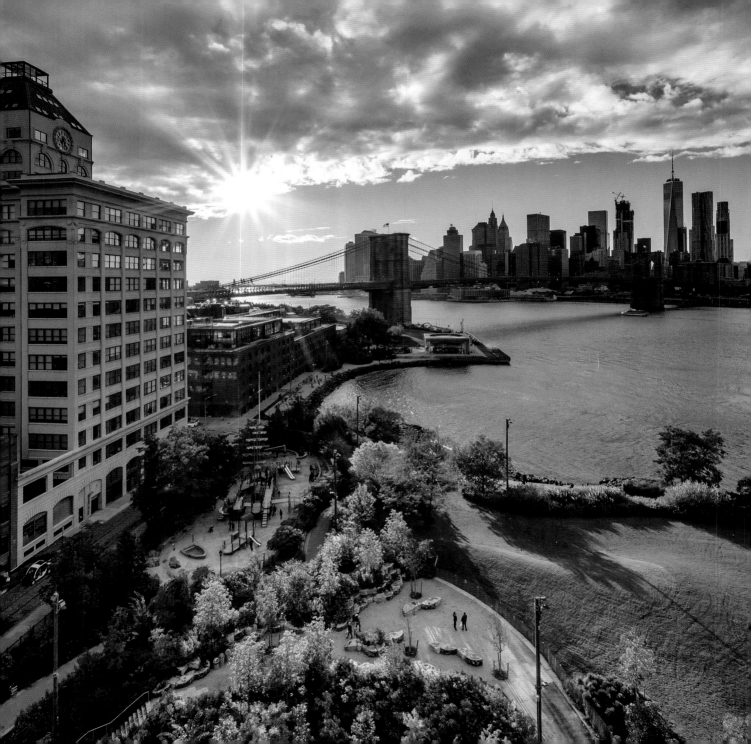

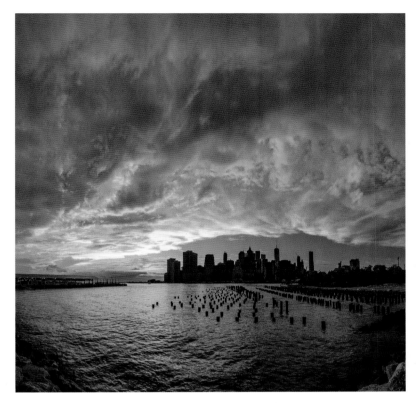

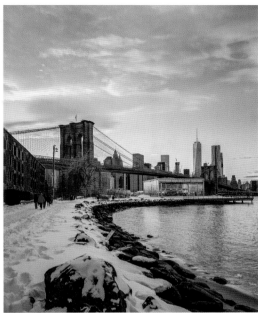

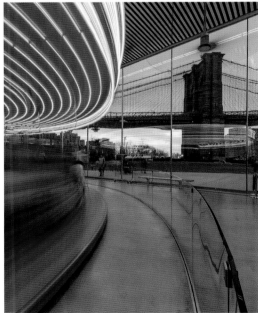

Brooklyn Bridge Park's cityscape perspective, framed by the Brooklyn Bridge, the piers, and the East River.

OPPOSITE: **@papakila** Overlooking Brooklyn Bridge Park as a storm clears over the Brooklyn Bridge and Lower Manhattan.

TOP LEFT: **@papakila** Spectacular cloud formations at sunset, seen from the pilings of Brooklyn Bridge Park.

TOP RIGHT: **@gmathewsva** Calm after a winter storm along the Brooklyn side of the East River.

BOTTOM RIGHT: **@gmathewsva** Round and round at Jane's Carousel.

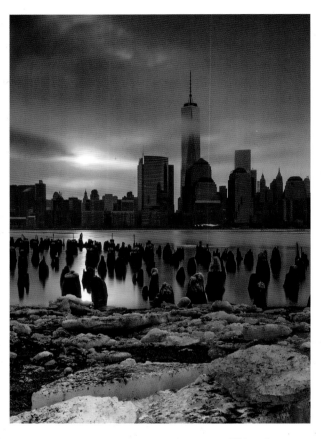

ABOVE: **@jkhordi**
Dramatic sunrise
from the waterfront,
Newport, NJ.

RIGHT: **@bklyn_block**
Fire and ice from
the Brooklyn
waterfront at sunset.

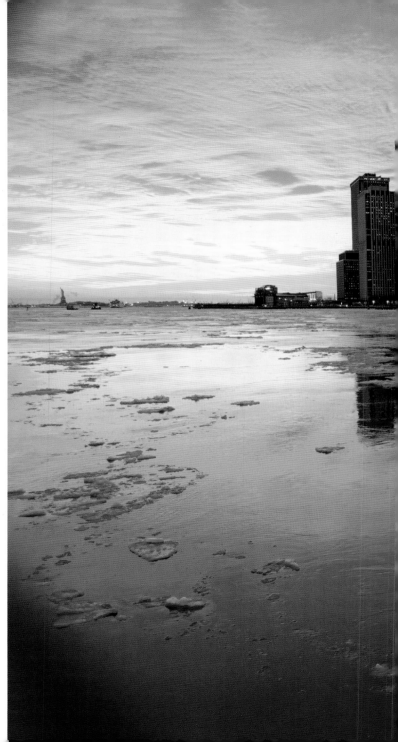

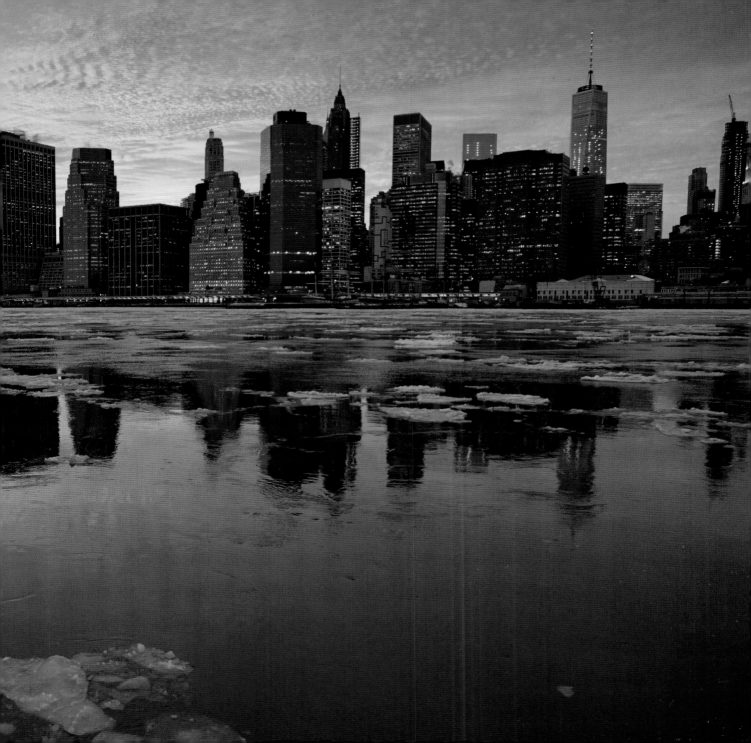

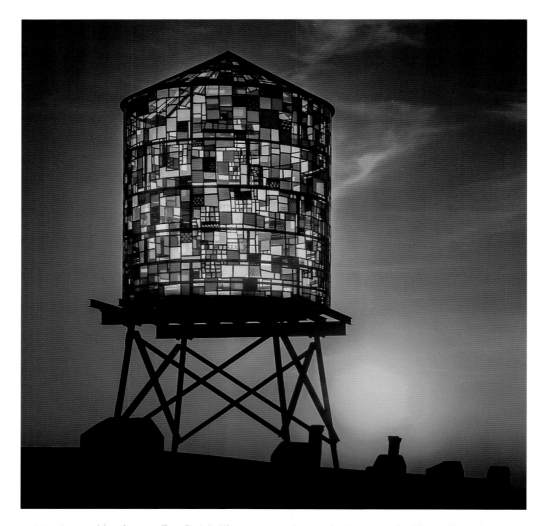

ABOVE: **@coryschlossimages** Tom Fruin's *Watertower* sculpture glowing atop a building in Brooklyn.
OPPOSITE: **@dankurtzmanphotography** Spellbound by Tom Fruin's stained-glass *Kolonihavehus* in Brooklyn Bridge Park.

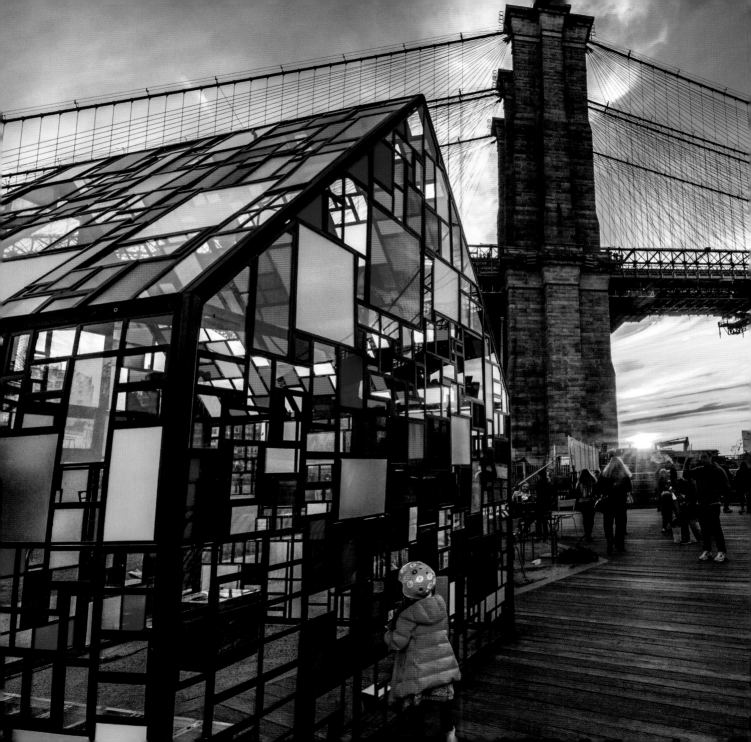

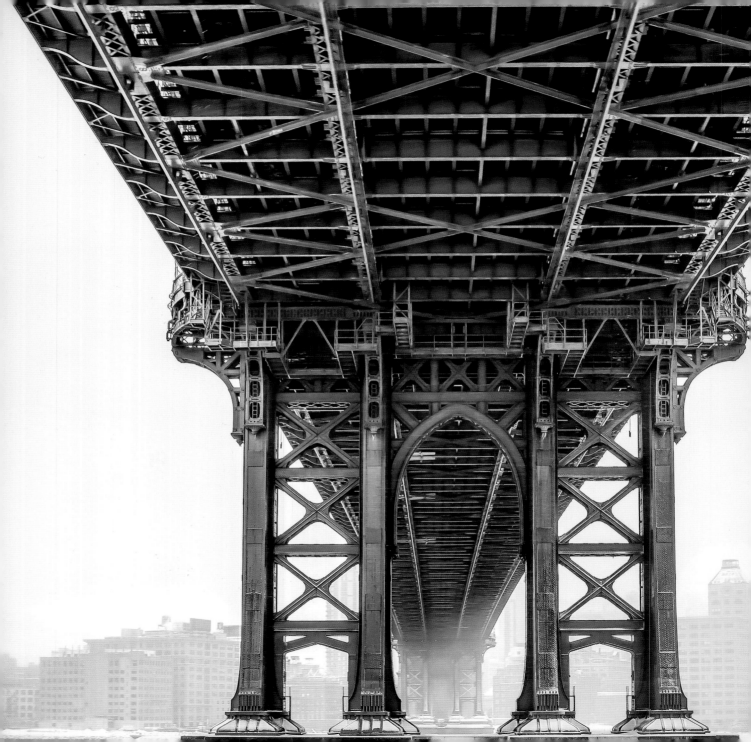

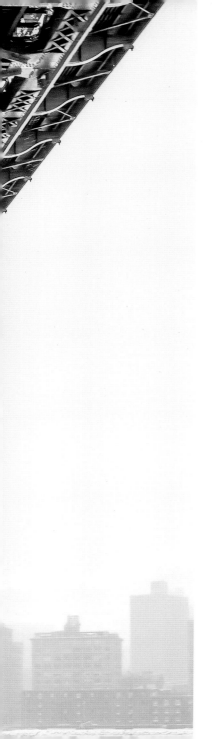

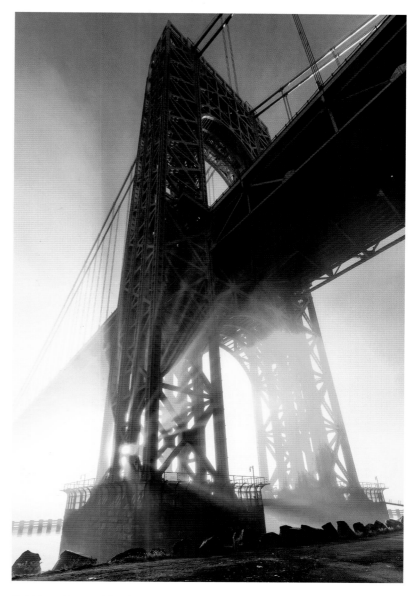

OPPOSITE: **@coryschlossimages**
Under the Manhattan Bridge—
captured from the backseat
of a moving taxi on the upper
deck of the FDR Drive.

ABOVE: **@beholdingeye**
Sunrise colossus, from
underneath the George
Washington Bridge.

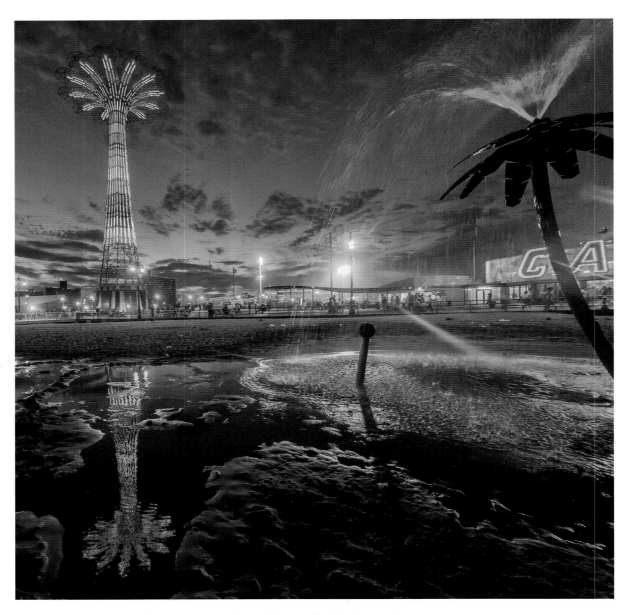

ABOVE: **@nyclovesnyc** The Parachute Jump at Coney Island, a Brooklyn landmark.
OPPOSITE: **@nyclovesnyc** A sea of humanity at Coney Island.

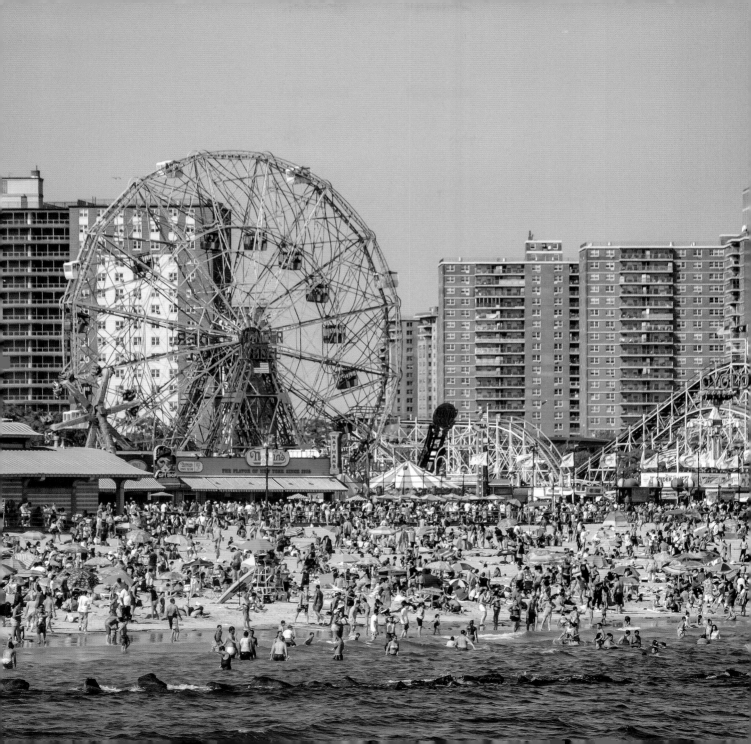

THIS PAGE, CLOCKWISE FROM TOP LEFT: **@garyhershon** Cool mist on a hot day in Brooklyn. **@garyhershorn** Sunset layup in Jersey City, NJ. **@nyclovesnyc** Bikers at the Battery Bosque's Spiral Fountain.

@garyhershon An ambitious mode of transportation during a blizzard.

OPPOSITE: **@nyclovesnyc** Sunset over the Unisphere in Flushing Meadows–Corona Park, Queens.

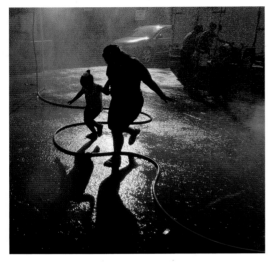

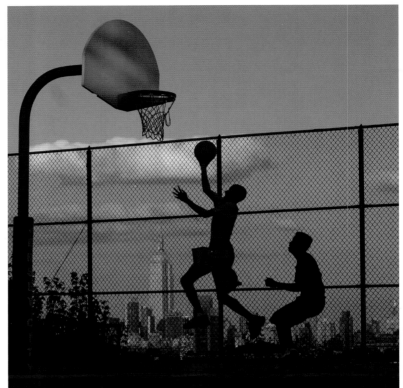

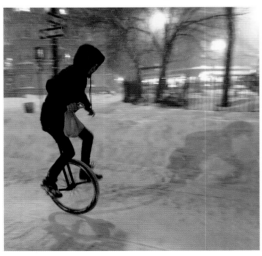

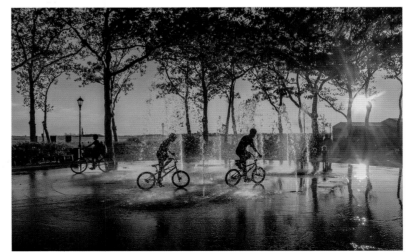

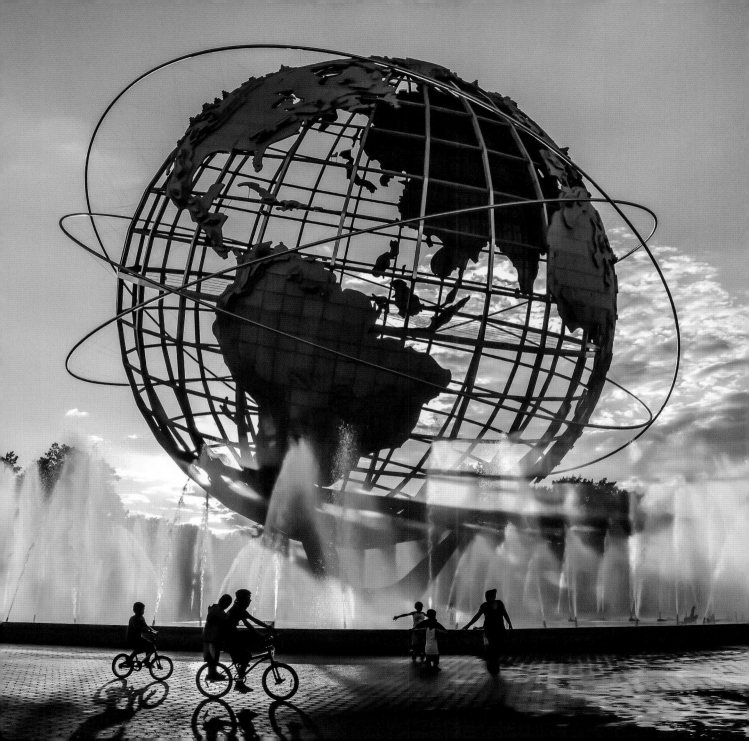

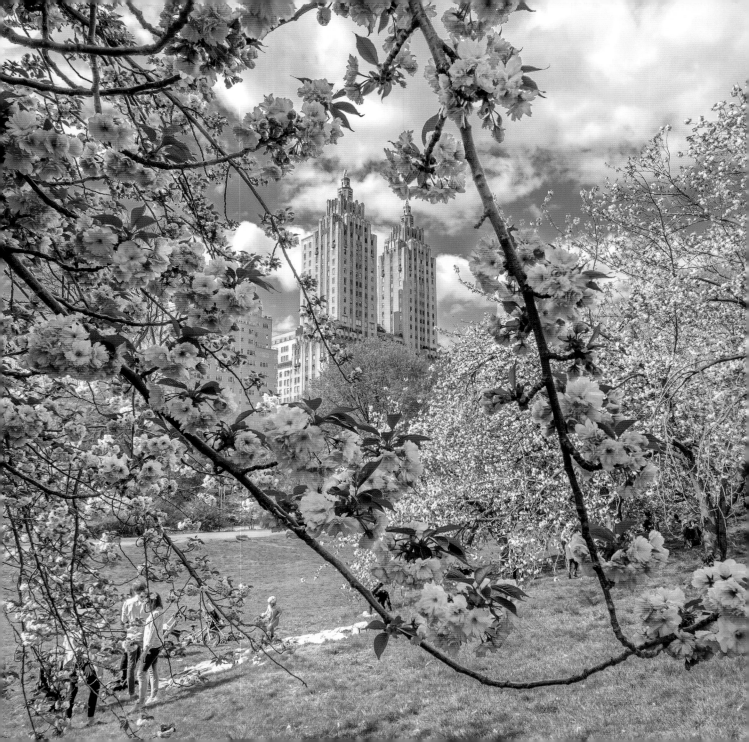

OPPOSITE: **@nyclovesnyc** Cherry blossoms in Central Park framing the towers of the landmark Eldorado building on the Upper West Side.

TOP: **@vincentjames-photography** Pear blossoms in front of the historic Alwyn Court building in Midtown.

BOTTOM LEFT: **@mc_gutty** Spring in full blossom on Roosevelt Island.

BOTTOM RIGHT: **@212sid** Cherry blossoms by the Flatiron Building.

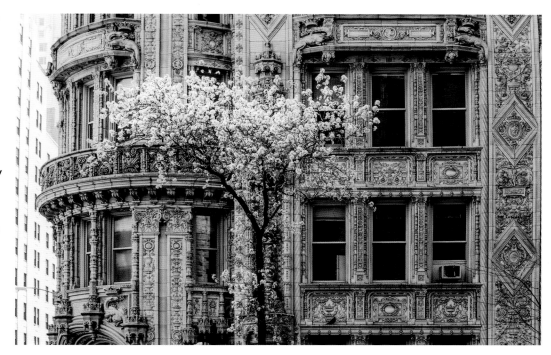

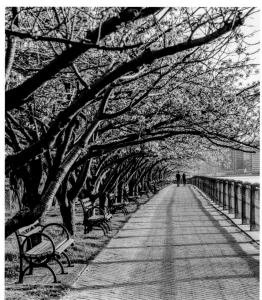

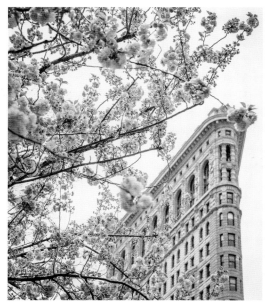

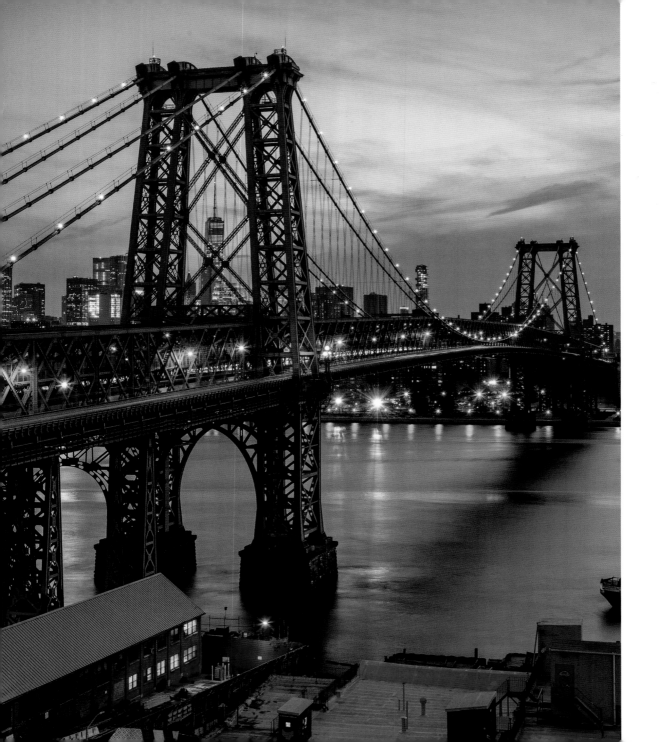

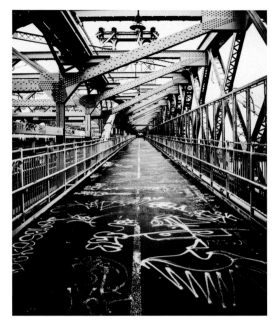

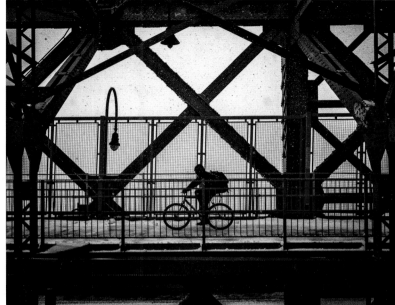

OPPOSITE: **@hindoben**
Overlooking the
Williamsburg Bridge
at "Blue hour."

ABOVE: **@m_bautista330**
Graffiti guides the way
on the Williamsburg
Bridge walkway.

TOP RIGHT:
@beholdingeye
Morning commute.

BOTTOM RIGHT:
@killianmoore
Passing trains during
a snowstorm.

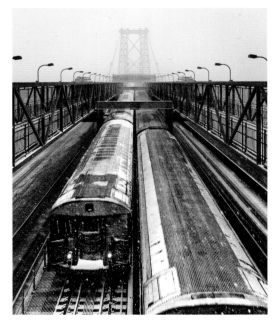

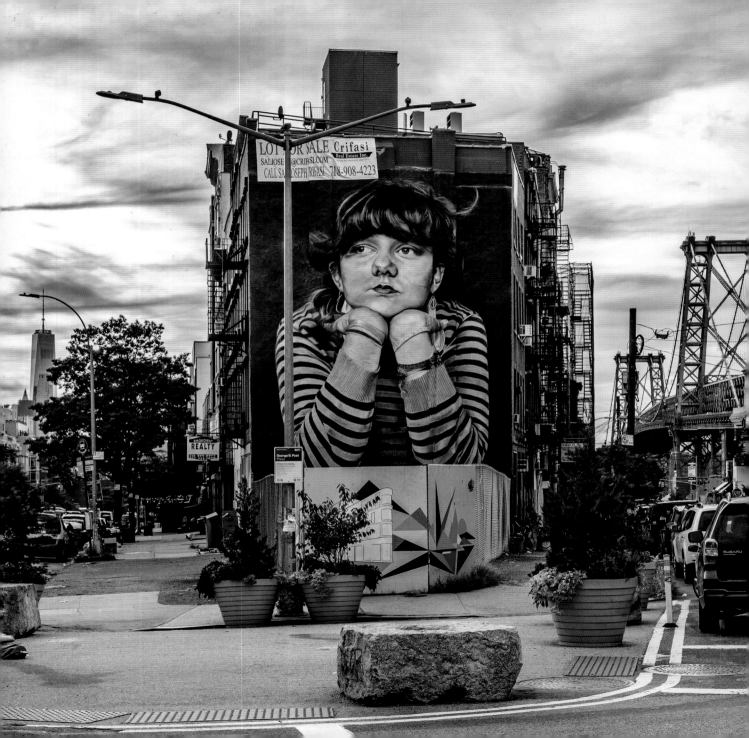

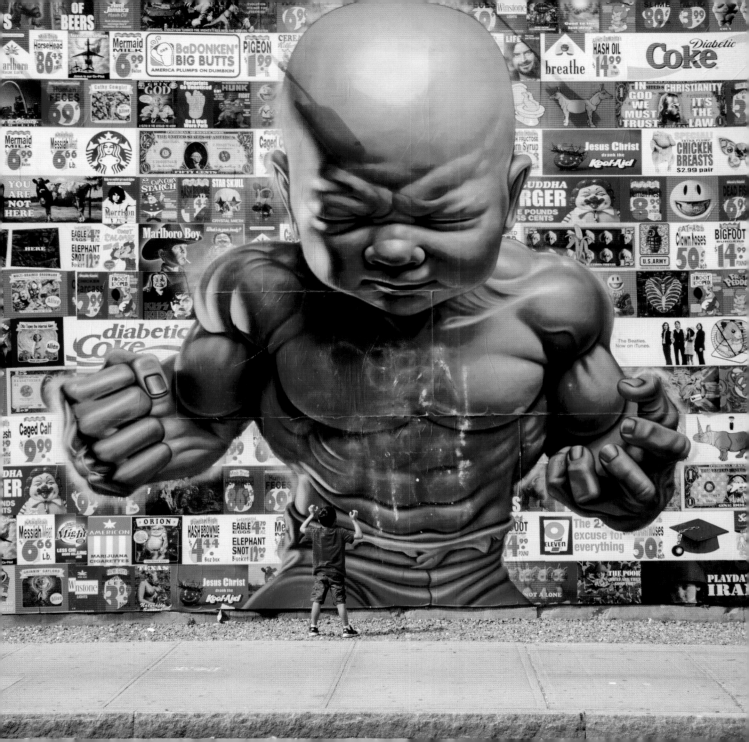

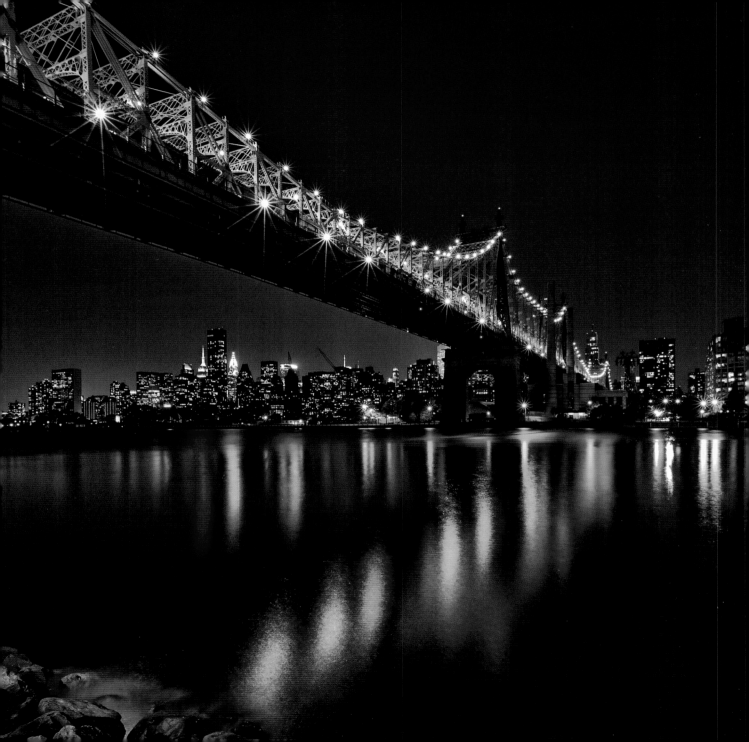

PRECEDING SPREAD:
(left) **@javan** *Lost Time*
mural by Colossal
Media & Steven Paul,
Williamsburg, Brooklyn.
(right) **@dankurtzman-
photography** Talking
back to *Temper Tot*,
mural by artist Ron
English, Bowery graffiti
wall, East Village.

OPPOSITE: **@beholdingeye**
The Queensboro Bridge
at dusk from the shores
of Roosevelt Island.

RIGHT: **@dubsonata**
Summer morning sky
erupting with color
over the Queensboro
Bridge.

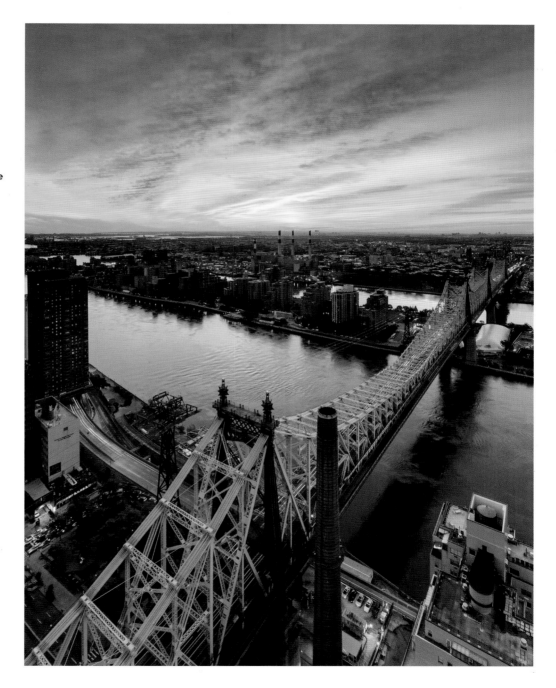

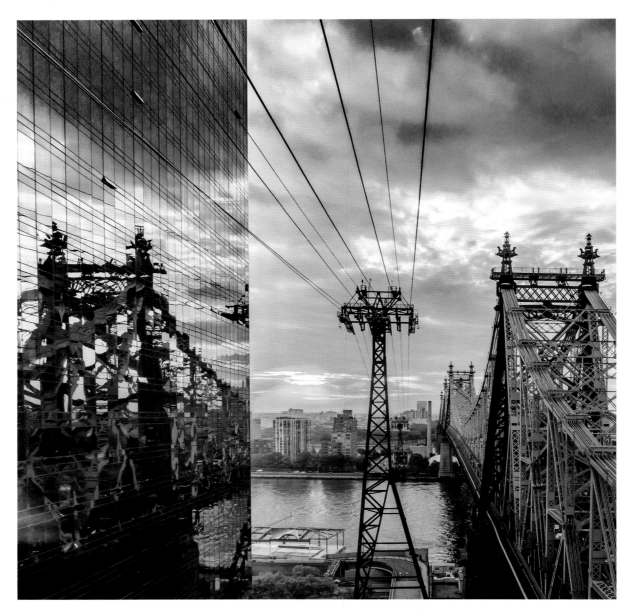

ABOVE: **@nyclovesnyc** Early morning view from inside the Roosevelt Island Tram.
OPPOSITE: **@mjininyc** Flying above Roosevelt Island after a winter storm.

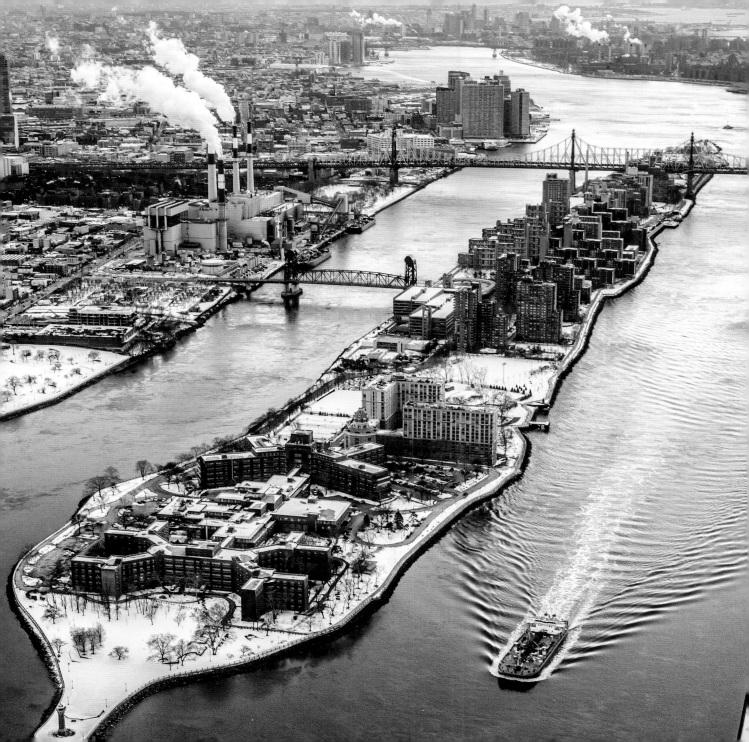

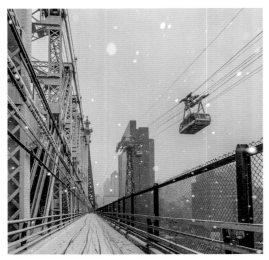

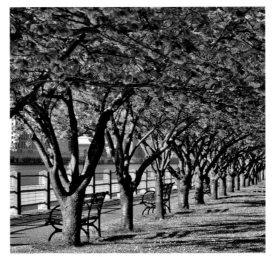

THIS PAGE, CLOCKWISE FROM TOP LEFT: **@nyclovesnyc** The Roosevelt Island Tram over a snowy Queensboro Bridge. **@gigi.nyc** Cherry blossoms along the East River on Roosevelt Island. **@dankurtzmanphotograpy** Autumn stroll on Roosevelt Island. **@milan2ny** Springtime cherry blossom petals on Roosevelt Island.

OPPOSITE: **@nyclovesnyc** The Roosevelt Island Tram above Second Avenue.

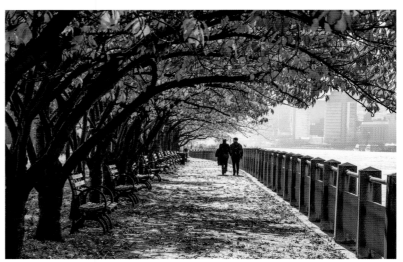

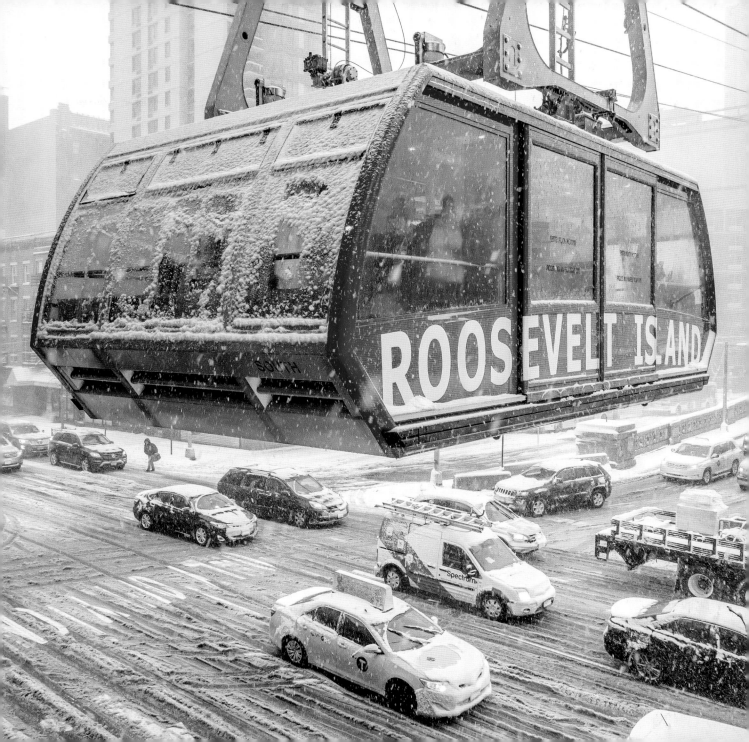

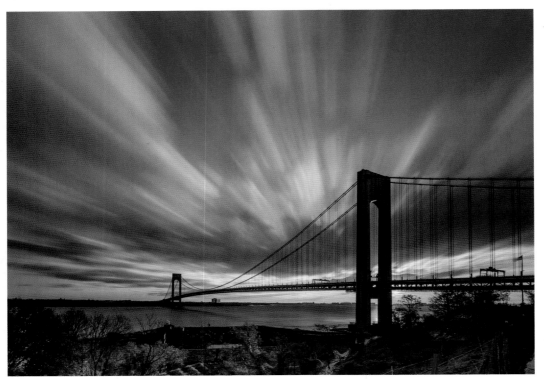

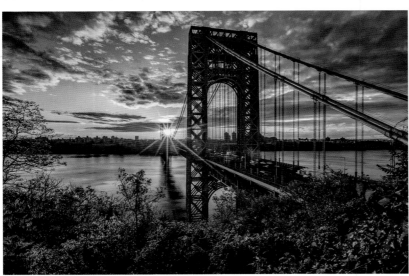

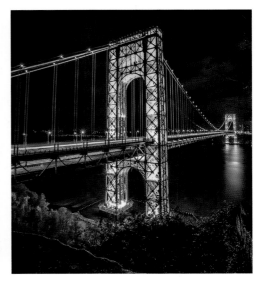

LEFT: **@dubsonata** A Staten Island view of sunrise over the Verrazano Bridge.

BOTTOM LEFT: **@beholdingeye** Sunrise at the George Washington Bridge, seen from Fort Lee, NJ.

BOTTOM RIGHT: **@jkhordi** The George Washington Bridge illuminated for Presidents' Day.

OPPOSITE: **@m_bautista330** The city's oldest standing bridge—High Bridge, connecting Manhattan to the Bronx.

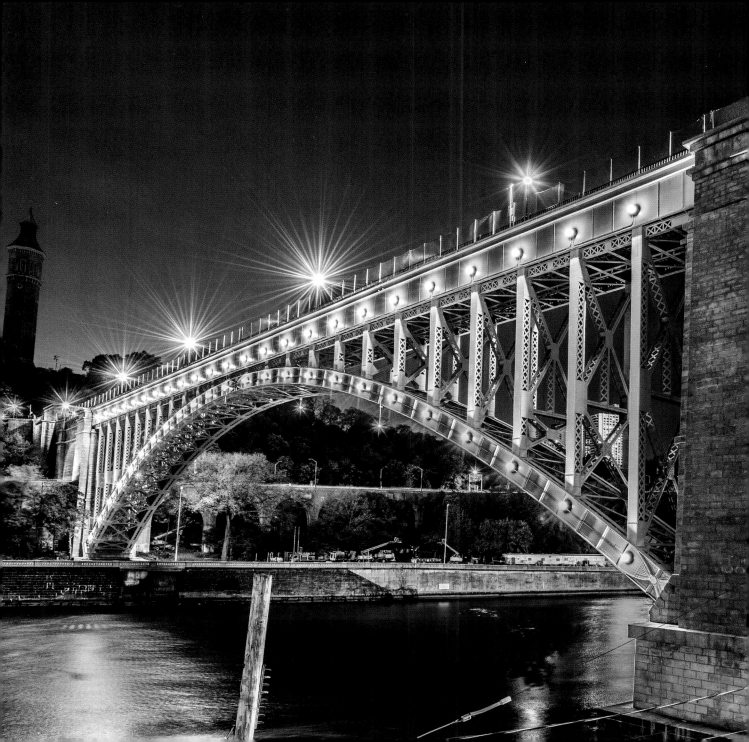

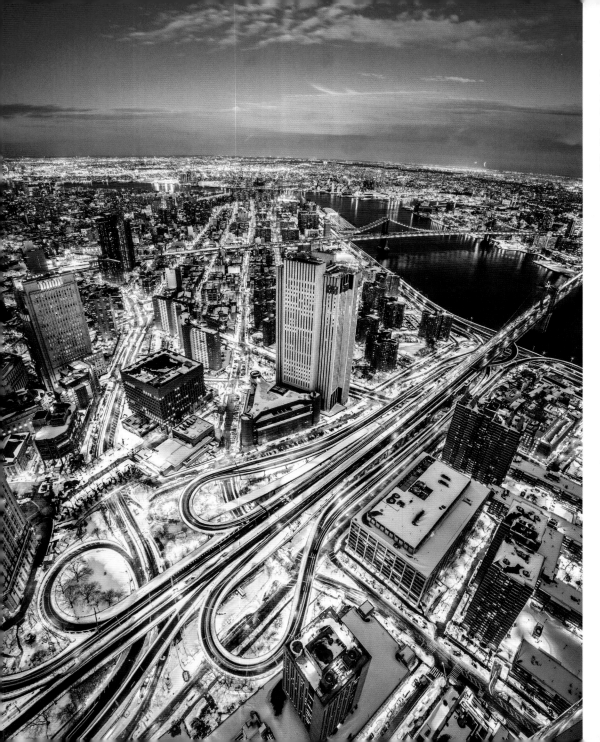

LEFT: **@mjinnyc**
Twilight view of Two Bridges and the East River after a blizzard.

OPPOSITE: **@mjinnyc**
Winter traffic over the George Washington Bridge.

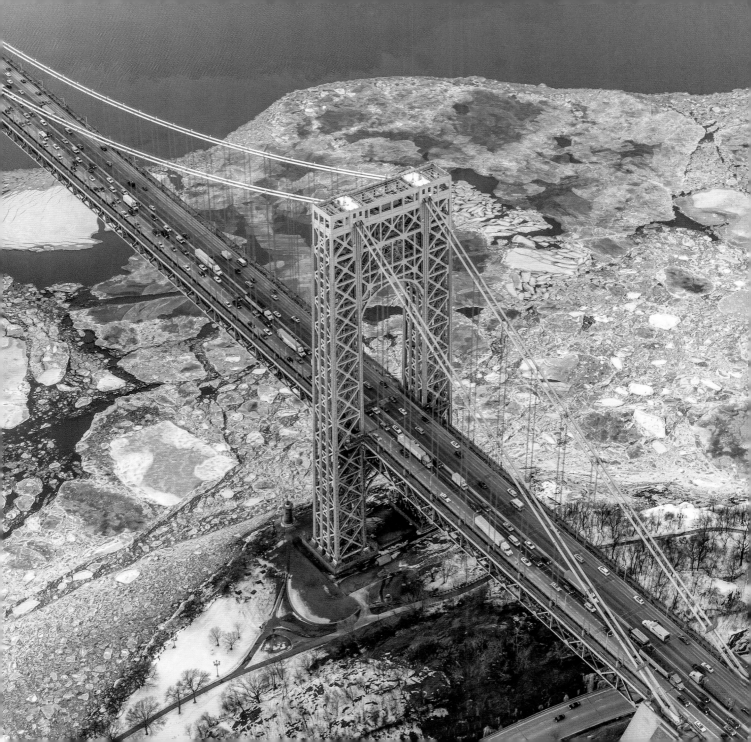

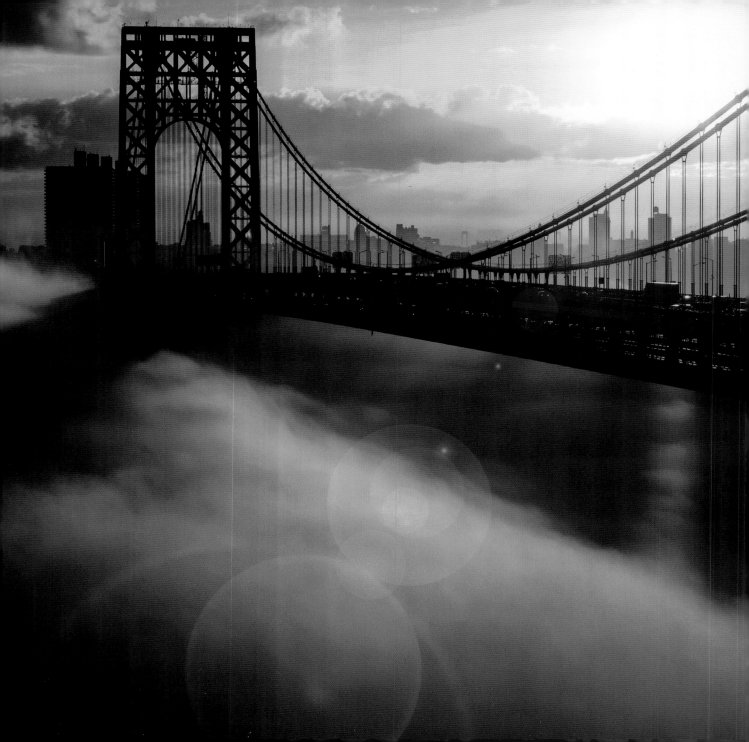

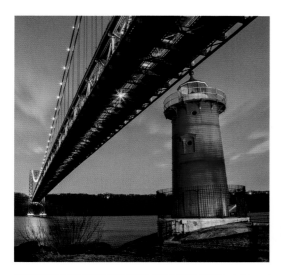

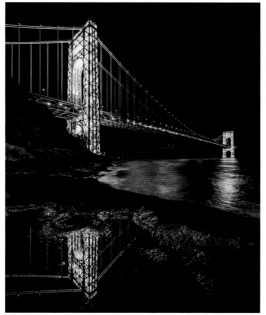

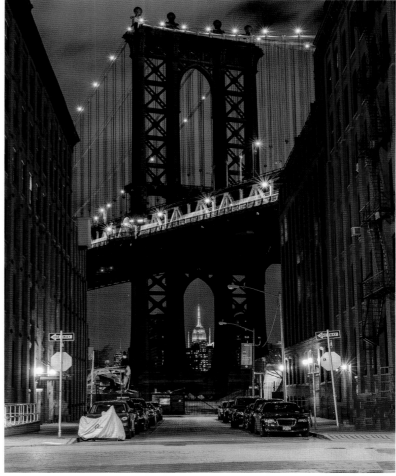

OPPOSITE: **@beholdingeye**
A once-in-a-lifetime sunrise "low fog event" at the George Washington Bridge.

TOP LEFT: **@matthewchimera-photography** The Little Red Lighthouse under the George Washington Bridge.

BOTTOM LEFT: **@gettyphotography**
The George Washington Bridge reflecting in the Hudson River.

ABOVE: **@gettyphotography** The Manhattan Bridge framing the Empire State Building on Washington Street in DUMBO, Brooklyn.

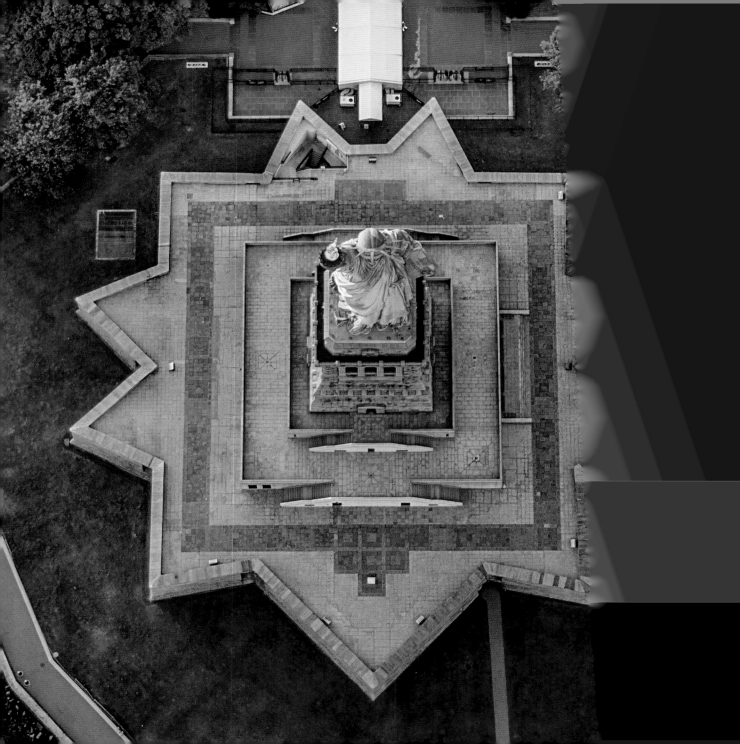

The Statue of Liberty from all angles.

OPPOSITE:
@i_am_lacombe Flying over the Statue of Liberty.

TOP LEFT: **@killianmoore** Lady Liberty and New York Harbor shimmering at "golden hour."

BOTTOM LEFT: **@nyclovesnyc** Cruising by Lady Liberty at sundown.

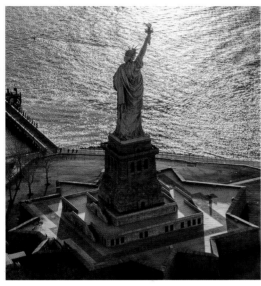

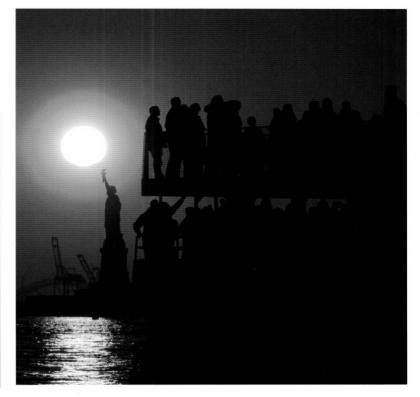

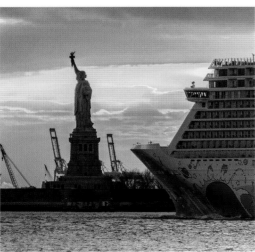

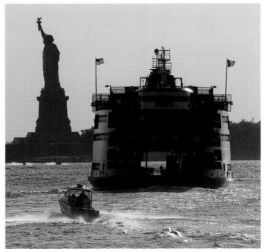

ABOVE: **@garyhershorn** Sunset at New York Harbor.

BOTTOM RIGHT: **@garyhershorn** The Staten Island Ferry's free ride past Liberty Island and its famous resident.

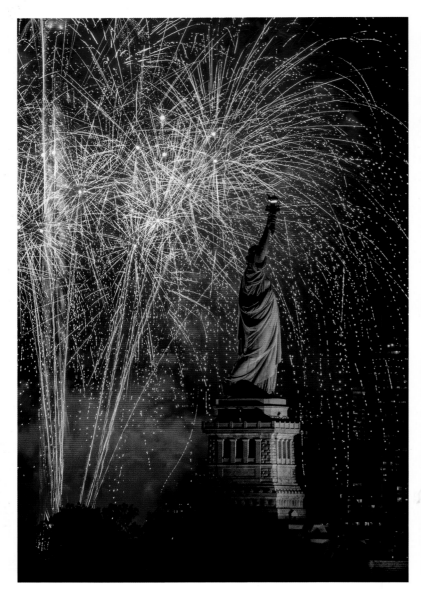

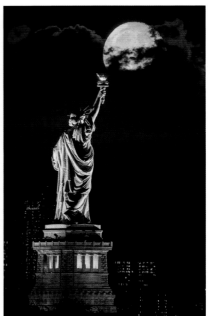

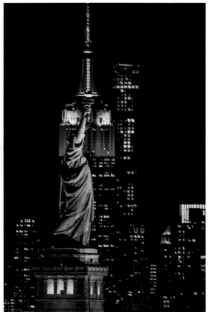

ABOVE: **@johnnyyonkers** Summer fireworks, from Jersey City, NJ.

TOP RIGHT: **@jkhordi** Full moon rising, from Jersey City, NJ.

BOTTOM RIGHT: **@jkhordi** Iconic alignment, from Bayonne, NJ.

OPPOSITE: **@jenirizarry** Sunrise from Liberty State Park, Jersey City, NJ.

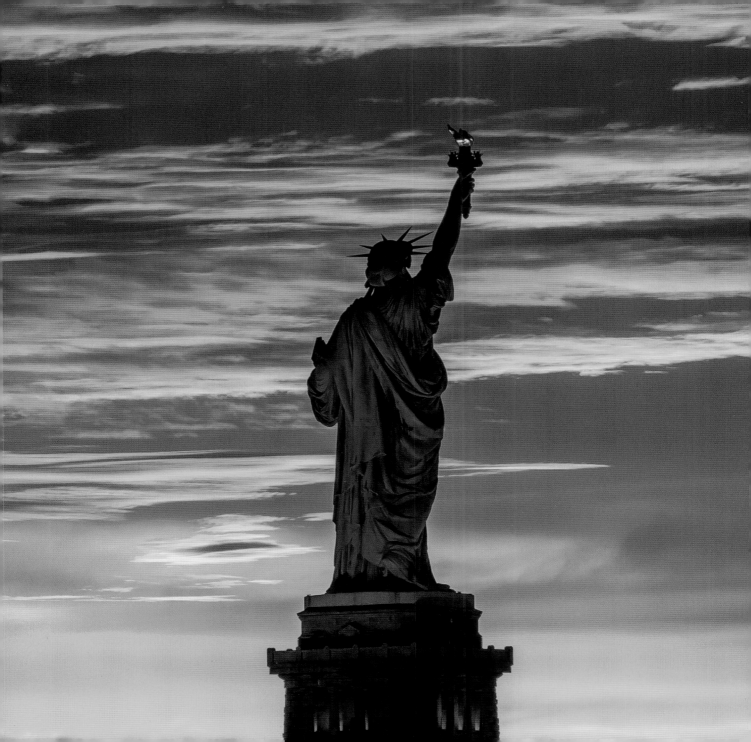

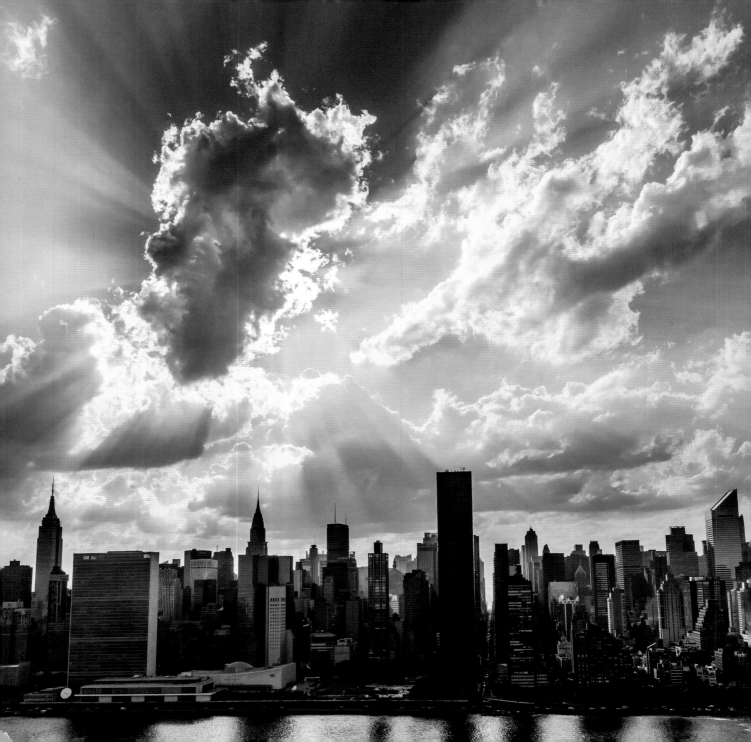

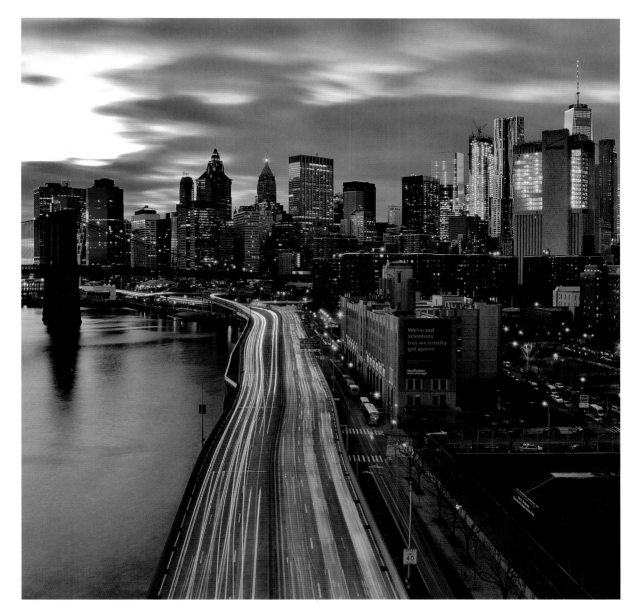

OPPOSITE: **@javan** A Long Island City view of the Manhattan skyline.
ABOVE: **@gigi.nyc** Overlooking the FDR Drive from the Manhattan Bridge.
FOLLOWING SPREAD: *(left)* **@dankurtzmanphotography** The Great Hall on Ellis Island.
(right) **@nyclovesnyc** A mural of immigrant children at Ellis Island, by JR, in Tribeca.

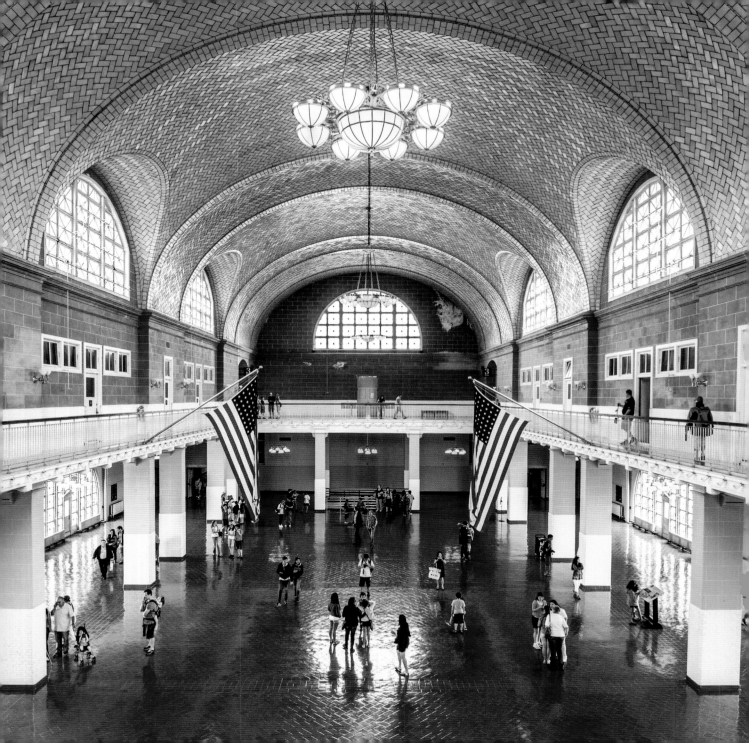

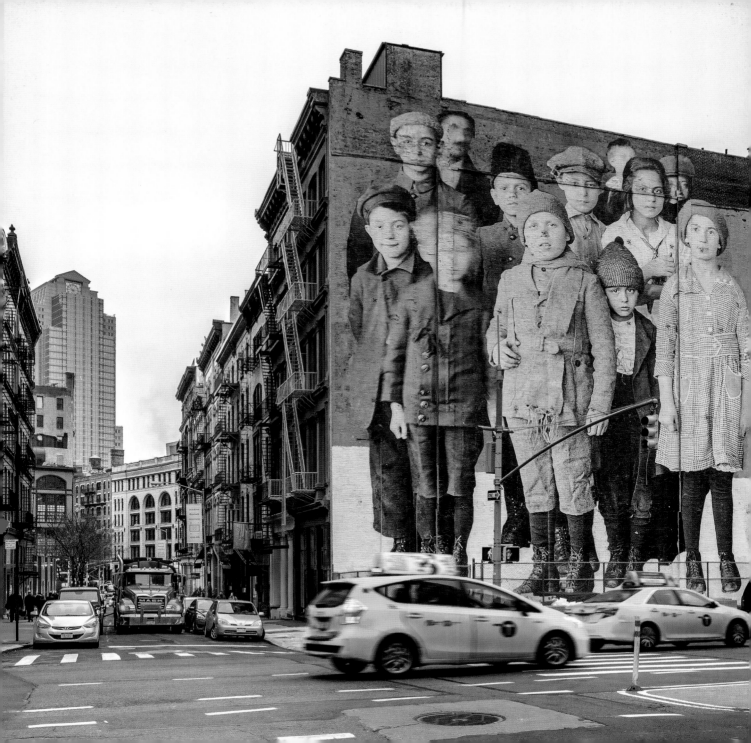

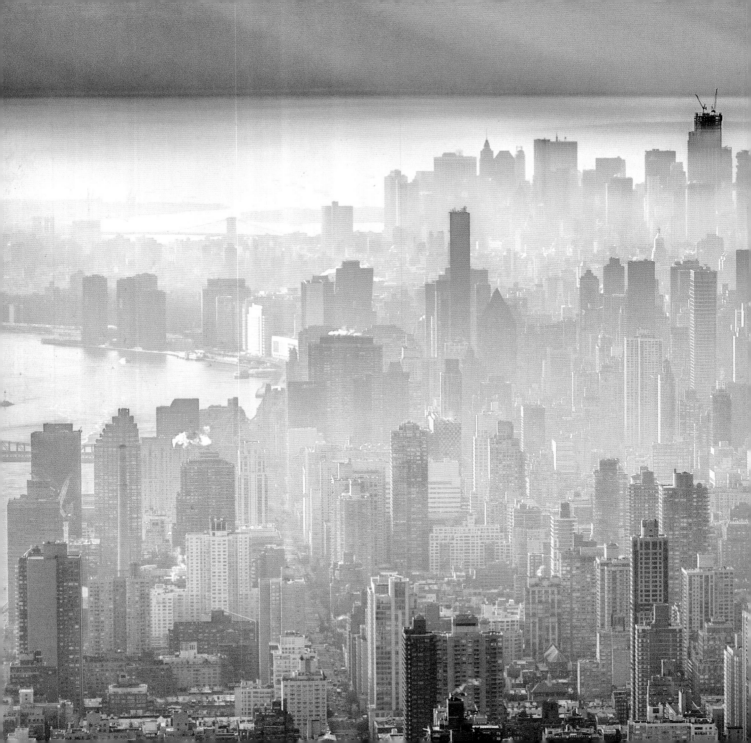

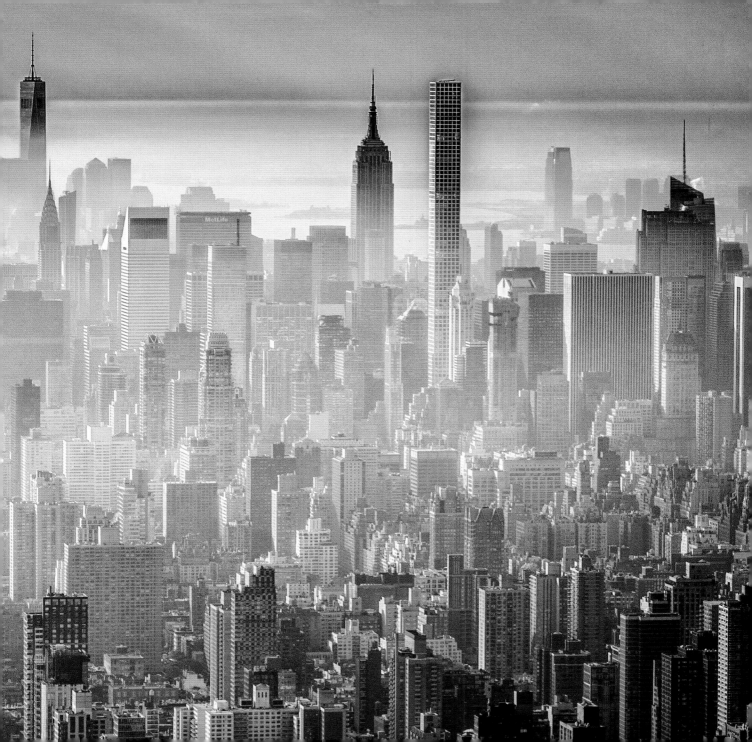

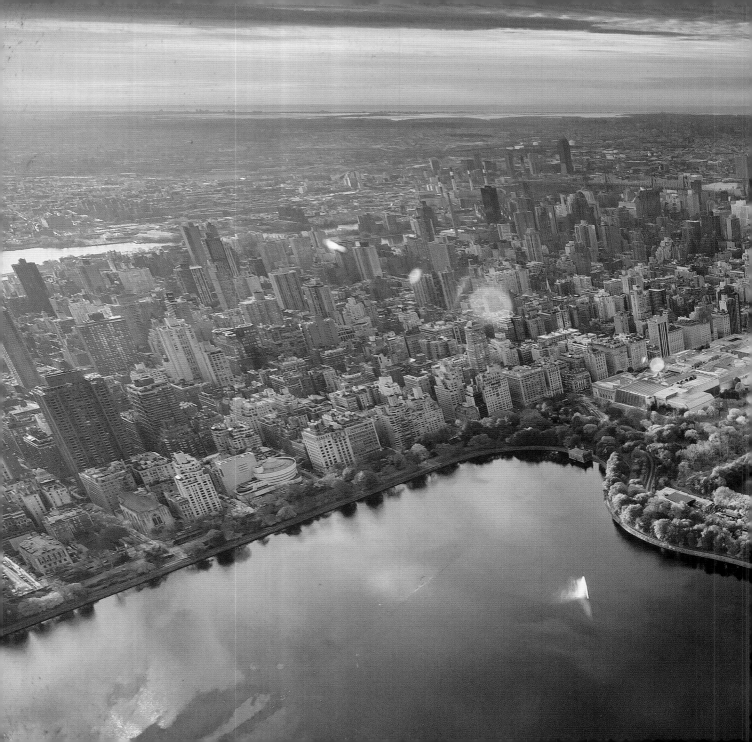

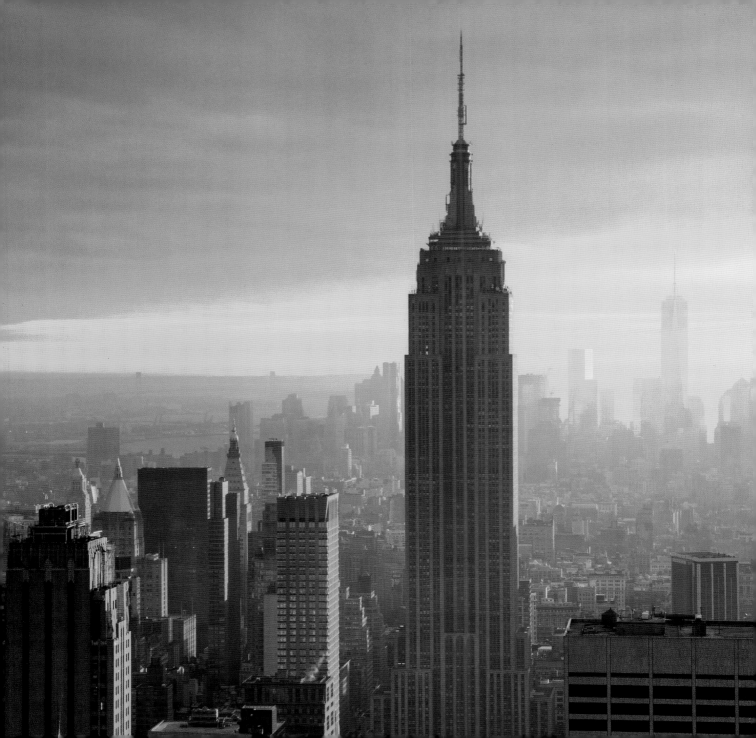

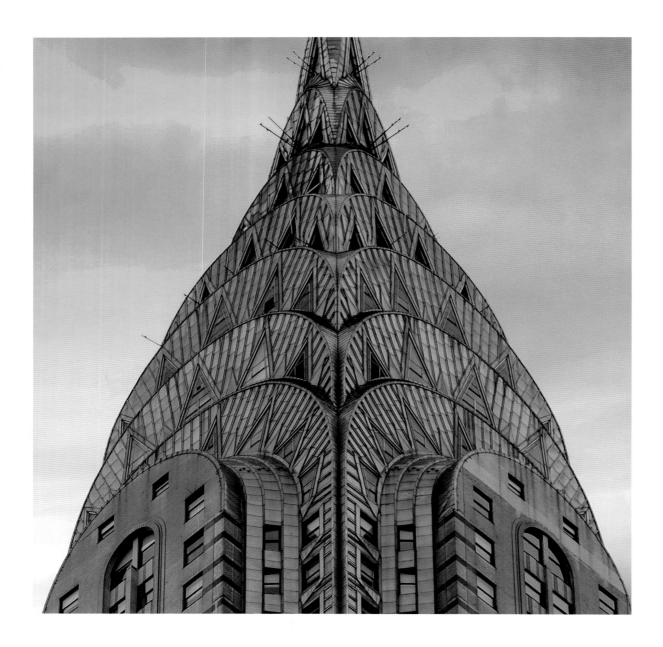

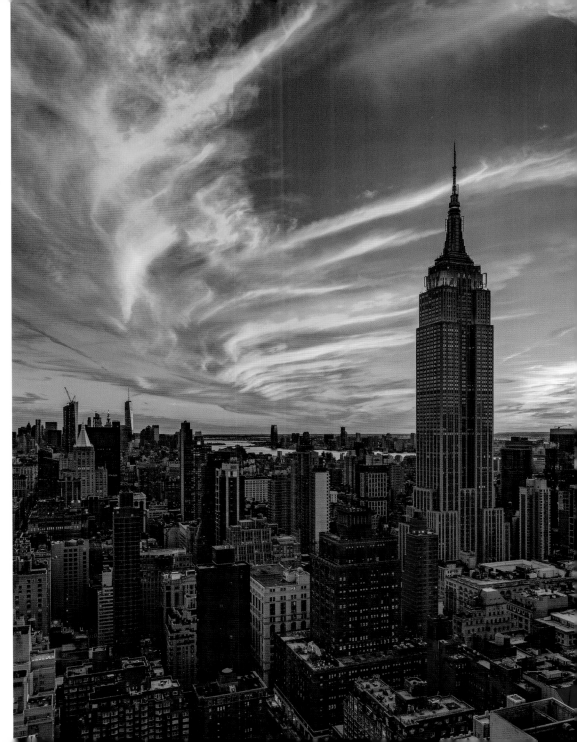

PRECEDING SPREAD: *(left)* **@johnnyyonkers** The Empire State Building and One World Trade Center, from the Top of the Rock. *(right)* **@dankurtzman-photography** Golden hour at the Top of the Rock.

OPPOSITE: **@i_am_lacombe** Sunset over the Chrysler Building.

RIGHT: **@gettyphotography** A fiery summer sunset seen from a Midtown rooftop.

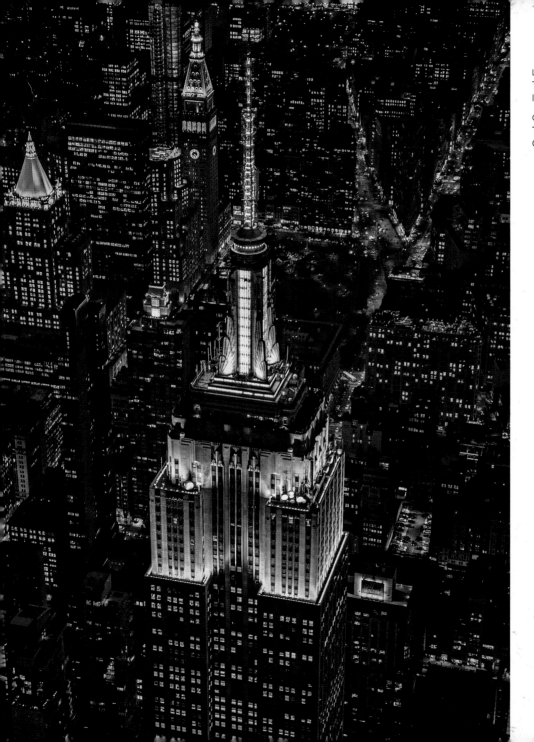

LEFT: **@2ndfloorguy**
The Empire State Building lighting the way.

OPPOSITE: **@2ndfloorguy**
The sparkling crown of the Chrysler Building.

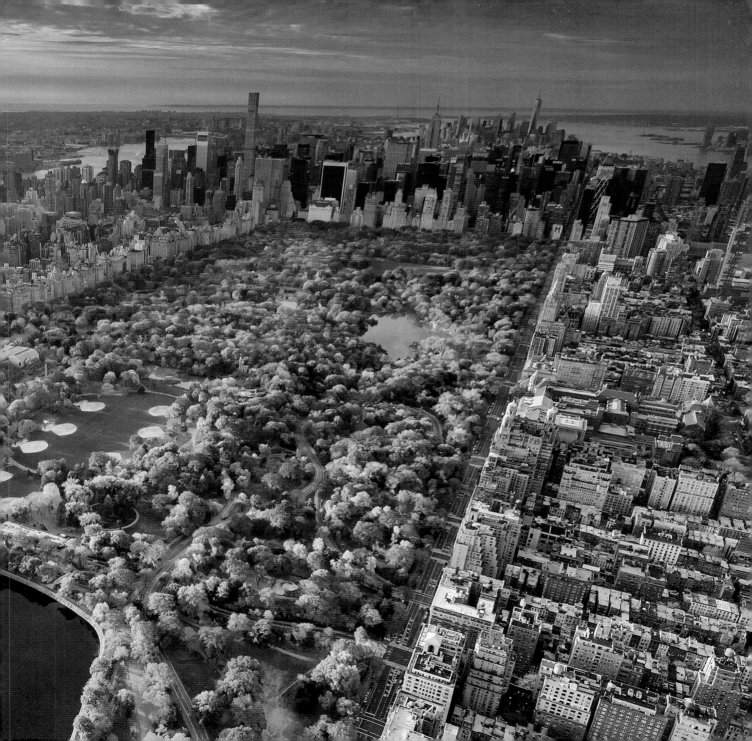

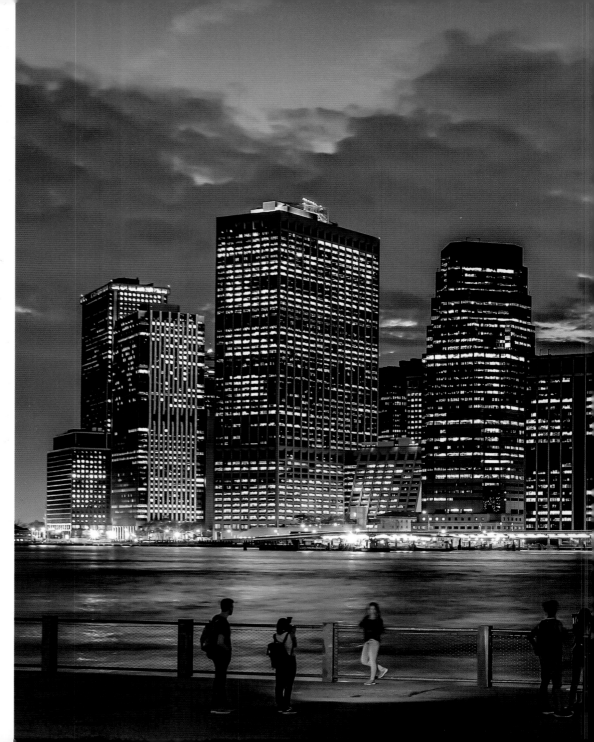

PAGES 194–95: **@mjinnyc**
Manhattan's skyscrapers rising above the morning haze.

PRECEDING SPREAD: **@bklyn_block** Soaring above Central Park on an autumn morning.

RIGHT: **@coryschlossimages** City lights flickering on at twilight from the Brooklyn waterfront.

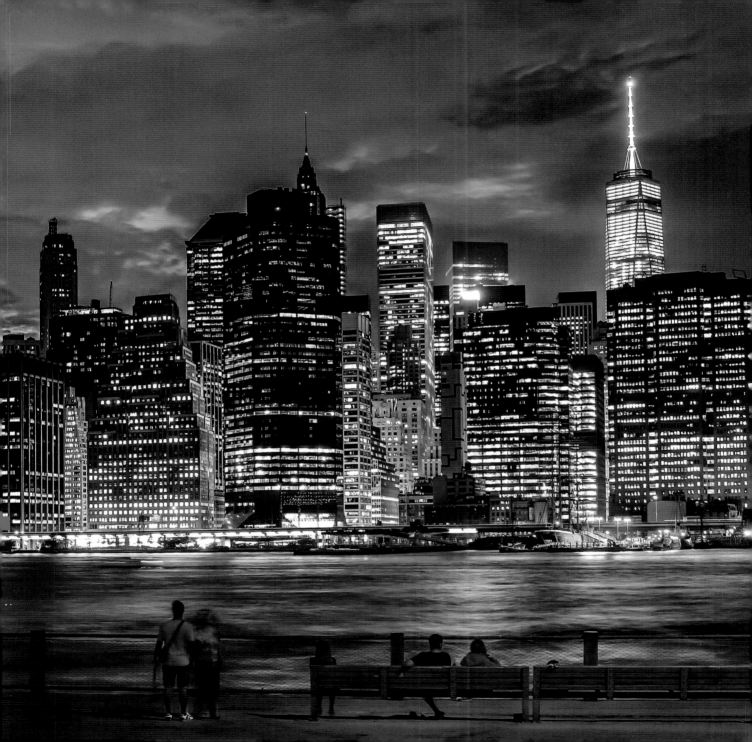

The 25 Most Instagram-Worthy Spots You Must See While in NYC

Here's a starting point for exploring and photographing the places that make New York City the world's most popular city on Instagram—from prime attractions like Times Square to lesser-known locations and vantage points that Instagram photographers return to time and again.

1. Times Square

One of the world's most popular Instagram spots, there is no better place to capture the bright neon lights and humming energy of the city that never sleeps. The "Red Steps" at the northern end of Times Square provide a great vantage point to take in the always lively scene.

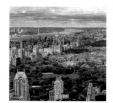

2. Central Park

Every corner of the park is picturesque, but must-sees include Bethesda Terrace, Bow Bridge, the Lake, the Pond, Gapstow Bridge, the Mall and Literary Walk, Sheep Meadow, the Reservoir, and the many pathways, arches, and rock outcroppings along the way.

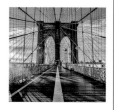

3. Brooklyn Bridge

Walking the pedestrian path on the Brooklyn Bridge offers striking views of the Manhattan skyline and up-close perspectives of the bridge and its steel suspension cables—particularly beautiful in late afternoon or early morning light.

4. Top of the Rock

Especially at sunset and twilight, Rockefeller Center's observation deck provides an unforgettable vantage point for sweeping views of the city, with the Empire State Building and One World Trade Center to the south and Central Park to the north.

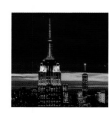

5. The Empire State Building

With its distinctive silhouette and ever-changing colorful lights, the city's most iconic landmark is perfect for street-level selfies, beautiful cityscapes, and citywide aerials from the observation deck.

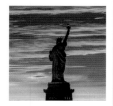

6. Statue of Liberty

New York's symbol of freedom and hope is best seen and photographed up close from Liberty Island or the Staten Island Ferry, or with a telephoto lens across the harbor from Brooklyn Bridge Park, Battery Park, or New Jersey's Liberty State Park and Harbor View Memorial Park.

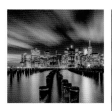

7. Brooklyn Bridge Park

The waterfront park along Brooklyn's East River offers glorious views of the Manhattan skyline, as well as the Brooklyn Bridge and Manhattan Bridge, especially as the city lights begin to gleam at twilight. The famous wooden pier pilings near the southern edge of Pier 1 are a favorite among photographers.

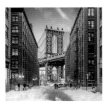

8. Washington Street in DUMBO, Brooklyn

The view down this famous cobblestone street is a New York classic. The old brick buildings perfectly frame the Manhattan Bridge, which in turn perfectly frames the Empire State Building below the lower arch of the bridge's tower.

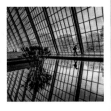

9. Metropolitan Museum of Art

Grand staircases, glorious ceilings, and a towering wall of windows make for striking images, particularly at the Temple of Dendur. The roof deck garden (open seasonally) has panoramic views looking across Central Park as well as photo-worthy contemporary art exhibits.

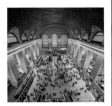

10. Grand Central Terminal

The most dramatic indoor space in the city, the main concourse is best viewed looking down from atop the steps on either side. During early morning hours at certain times of the year, beams of sunlight filter through the large windows to cast commuters in shadow.

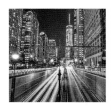

11. One World Trade Center

The 360-degree views atop the tallest building in the Western Hemisphere are awe-inspiring. The 1,776-foot tower is best photographed from the 9/11 Memorial, Fulton Street, above the Battery Park underpass, the North Cove Marina at Brookfield Place, or vantage points across the rivers.

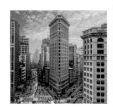

12. Flatiron Building

The elegant, wedge-shaped building at Fifth Avenue, Broadway, and 23rd Street is one of the most interesting landmarks to photograph, whether up close on street level or from different angles that show the convergence of traffic on the surrounding streets.

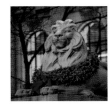

13. New York Public Library

New York Public Library's main branch, at Fifth Avenue and 42nd Street, is a stunning architectural landmark, highlighted by its historic Rose Main Reading Room, the beautiful arched corridors on the second floor, and the lion statues at its front steps.

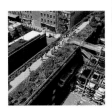

14. The High Line

This elevated, beautifully landscaped park was built atop an old rail line. Spanning twenty-two blocks from Hudson Yards to Chelsea, the High Line provides unique views of Manhattan's West Side.

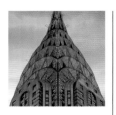

15. Chrysler Building

The Art Deco–style skyscraper is perhaps the most beloved among New Yorkers—and the most photogenic. Best ground-level vantage points are along 42nd Street across from Grand Central Terminal, the Tudor City Overpass, and Roosevelt Island.

16. Bryant Park

From an ice-skating rink and holiday shops in the park's winter village to yoga classes and movie nights in the summer, Bryant Park is an oasis for locals and tourists to relax and people-watch year round.

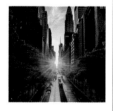

17. Tudor City and 42nd Street

Fantastic during all seasons, the view from the Tudor City Overpass looking west along 42nd Street takes on a special magic at sunset during the late spring and early summer, especially during "Manhattanhenge" (see page 204).

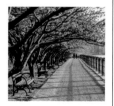

18. Roosevelt Island

For the price of a subway ride, the tram to Roosevelt Island offers spectacular elevated views of the city as it passes over the East River alongside the Queensboro Bridge. The island's promenade is especially beautiful in spring when the cherry blossoms bloom and in fall.

19. Manhattan Bridge Walkway

The Manhattan side of this bridge has great views overlooking the streets of Chinatown—most notably, East Broadway—and the vibrant graffiti on the nearby rooftops. Passing over the FDR Drive showcases a dramatic view of the downtown skyline.

20. Delmonico's

The most Gotham-esque corner in Manhattan can be found at the intersection of Beaver and William Streets in the Financial District, where this restaurant has stood since 1837. The landmark building photographs particularly well in rain or snow.

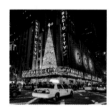

21. Rockefeller Center and Radio City Music Hall

Here the architecture, sculpture, and murals keep photographers clicking, as well as the famous Christmas tree and ice-skating rink. Nearby Radio City Music Hall, with its neon marquee spanning a full city block, makes for the quintessential snapshot.

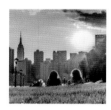

22. Gantry Plaza State Park

This gorgeous park in Long Island City has views looking across the East River at the Manhattan skyline. The sun sets behind the city from this vantage point, making it another popular viewing spot during the annual "Manhattanhenge" sunset alignment (see page 204).

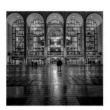

23. Lincoln Center

The plaza at Lincoln Center is particularly magical at nighttime in the glow of the illuminated buildings, highlighted by the Metropolitan Opera House with its soaring windows. The choreographed water and light shows of Revson Fountain create a lovely backdrop for silhouettes.

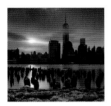

24. Hudson River Waterfront in New Jersey

Some of the best views of the Manhattan skyline are along the Hudson River Waterfront Walkway: the northern end of Liberty State Park, the Exchange Place boardwalk in Jersey City, and Pier C Park on Sinatra Drive in Hoboken.

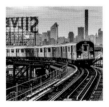

25. New York Subway and Transportation Hubs

Subway stations, platforms, and passageways are photo destinations unto themselves. The most popular include the Oculus in the World Trade Center Transportation Hub, Fulton Center, the Second Avenue subway, 34th Street–Hudson Yards, Ninth Street PATH Station, Queensboro Plaza, Coney Island–Stillwell Avenue, and the abandoned City Hall station (which can be visited on tours through the New York Transit Museum).

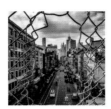

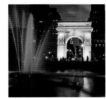

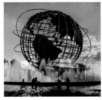

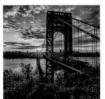

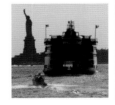

And Even More Favorite Spots

Manhattan

- 42nd Street in Times Square
- Battery Park
- **Chinatown**
- The Cloisters
- Hudson River Park
- Morgan Library & Museum
- Solomon R. Guggenheim Museum
- Staple Street Skybridge
- Stone Street
- Two Bridges
- **Washington Square Park**

The Outer Boroughs

- Brooklyn Botanic Garden
- Bushwick Collective, Brooklyn
- **Coney Island, Brooklyn**
- Hunter's Point South Park, Queens
- New York Botanical Garden, The Bronx
- Prospect Park, Brooklyn
- **The Unisphere, Flushing Meadows–Corona Park, Queens**
- Yankee Stadium, The Bronx

Points In Between

- Ellis Island
- **George Washington Bridge**
- Governors Island
- Manhattan Bridge
- Queensboro Bridge
- **Staten Island Ferry**
- Verrazano–Narrows Bridge
- Williamsburg Bridge

And Points Beyond

- Belmar Fishing Pier, Belmar, NJ
- Fort Lee Historic Park, Fort Lee, NJ
- Hamilton Park, Jersey City, NJ
- Lefrak Point Lighthouse, Jersey City, NJ
- Liberty State Park, Jersey City, NJ
- Montauk Point Lighthouse, Montauk, NY
- New Croton Dam, Cortlandt, NY
- Ross Dock Picnic Area, Fort Lee, NJ
- Sleepy Hollow Lighthouse, Sleepy Hollow, NY

The 10 Most Instagram-Worthy Events You Must Experience While in NYC

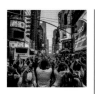

1. Manhattanhenge
This solar phenomenon occurs twice a year around May 30 and July 12, when the setting sun lines up with the Midtown grid and bathes the streets in amber and gold. The best viewing spots are 14th, 23rd, 34th, 42nd, and 57th Streets.

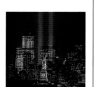

2. Tribute in Light
Lit every year in honor of the anniversary of September 11, these monumental beams of light are visible across the five boroughs.

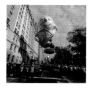

3. Macy's Thanksgiving Day Parade
Early birds get the perfect views along the parade route—but a bird's-eye view from a window or rooftop is also photo-worthy.

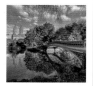

4. Fall in Central Park
Perfectly framing the park's photogenic bridges, arches, and meadows, the fall colors in this urban oasis usually peak between late October and early November.

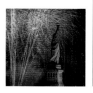

5. 4th of July Fireworks
The city's waterfront and rooftops have the most spectacular views of the fireworks bursting over the city's skyline.

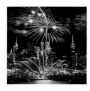

6. Chinese New Year Parade and Fireworks
Manhattan's Chinatown, Sunset Park, Brooklyn, and Flushing, Queens, have exuberant celebrations at the lunar new year (between January 21 and February 20).

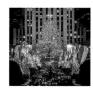

7. Rockefeller Center Christmas Tree Lighting
Framed by golden angels and beautiful architecture, this festive ceremony lights up the holiday season at Midtown's Rockefeller Center.

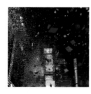

8. Times Square New Year's Eve
Brave the crowds and cold for an epic way to ring in the New Year—from the countdown and colorful pyrotechnics to confetti-strewn streets. Fireworks can also be seen over New York Harbor, Central Park, Prospect Park, and Coney Island.

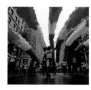

9. Gay Pride Parade
The city is awash with rainbow colors during the annual LGBT Pride parade at the end of June. The celebration culminates with a spectacular fireworks display over the Hudson River.

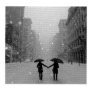

10. Any snowstorm that blankets the city!
A snowfall can magically suspend the usual bustle of the city, when parks, streets, and even Times Square turn into a winter wonderland.

Contributors

This book celebrates the work of an array of talented photographers who are dedicated to capturing the vibrancy and energy of New York City on Instagram. And like "the city that never sleeps," they're still out there 24/7, photographing incredible sights and sharing their work with ever more followers. Check out their websites, portfolios, and prints—and, of course, follow them on Instagram!

@212sid Sidney Chua moved to Manhattan from Singapore almost twenty years ago to attend New York University, followed by a career in finance. He took up photography to document his love for travel and New York City, and has now visited nearly every continent.
Photo credits: pages 47, 54, 65, 90, 102, 120, 124, 169, 204 (no. 7).

@2ndfloorguy Randy Haron is a photographer, adventurer, and avid aerial enthusiast based in California. Known for his "doors-off" helicopter flights and epic landscapes, Randy showcases the natural beauty in everyday wonders.
Photo credits: pages 22, 23, 33, 87, 99, 133, 143, 201 (no. 12).

@b911bphoto Brayan Casas is a New York City–based hobbyist photographer who loves to play tourist in his hometown. He is passionate about all types of photography. www.bhcphotography.com.
Photo credits: pages 107, 127, 142.

@beholdingeye Paul Seibert is an New York City area–based photographer who strives to inspire with his work and to capture extraordinary images in any setting—from weddings and headshots to aerial and cityscape photography. www.paulseibertphotography.com.
Photo credits: pages 13, 25, 26, 35, 38, 51, 88, 127, 150, 152, 163, 171, 174, 180, 184, 203 (right-hand column, fifth from top), 204 (no. 6).

@bklyn_block Nadia Block is a Brooklyn-based artist whose photography was originally a starting point for her landscape and pet paintings, but now photography is her creative expression. www.nadiablockphotography.com.
Photo credits: pages 74–75, 158–59, 196–97.

@chief770 Brian Koch has worked for over twenty-five years in New York City commercial real estate operation and enjoys the artistic outlet that photography provides as a hobby.
Photo credits: pages 32, 44, 47, 96, 108, 128, 131, 135, 140.

@clearbluskyes Sarah Carroll, originally from Nashville, began to further her love of photography when she moved to New York City, where she enjoys capturing cityscapes, iconic sights, and glimpses of urban life. www.clearbluskyes.com.
Photo credits: pages 83, 125, 129, 132.

@coryschlossimages Cory Schloss is a crude oil trader, self-taught photographer, and native New Yorker who specializes in capturing city landscapes and scenery, as well as portraiture. www.coryschlossimages.com.
Photo credits: pages 36, 78, 86, 130–31, 136, 154, 160, 162–63, 198–99, 200 (no. 2).

@dankurtzmanphotography Dan Kurtzman is a freelance photographer and photo-

graphy book editor based in San Francisco, specializing in landscape and travel photography. As creator of the popular Instagram hubs @wildnewyork, @wildbayarea, and @wildcalifornia_, he has worked to build community and bring together talented artists on both coasts. www.dankurtzman.com.
Photo credits: pages 14, 15, 17, 19, 37, 55, 61, 77, 94–95, 96, 97, 98, 101, 104, 106, 109, 126, 133, 138–39, 148, 161, 173, 178, 192, 200 (nos. 1, 5), 201 (no. 9), 202 (nos. 17, 21), 203 (right-hand column, top)

@dantvusa Dan Martland (aka English Dan) is a broadcast television cameraman living and working in New York City, whose real passion lies in photography. www.dantv.co.
Photo credits: pages 29, 39, 45, 105, 133, 146, 204 (no. 2).

@dario.nyc Dario Lopez is an amateur photographer from Paraguay who has been living and working in New York City for the past twenty-five years.
Photo credits: pages 93, 148.

@dubsonata Christopher Markisz is a photographer from New York City living in the San Francisco Bay Area, specializing in content creation, private instruction, and event coverage. www.christophermarkisz.com.
Photo credits: pages 8, 28, 112, 175, 180.

@fatiography Fatima RK is an advertising veteran and freelance media strategist based in New York City who shoots mainly

portrait/street photography for clients around the world.

Photo credits: pages 32, 42, 146, 202 (no. 20).

@garyhershorn Gary Hershorn is a former Reuters photojournalist who now freelances as a photographer and photo editor based in New York City. www.garyhershorn.com.

Photo credits: pages 13, 46, 47, 59, 134, 166, 187, 203 (right-hand column, bottom), 204 (no. 3), 204 (no. 9).

@gettyphotography Bruce Getty is a New York native and California transplant whose expertise and love for cityscape and landscape photography shows in all his work. A talented and passionate artist and photographer, he is known for capturing unique perspectives and for teaching his methods to many aspiring photographers.

Photo credits: pages 10, 21, 27, 185.

@gigi.nyc Gigi Altarejos is a photography enthusiast with a passion for sharing what she sees during weekend walks around New York City and its parks. www.giginyc.net.

Photo credits: pages 58, 66, 76, 79, 93, 106, 117, 124, 148, 178, 191, 200 (no. 4), 202 (no. 19), 204 (no. 8).

@gmathewsva George Mathew is a brand design strategist, serial entrepreneur, and passionate photographer, originally from the land of elephants and tigers, now residing in the concrete jungle that's New York City.

Photo credits: pages 56, 70, 92, 157, 201 (10).

@gmp3 Gerry is a New York City–based photographer who is passionate about capturing the energy of the city through his eyes as he focuses on urban landscape and street photography.

Photo credits: pages 44, 64, 89, 95, 111, 112.

@golden2dew Zahava is a vice-president in the banking world whose life's passion is storytelling through photography and travel, with a specialization in street photography. She particularly enjoys capturing moments on the streets of Manhattan neighborhoods such as SoHo and the West Village.

Photo credits: pages 38, 65, 114, 115, 123.

@hinboben Hind Ben is a New York–based photographer who enjoys chasing puddles, reflections, staircases, and unique perspectives of old and new buildings in the city—especially the Empire State Building, her greatest love.

Photo credits: pages 41, 60, 81, 114, 170.

@i_am_lacombe David LaCombe is a New York City–based photographer specializing in aerial and travel photography.

Photo credits: pages 20, 73, 82, 96, 151, 186, 201 (no. 13), 202 (no. 15).

@javan Javan Ng is a self-taught photographer from Singapore who focuses mainly on urban photography as well as portraits and fashion. www.javanng.com.

Photo credits: pages 16, 24, 44, 60, 63, 71, 72, 112, 146, 172, 190, 202 (no. 22), 203 (no. 25).

@jenirizarry Jennifer Irizarry is an emergency medicine physician assistant and native New Yorker who spends her free time capturing all things New York. www.myjoiphotos.com.

Photo credits: pages 49, 189, 200 (no. 6).

@jkhordi Jennifer Khordi is an IT professional originally from New York City living in New Jersey who does photography in her spare time and enjoys teaching workshops. She specializes in moon, Milky Way,

helicopter, storm, and NYC skyline shots. www.khordiphotography.com.

Photo credits: pages 12, 30–31, 112, 113, 144–45, 158, 180, 188, 203 (no. 24).

@johnnyyonkers John Bacaring is a New Jersey photographer whose passion for photography allows him to tell a story through his images and to capture moments in time that create memories. www.bacaringart.com.

Photo credits: pages 13, 18, 28, 50, 114, 188, 204 (no. 5).

@kaaren_citaa Karen V. Peralta discovered her love and passion for photography through Instagram. Based in the San Francisco Bay Area, she enjoys capturing landscape, macro, and wildlife, and discovering new wonders through her photographic adventures.

Photo credit: page 79.

@killahwave Jamie Huenefeld is a photographer based in New York City, specializing in landscapes and live music. Creator of the popular Instagram community hubs @ig_nycity and @ig_unitedstates_. killahwave.smugmug.com.

Photo credits: pages 29, 34, 104, 123, 131, 201 (no. 11).

@killianmoore Killian Moore, originally from Ireland, provides a glimpse into the life of an average New Yorker with images that are anything but average.

Photo credits: pages 50, 53, 103, 110, 141, 171, 187.

@matthewchimeraphotography Matthew Chimera is a media professional who loves to explore New York with his camera.

Photo credits: pages 10, 47, 68, 83, 84, 85, 93, 100, 103, 121, 123, 142, 154, 185, 203 (right-hand column, second from top).

@m_bautista330 is a New Yorker, originally from the Dominican Republic, with a deep passion for photography. His creative approach shows in the way he captures cityscapes and life in the Big Apple. Creator of the popular Instagram hub @weekly_feature.

Photo credits: pages 40, 80, 171, 181.

@mc_gutty Mike Gutkin is a stem-cell research scientist and freelance photographer based in New York City. Mike's warm and vibrant style follows him through the city streets and abroad on his local and international travels.

Photo credits: pages 86, 153, 169, 200 (no. 3), 202 (no. 18).

@mfln.nyc Mark Feliciano is a photography enthusiast living in New York City who enjoys capturing street scenes and glimpses of city life from unique perspectives. Founder of the popular Instagram community hub @icapture_nyc.

Photo credit: page 41.

@midnight.xpress is a New York–based explorer who likes to photograph the unseen places of the city, such as subway tunnels, sewers, bridges, and skyscrapers.

Photo credits: pages 29, 52, 67, 133.

@milan2ny Milan Calangi is a photography enthusiast from Milan, Italy, now living in New York, who loves traveling and has her heart set on discovering the world through lenses. Flickr.com/milan2ny.

Photo credits: pages 10, 69, 146, 178.

@mjinnyc is a self-taught photographer from Portland, Oregon. Currently based in New York City, he specializes in aerial and urban exploration photography. www.mjinnyc.com.

Photo credits: pages 177, 182, 183, 194–95.

@newyorkcitykopp Kelly Kopp is a photographer whose love of New York and passion for photography is reflected in the images he captures of the everyday life of busy New Yorkers and visitors.

Photo credits: pages 62, 79, 81, 86, 89, 142, 202 (no. 16), 204 (no. 1).

@nikonej EJ Gomez is a wedding videographer based in the San Francisco Bay Area, whose passion for landscape photography and exploration has led him on many adventures from California to New York and beyond. He curates the popular Instagram hubs @wildcalifornia_ and @global_hotshotz.

Photo credit: pages 90–91.

@nyclovesnyc Noel Y. Calingasan is a neuroscientist by profession and a photography enthusiast who loves photographing New York City, where he currently lives. flickr.com/nyclovesnyc.

Photo credits: pages 6, 9, 28, 43, 57, 63, 69, 79, 89, 90, 104, 106, 127, 154, 164, 165, 166, 167, 168, 176, 178, 179, 187, 193, 201 (no. 8), 203 (no. 23), 203 (right-hand column, third and fourth from top), 204 (no. 4).

@nyctme Sam Perez is a New York City photographer specializing in cityscapes and street photography. As creator of the popular Instagram hubs @nycprimeshot and @usaprimeshot, he enjoys organizing Instameets, photography tours, and bringing people together in the New York Instagram community. FB.com/nyctme.

Photo credits: pages 57, 85.

@nyroamer Ashley lives in New York City and holds a passion for all that is New York, noting her inspiration in its cityscapes, people, and gritty streets. She is passionate about showcasing the beauty of the city.

Photo credits: pages 32, 57, 89, 95, 106, 114.

@papakila Don Doherty is a Brooklyn-based photographer in love with the streets, the skylines, and the people of New York City.

Photo credits: pages 5, 11, 41, 122, 137, 147, 149, 155, 156, 157, 201 (no. 7).

@pictures_of_newyork is a self-taught photographer whose love for New York City can be seen in her images capturing the city's architecture and energy that she loves to share with the world.

Photo credits: pages 65, 103.

@thewilliamanderson William Anderson is a freelance photographer based in New York City who shoots primarily urban/street photography for clients and tourism boards around the world.

Photo credits: pages 2, 48, 57, 63, 154, 204 (no. 10).

@timothyschenck Timothy Schenck is a photographer of fine scenery from on high, architecture, art, and a city under constant construction—capturing New York City history one frame at a time. www.timothyschenck.com.

Photo credits: pages 38, 116, 118, 119, 201 (no. 14).

@vincentjamesphotography Vincent James, a New York native, is a musician, composer, and fine-art nature photographer based in the San Francisco Bay Area who specializes in natural light portraits and enjoys teaching photography workshops. www.vincentjames.net.

Photo credits: pages 141, 169.

Other New York Instagram Accounts to Follow
@wildnewyork, @nycprimeshot, @ig_nycity, @icapture_nyc, @nycgo, @loves_nyc, @what_i_saw_in_nyc, @humansofny, @nyonair

About the Editor

Dan Kurtzman is a writer and photographer who got his start as a photojournalist and now specializes in landscape and travel photography. On Instagram he has built popular followings in both New York and San Francisco on his @wildnewyork, @wildbayarea, and @wildcalifornia_ community accounts, where he showcases the beautiful and inspiring work of some of Instagram's most talented artists. As both a curator and connector, he has worked to build community and bring together photographers on both coasts. His own photography can be seen on Instagram at @dankurtzmanphotography and on his website: www.dankurtzman.com.

Acknowledgments

I would like to express my deepest gratitude to the incredibly talented photographers who contributed their beautiful images to this book. Their creativity and dedication inspire me on a daily basis, and I can't thank them enough for the honor of curating their amazing work, and for their unwavering enthusiasm and support for this project. We are all indebted to Instagram for creating an extraordinary photo-sharing network and a thriving worldwide community of photographers that has enriched our lives.

I wish to extend my sincerest thanks to my fabulous editors, James O. Muschett and Elizabeth Smith, the wonderful designer, Lynne Yeamans, and the rest of the talented team at Rizzoli for their tremendous work, skillful guidance, and careful attention to detail in creating this book, especially Charles Miers and Kathleen Jayes for believing in this project from the beginning. I am also immensely grateful to my outstanding agent, Danielle Svetcov, for her diligent work to make this book a reality.

Many thanks and emphatic emojis go out to my photographer friends who have been sources of inspiration and invaluable help, including Don Doherty, Paul Seibert, Noel Y. Calingasan, Vincent James, Augusto Andres, Nicholas Steinberg, and EJ Gomez. I am also thankful for the feedback and support of Thomas Fahy at every step, as well as Todd Smithline, Shannon Farley, Sarah Schroeder, Daniel Wasson, Josh Archibald, John Nein, Lara Abbott, Craig Forman, Lou Kipilman, and Warren Graff.

I am especially fortunate to have the love and support of my family, Ken and Caryl Kurtzman, Gisele and Todji Kurtzman, the rest of the Kurtzman, Smithline, and Swanson clans, Baylee and Lois DeCastro, and the photography mentors in my family—David Kurtzman, Howard Parks, and the late Mike DeCastro, who sparked my love of cameras and darkrooms at an early age.

Lastly, I am thankful beyond words to my inspirational and ever-encouraging wife, Laura, and my son, Joel, for keeping me grounded with their laughter, love, and support, and for helping me to see everything more clearly through their eyes.